CASH

THE AUTOBIOGRAPHY

Johnny Cash

with Patrick Carr

HarperOne

An Imprint of HarperCollins*Publishers*

HarperOne

Design by Joseph Rutt

FIRST HARPERCOLLINS PAPERBACK EDITION PUBLISHED IN 2003

Library of Congress Cataloging-in-Publication Data is available.

ISBN: 978–0–06–072753–6

24 25 26 27 28 LBC 47 46 45 44 43

To John Carter Cash
The Gift. You have it. Never forget.

Contents

Acknowledgments

For encouragement and inspiration, Jack Shaw, June Carter, Lou Robin, Mark Chimsky, Patrick Carr, Tom Grady, W. S. Holland, Karen Adams, Kelly Hancock, Lisa Trice, Joanne Cash Yates, Louise Garrett, Tommy Cash, Reba Hancock, Jack Cash, Roy Cash, and George T. and Winifred Kelley.

To Billy Graham, who suggested this book in the first place, then continued to encourage me to do it.

And a special thanks to Reba Hancock. You gave all for me, day and night, for forty years.

And many, many more I'll regret not mentioning when I realize that I didn't.

Patrick Carr adds some others to thank for their work on this book: David Hennessy, Debra Kalmon, Terri Leonard, Kevin McShane, Ann Moru, Karen Robin, Joseph Rutt, Robin Sturmthal, Steve Sullivan, Kris Tobiassen, Lyn Wray, and Chris Wright.

PART I

Cinnamon Hill

1

My line comes down from Queen Ada, the sister of Malcolm IV, descended from King Duff, the first king of Scotland. Ada's holdings encompassed all the land east of the Miglo River in the Valley of the Bran, in what is now the county of Fife. Malcolm's castle is long gone, but you can still see some of its stones in the walls of the church tower in the little village of Strathmiglo. The motto on my people's coat of arms was "Better Times Will Come." Their name was Caesche; with emigration in the sixteenth and seventeenth centuries it came to be spelled the way it was pronounced, C-A-S-H.

The first American Cash was William, a mariner who captained his own ship, the *Good Intent,* sailing out of Glasgow across the Atlantic with cargoes of pilgrims for the New World until he himself settled in Essex County, Massachusetts, in 1667. His descendants migrated to Westmoreland County, Virginia, in the very early 1700s, before

3

George Washington was born there, and then moved on to Bedford and Amherst counties. My direct line went farther south, to Henry and Elbert counties in Georgia, where my great-grandfather, Reuben Cash, was born. He fought for the Confederacy and survived the Civil War.

His home didn't. Sherman's troops stripped and burned his Georgia plantation, so he moved his family farther west, homesteading across the Mississippi in Arkansas when his son, my grandfather, William Henry Cash, was six. William Henry Cash grew up in Toledo, Arkansas, a community that began disappearing as soon as the railroad came through nearby Rison. He became a farmer and a minister, what they called a circuit rider, a traveling preacher serving four widely scattered congregations. He rode a horse and he carried a gun, and never once did he take a penny for his preaching—though as my daddy told it, the yard and the barn and the stables were full of animals people had given him, and there was always enough to feed his twelve children. Parkinson's disease sent him from this world at the age of fifty-two, in 1912.

Daddy, the youngest son and the only child still at home, was just fifteen at the time, but he supported my grandmother until her death three years later, after which he enlisted in the army. His first posting, in 1916, was to General John J. Pershing's command in Deming, New Mexico, and he was under Pershing when Pancho Villa came through and burned Columbus. I remember him telling me that for three nights he lay with his head in Mexico and his feet in Texas, waiting for Villa. Villa never came; Pershing had to go looking for him.

Daddy's name was Ray Cash. He married my mother, Carrie Rivers, on August 18, 1920. I was their fourth child.

Daddy had a lot, but he didn't have money. The Depression had ruined cotton farming—already a hard, marginal living for people like him at the bottom of the system—and he had to take whatever work could be had. Sometimes none could, so he spent his days roaming with his .22 rifle after squirrels, rabbits, possum, whatever might feed his family. Given a shot, he didn't miss. He couldn't afford to—in those

days a box of shells cost twenty cents. He worked at the sawmill; he cleared land; he laid track for the railroad; and when no work was available locally, he rode the freights to wherever advertisement, rumor, or chance offered payment in cash. Our house was right on the railroad tracks, out in the woods, and one of my earliest memories is of seeing him jump out of a moving boxcar and roll down into the ditch in front of our door. Lots of men did that. The trains slowed near our house, so it was a popular spot for jumping to avoid the railroad detectives at the station in Kingsland.

Those were certainly men to be avoided. I remember Daddy telling me about a time when he'd been riding the rods—clinging to the crossbars under a moving boxcar, a terribly dangerous way of riding unobserved. When the train stopped in Pine Bluff and he crawled out, he found a railroad detective standing right there. He suffered a beating and a cussing out, which he just had to stand there and take if he didn't want jail or worse. But when the train started moving again and the detective began walking away as the caboose came by, Daddy jumped on and hung there, cursing that railroad bull until he was out of sight. He laughed about that: he got in a few licks of his own *and* he got to ride in style, out from under those boxcars.

That same bull, by the way, picked on another hobo a while later. It wasn't his lucky day; the hobo pulled a gun and shot him dead.

My name is John R. Cash. I was born on February 26, 1932, in Kingsland, Arkansas. I'm one of seven children: Roy, the eldest, then Louise, Jack, myself, Reba, Joanne, and Tommy. We all grew up working the cotton fields.

I married Vivian Liberto of San Antonio, Texas, when I was twenty-two and went on to have four daughters with her: Rosanne, Kathy, Cindy, and Tara. Vivian and I parted, and in 1968 I married June Carter, who is still my wife. We have one child together, John Carter, my only son. June brought two daughters, Carlene and Rosie, to our marriage. Now we have a combined total of twelve grandchildren and

so many sons-in-law, past and present, that June makes a joke of it in her stage act.

My work life has been simple: cotton as a youth and music as an adult. In between I was an automobile factory worker in Michigan, a radio intercept operator for the United States Air Force in Germany, and a door-to-door appliance salesman for the Home Equipment Company of Memphis, Tennessee. I was a great radio operator and a terrible salesman. I hated the assembly line.

My first records were on the Sun label, run by Mr. Sam Phillips in Memphis and featuring Elvis Presley, Carl Perkins, Jerry Lee Lewis, Roy Orbison, Charlie Rich, and others as well as myself. My first single was "Cry, Cry, Cry" in 1955, my first big hit "I Walk the Line" in 1956. I left Sun Records for Columbia in 1958, and shortly after that I left Memphis for California.

My affair with pills had already begun. It quickly became all-consuming, eating me up for the next decade or so. Amazingly, it didn't completely ruin my career. During those years I made music I'm still proud of—particularly *Ride This Train, Bitter Tears,* and my other concept albums—and I had commercial success: "Ring of Fire" was a big hit for me in 1963. By that time I'd destroyed my family and was working hard on doing the same to myself.

I survived, though. I moved to Nashville, kicked my habit, and married June. My career accelerated. The *Johnny Cash at Folsom Prison* album was a huge success, and in 1969 I began hosting *The Johnny Cash Show* on the ABC TV network. After "Flesh and Blood" in 1970, I didn't·have a chart-topping single until "One Piece at a Time" in 1976, long after *The Johnny Cash Show* was history.

Between the early '70s and the early '90s I didn't sell huge numbers of records, but again I have to say that I made some music I'm still proud of, and those years weren't dull. I wrote my first autobiography, *Man in Black,* and my first novel, *Man in White.* I teamed up with Waylon Jennings, Kris Kristofferson, and Willie Nelson in the Highwaymen. I left Columbia, owned by CBS Records, and went to

Mercury/Polygram. I got elected to the Country Music Hall of Fame and the Rock 'n' Roll Hall of Fame. I got addicted to pain pills, got treated at the Betty Ford Clinic, recovered, got addicted again, and recovered again. I just about died, got saved by heart bypass surgery, and just about died again. I worked hundreds and hundreds of shows. I kept my operation together, more or less, until the wheel of fortune rolled around to me again.

That happened in 1994, when I formed an alliance with Rick Rubin, producer of radically non-Nashvillian acts like the Beastie Boys and Red Hot Chili Peppers, and made my *American Recordings* album. According to the media at the time, that caused an overnight change in my status from "Nashville has-been" to "hip icon." Whatever they called me, I was grateful. It was my second major comeback; the minor ones have been too many to count.

I'm still on the circuit today, still recording, still writing songs, still showing up to play everywhere from Midwestern auditoriums to Manhattan trend spots to the Royal Albert Hall.

I'm in reasonable shape physically and financially. I'm still a Christian, as I have been all my life.

Beyond that I get complicated. I endorse Kris Kristofferson's line about me: "He's a walking contradiction, partly truth and partly fiction." I also like Rosanne's line: "He believes what he says, but that don't make him a saint." I do believe what I say. There are levels of honesty, though.

And there are levels of intimacy. I go by various names. I'm Johnny Cash in public and on record sleeves, CD labels, and billboards. I'm Johnny to many people in the business, some of them friends and acquaintances of many years. To June, I'm John, and that's my name among other intimates: my band, my sons-in-law, many friends, and people who work closely with me. Finally, I'm J.R., my name from childhood. My brothers and sisters and other relatives still call me that. So does Marty Stuart. Lou Robin, my manager, alternates between J.R. and John.

June recognizes that I operate at various levels, so she doesn't always call me John. When I'm paranoid or belligerent, she'll say, "Go away, Cash! It's time for Johnny to come out." Cash is her name for the star, the egomaniac. Johnny is her name for her playmate.

Several names, several homes. I'm part gypsy, part homebody, so I live according to a rhythm alien to most people but natural to me, splitting my time on a semi-predictable basis between my big house on Old Hickory Lake just outside Nashville; my farm at Bon Aqua, farther outside Nashville; the house in Port Richey, Florida, that June inherited from her parents; an endless succession of hotels all over the world; my bus; and my house in Jamaica, Cinnamon Hill.

Today I'm sitting on my back porch, high on my hill, looking out northward over the Caribbean toward Cuba ninety miles away. It's peaceful here. The occasional thudding of an ax or buzz of a chain saw comes down out of the woods climbing up around my house, and behind me, somewhere back in the house itself, I can hear the little sounds of Desna, Carl, Donna, Geraldine, and Mr. Poizer our Jamaican staff, preparing breakfast. Otherwise it's just the shifting clear light, the circling of john-crows and darting of hummingbirds, the soft rustle of tropical leaves in the trade winds. I love this place. I look over toward the front gate and see a guard walking the perimeter, one of our regulars, a wiry, grim-looking character toting a nickel-plated Remington 12-gauge. All I can say about him is that I'm glad he's on *my* side.

I've been thinking about the robbery—I've had to for this book, otherwise I'd just as soon forget it—but I'm not in the mood to tell that story. I'd much rather address its antidote, the flip side of violence, tragedy, addiction, and all the other many trials and tribulations this world has to offer. So right at the beginning here, I'm going to take stock of my blessings and tell you what I'm thankful for. It always puts things in perspective.

I'm thankful for a pair of shoes that really feel good on my feet; I like my shoes. I'm thankful for the birds; I feel like they're singing just

for me when I get up in the morning, saying "Good morning, John. You made it, John." And that first ray of sunshine; I'm thankful for living through the night to see it. I'm thankful I don't have a terminal disease, that I'm in fairly good health, that I can get up in the morning and walk down and have breakfast, then walk along the jungle trails and smell the flowers—the jasmine, the love vines, the orchids.

I'm thankful that I have a good wife beside me, that I can trust her and depend on her in a lot of ways. I'm thankful she's a soul mate, that we can talk to each other sometimes without even speaking and have an understanding on a lot of things. I'm thankful she loves my children. I'm thankful I don't have rambling on my mind, that I'm not thinking about other women, so long as I keep my heart and mind together.

I'm thankful I don't have a passion for cars, like so many entertainers who blow all their money that way—my car is almost nine years old and I have no intention of trading it in. I'm thankful that money is not my god, that for me it's a means to an end.

I'm thankful for my family—thankful for daughters and grandchildren and a son who love me, and thankful that their love is unconditional. I have a lot of good friends, and I'm thankful for them, too.

I'm thankful for my gift—my mother always called my voice "the gift"—and that even though I haven't written a song in quite a while, I've got a bunch of them raising cane in my brain, wanting to be laid down on paper. I'm thankful that God has inspired me to want to write, and that He might possibly use me to influence somebody for the good, if I can see the opportunities through the smokescreen of my own ego.

I'm thankful I'm not the ugliest man in the world, that I'm not all that ashamed to go on stage and face a crowd. I'm no picture, but if I were as ugly as some I've seen on stage, I wouldn't go. I'm not talking about physical appearances especially, but ugly souls.

Finally, I'm thankful, *very* thankful, that at this moment I have absolutely no craving for any kind of drug. I've been up almost three hours today, and this is the first time I've thought about it, and even

then it's in the spirit of gratitude. So my disease isn't active. Last night I saw a bottle of wine passed around the table, and I never once thought about taking even a sip of it. (So why am I thinking about it now? *Watch it, Cash!* Gotta never be complacent. Never take anything for granted. Don't forget, great prices have been paid and will be paid again if you get too smug, too egotistical and self-assured.)

I'm thankful for the sea breeze that feels so good right now, and the scent of jasmine when the sun starts going down. I'm a happy man.

I'm thankful I was led to this place. Jamaica has saved and renewed me more times than I can count.

Partly it's the isolation. It's not Nashville, or Tennessee, or even the United States, and the Jamaican telephone system has its own mysterious schedule beyond the influence of even the most important people. Sometimes it decides that I just don't need it. Usually it's right.

That's nice enough, but I love Jamaica for deeper reasons. The lushness of the vegetation, the purity of the air, the rain-washed hills, the sparkling sky at night—these are pieces of my childhood in Arkansas. Back then, back there, the air was so clear that even if the moon wasn't up, sometimes the stars by themselves would be so bright that they'd cast enough light for you to see your way. I loved that. I loved walking through the woods down the trail to the river where I'd go fishing long about May and June when the growing season was in its prime, whipping my fishing pole through the leaves ahead of me to expose the cottonmouth moccasins that would lurk just off the trail. I loved the greenery, the growing things in their seasons, the constancy and the dependability of it all. You know—next May, the fishing trail will be the same as it is this May. There'll be May pops, the little fruit that comes out in May every year. There'll be blackberries by the Fourth of July, depend on it. Pretty soon, it'll be warm enough to start going barefoot . . .

At a very early age I looked forward to all that, to the seasons turning and nature taking its course. And while I didn't put such words to

it at the time, I was very aware that I was part of nature—that I sprang from the soil, and as long as I followed the natural order of things, I'd be okay.

I remember just how the earth felt under my bare feet, even the rocks in the road. I didn't wear shoes year-round, except to school, until I was about fifteen, and the soles of my feet were like leather. I remember the taste of green peas straight from the plant, the tantalizing difference between the peas themselves and their sweet, crisp shells. I remember raw okra—I'd pick pieces off the plants as I passed through the fields. I remember how wonderful it felt to sit down in the tomato patch and eat the ripe ones straight off the vine.

In Jamaica I can come close to those days and those ways. Here, you can depend on the Ackee trees to put out their fruit each year. During the rainy season you can count on runoff from the mountains rushing over the waterfall near my house, just as you know it will slow to a trickle come January and February. Any night of the year you can walk out any door and look up, and there above you will be all the brilliance and beauty of the stars; I've looked through a telescope from here and seen as many as five of the moons of Jupiter. From here I can get in my car and go down to one of the local markets and buy tomatoes with their stems still on, potatoes still flecked with dirt from the fields. I can pick bananas from the trees in my own yard when they're perfectly ripe, just exactly right, and no banana in the world ever tasted as good. I can go barefoot, even if my sixty-five-year-old soles aren't nearly as tough as that Arkansas country boy's. I can feel the rhythms of the earth, the growing and the blooming and the fading and the dying, in my bones. My *bones*.

When we clasp hands around the dinner table every night and we ask God to grant us rest and restoration, that's the kind of restoration I'm talking about: to keep us as one with the Creator. To rest in nature's arms.

2 Inside me, my boyhood feels so close, but when I look around, it sometimes seems to belong to a vanished world. In the United States in the late 1990s, is it really possible to imagine whole families, boys and girls of eight to eighteen at their parents' sides in the cotton fields, working through the July heat from dawn to dusk, driving away exhaustion with songs of the spirit? Are there still places where a young boy can leave his house after breakfast with just a fishing pole and spend the whole day rambling and adventuring alone, unsupervised and unafraid, trusted and un–feared for?

Perhaps there are. I hope so. But I suspect otherwise. I think that even if such places do exist, our televisions have blinded us to them.

I was talking with a friend of mine about this the other day: that country life as I knew it might really be a thing of the past and when music people today, performers and fans alike, talk about being "coun-

try," they don't mean they know or even care about the land and the life it sustains and regulates. They're talking more about choices—a way to look, a group to belong to, a kind of music to call their own. Which begs a question: Is there anything behind the symbols of modern "country," or are the symbols themselves the whole story? Are the hats, the boots, the pickup trucks, and the honky-tonking poses all that's left of a disintegrating culture? Back in Arkansas, a way of life produced a certain kind of music. Does a certain kind of music now produce a way of life? Maybe that's okay. I don't know.

Perhaps I'm just alienated, feeling the cold wind of exclusion blowing my way. The "country" music establishment, including "country" radio and the "Country" Music Association, does after all seem to have decided that whatever "country" is, some of us aren't.

I wonder how many of those people ever filled a cotton sack. I wonder if they know that before I became "not country" in the '90s, their predecessors were calling me "not country" in the '50s and the '60s, and the '70s too (I was invisible in the '80s).

But that's a minor irritant. It doesn't even come close to the happiness I feel about being given a new lease on a creative life I thought might be drawing to a close, or the thrill of playing to eager young audiences. Sometimes that feels like '56 all over again, out there on the road in the first days of rock 'n' roll with Carl, Roy, Jerry Lee, Elvis, and all those other Memphis rabble-rousers.

But yes, before rock 'n' roll there was country, and before Memphis, for me anyway, there was Arkansas.

The first song I remember singing was "I Am Bound for the Promised Land." I was in the back of a flatbed truck on the road to Dyess, Arkansas, from the first house I remember living in: the place next to the tracks out in the woods near Kingsland, Arkansas, where my family had ended up after a succession of moves dictated by the rigors of the Depression. That was a real bare-bones kind of place, three rooms in a row, the classic shotgun shack. It shook like the dickens every time

a train went by. It wasn't as bad as the house I'd been born in, though. I don't remember living in that one, but I saw it once when I went to visit my grandfather. It was a last resort. It didn't have windows; in winter my mother hung blankets or whatever she could find. With what little we had, my parents did a lot.

The new house toward which the flatbed truck was taking us was something else, a brand new deal of the New Deal. Late in 1934, Daddy had heard about a new program run by the Federal Emergency Relief Administration in which farmers like him who had been ruined by the Depression were to be resettled on land the government had bought. As he explained it in later years, "We heard that we could buy twenty acres of land with no money down, and a house and barn, and they would give us a mule and a cow and furnish groceries through the first year until we had a crop and could pay it back, and we didn't have to pay until the crops came in." That's exactly what the deal was, and more: in forty-six different places in the agricultural United States, these "colonies" were being created on a cooperative basis. In the settlement toward which we were headed, we and all the other families would have a stake in the general store, the cannery, the cotton gin, and other facilities; we were all responsible for them and we all shared in their profits, if any. The cotton we produced would go into the communal crop to be sold higher up the line for better prices than small individual crops could be. So as I've said in the past, I grew up under socialism—kind of. Maybe a better word would be communalism.

Our new community was named after the administrator of the FERA program for Arkansas, W. R. Dyess. All in all, it covered about 16,000 acres of Delta bottomland in Mississippi County. It was laid out like the spokes of a wagon wheel. Our place was Number 266, out on Road Three, about two and a half miles from the center.

I remember coming to that house so clearly. It took us two days to travel the 250 miles from Kingsland, first on gravel roads and then on dirt roads turned to mud by a hard, bitterly cold rain. We had to stop overnight by the roadside in the truck the government had sent for us,

and we kids slept in the back with just a tarpaulin between us and the rain, listening to Moma cry and sing.

Sometimes Moma would cry and sometimes she'd sing, and sometimes it was hard to tell which was which. As my sister Louise put it later, that was one of the nights when you couldn't tell. It all sounded the same.

When we finally got to Dyess, the truck couldn't get up the dirt road to our house, so Daddy had to carry me on his back the last hundred yards through the thick black Arkansas mud—gumbo, we called it. And that's where I was when I saw the Promised Land: a brand new house with two big bedrooms, a living room, a dining room, a kitchen, a front porch and a back porch, an outside toilet, a barn, a chicken house, *and* a smokehouse. To me, luxuries untold. There was no running water, of course, and no electricity; none of us even dreamed of miracles like that.

The house and the outbuildings were simple and basic, but sound, and identical to all the homesites in the colony. All of them were built to the same plan by the same thirty-man construction crew, who'd complete one site every two days, then move on to the next. I vividly remember the sight of their empty paint buckets, five of them, sitting in the middle of the living room floor, the only objects in the house: green for the trim, white for everything else. We settled in as best we could that first night. I don't remember how we stayed warm.

The next day, Daddy put on a pair of hip waders and went out to take stock of our land. It was jungle—I mean real jungle. Cottonwood and elm and ash and hickory as well as scrub oak and cypress, the trees and vines and bushes tangled up so thick in places that you couldn't get through, some of it under water, some of it pure gumbo—but Daddy could see its potential. "We've got some good land," he said simply when he came back, with an air of hope and thanks we could all feel. That was a significant remark.

The land was awfully hard to clear, but Daddy and my oldest brother, Roy, then almost fourteen, went at it from dawn till nighttime

six days a week, starting on the highest ground and working their way downward foot by foot, cutting with saws and axes and kaiser blades—long-handled machetes—and then dynamiting and burning out the stumps. By planting season the first year they had three acres ready. Two went for cotton, a cash crop Daddy would use to make his first payment to the government, and the other went for animal feed and food for our table: corn, beans, sweet potatoes, tomatoes, and strawberries.

The crops came in well that first year, and the Cashes were on their way. The following spring I was five and ready for the cotton fields.

You often hear Southern musicians of my generation, black and white, bluesmen, hillbilly singers, and rockabillies alike, talking about picking cotton (and doing whatever it took to get out of the cotton fields), but I've sometimes wondered if the people listening to us, who are usually younger and/or more urban than we are, have any real grasp of the life we're talking about. I doubt if most people these days even know what cotton is, beyond being a comfortable kind of fabric. Maybe they'd like to know. Maybe *you* would, if only as musicological background. Huge swatches of the blues and country music do after all come from the cotton fields in a very real way: many a seminal song was actually created there, and even more were spread from person to person.

Here, then, is how it went with cotton and us.

We planted our seeds in April, and if we worked hard enough and our labors bore fruit and the Big Muddy didn't rise and the army worms didn't come through and no other natural disasters were visited upon us, the first blooms opened on plants that were four feet high in October. We began picking soon after that, though we couldn't pick efficiently until a killing frost had stripped the leaves off the plants and made the bolls easier to see. Picking lasted on through December, when the winter rains started coming and the cotton started turning dark, descending in quality and losing its value as it did so. These days they spray the plants with chemicals so the leaves will fall off early, then har-

vest with machines. They're polluting the groundwater and ruining the land. We never used any chemicals on our land—not that I have anything against fertilizers when they're properly used; we just couldn't afford them.

Our cotton was of the Delta Pine variety, so called because its long fibers, much longer than most commercial cotton grown in the United States at the time, reminded whoever named it of pine needles. Our rich, virgin Delta land supported it well, and in our first few years, before the soil got tired, our yield was outstanding. I remember Daddy bragging about two bales to the acre, which was unheard of in other parts of the country: neck-high plants just covered up with bolls, and Strict High Middlin' cotton all the way.

Which I guess calls for an explanation. Strict High Middlin', like the everyday expression "fair to middlin'," was a grade of cotton. When we got our crop to the gin, they'd take a knife and cut into the bales. The expert would pull the fibers out and fool with them a while, then make his decision, write down the grade, and tie it to the bale of cotton. He'd be looking mostly at the length of the fibers, their strength, and their color, and the grades he had to work with, if I remember it right, were Strict High Middlin', High Middlin', Fair to Middlin', Middlin', Low Middlin', and Strict Low Middlin'. Those grades mattered a lot, too: when you got the bales to market, a bale of Strict Low Middlin' would go for, say, twenty-eight cents a pound, whereas Strict High Middlin' would get you thirty-five cents.

After the first few years of spectacular yields, Daddy's hope was that he could get Fair to Middlin' from our land, even if the yield kept going down. By the time I was into my teens, we were really lucky to get a bale to the acre; usually it was more like ten or twelve bales of cotton from twenty acres. Finally it got down to where an acre wasn't giving us more than three-quarters of a bale. That was when a lot of the farmers in Dyess started selling out. Daddy kept going, though. He went to the Farm Home Administration and signed up to start making payments on the farm next door to ours. That helped, but the land

wasn't as good as ours, so it didn't help much. Daddy got the best from it, though; he was a really hard worker, and he was smart and careful about rotating his crops and keeping his land well drained. I think he even experimented with other kinds of cotton, but he always went back to Delta Pine. That's the only kind *I* remember, anyway.

We couldn't afford fertilizer, as I've said, so we were limited to crop rotation as a way of getting minerals back into the soil. After the first seven years or so, when I was about ten, we started having to turn a patch of cotton land to soybeans here or to corn there. We had to sacrifice one piece completely, early on, for an alfalfa patch to provide winter feed for our cow and our mule, both of which were absolutely essential to our livelihood. Wherever you plant alfalfa you can forget about planting anything else, because the alfalfa comes back year after year and you can't plow it under.

I started out in the fields as a water boy, which is just how it sounds: you tote drinking water to the grown-ups and older children. By the time I was eight, though, I too was dragging a cotton sack. We didn't carry those nice baskets like you see in the movies; we used heavy canvas sacks with tar-covered bottoms, six feet long if you were one of the younger children, nine feet long for big kids and grown-ups. We'd fill that sack up to near the top, and then we'd shake it, pack the cotton down good and hard, and start picking again. By the time you were ready to haul your sack to the wagon, you'd have about thirty pounds of cotton in there, or forty or fifty pounds if you had a nine-foot sack. Going at it really hard for ten hours or so, I could pick about three hundred pounds; most days it was more like two hundred.

It wasn't complicated. You just parked the wagon at one end of the rows and went to it. If there were two of you together, maybe you'd pick three rows at a time, with both of you sharing the picking on the middle row. If you were Daddy, you'd *always* pick two rows at a time. Myself, I'd pick just one row. It looked like you were making more

progress that way—to the others of course, but more importantly to yourself. Believe me, I needed all the encouragement I could get.

It's true, there really wasn't much to recommend the work. It exhausted you, it hurt your back a lot, and it cut your hands. That's what I hated the most. The bolls were sharp, and unless you were really concentrating when you reached out for them, they got you. After a week or two your fingers were covered with little red wounds, some of them pretty painful. My sisters couldn't stand that. They got used to it, of course—everybody did—but you'd often hear them crying, particularly when they were very young. Practically every girl I knew in Dyess had those pockmarked fingers. Daddy's hands were as bad as anyone else's, but he acted as if he never even noticed.

Of course, planting and picking wasn't all that cotton demanded of us. The real work came in between. Once you'd planted the seeds, you had to keep the weeds down, and that was some job: the vines that had been cut off to ground level when the land was cleared came charging back up come late March or early April, and from that point on they grew faster than we could cut them down. We'd be out there working our way through the eight-acre field, everybody with a hoe and a file for sharpening it every hour or so, and by the time we approached the end of the rows we were weeding, we'd look back and see new growth already covering up the cotton plants. By the first week in June the cotton plants would be a foot high, but the weeds would be eighteen inches or two feet. Crabgrass was one of the worst enemies, and then there were what we called cow-itch vines, long creepers that wrapped themselves around the cotton stalks and tried to choke them down.

So we just worked and worked and worked. We'd get a break now and again when it rained too hard for us to get to the fields, but that was no bargain: the weeds kept growing without us, and they grew even faster after a good rain.

Come August and its doldrum heat, we had what we called laying-by time when it seemed that God let up a little on making the grass,

vines, and weeds grow, and for a two- or three-week period we'd work only three days a week in the cotton fields. That, though, was the time for digging potatoes, cutting hay and hauling it to the barn, and all that stuff. So there was never really any end to it; the work just went on and on. We did get those weeds chopped, though. We did get ahead with the cotton, and that was the thing: whatever else happened, you stayed ahead with the cotton.

There were of course forces against which we were powerless. The Mississippi was foremost in that regard—my song "Five Feet High and Rising" came from my own experience, not some storybook—but other acts of nature could and did wipe out a whole year's worth of your work and income. For instance, although we didn't have boll wee-vils where we were—they were more of a problem in Texas—we did once get in the way of army worms. They moved in massive congrega-tions, millions of them, and had an effect on the land in their path just like Sherman's boys had on Georgia. You'd hear about them coming, first from farmers miles away, then from those closer and closer until the worms were on the land right next door, and finally there they were, all over your own crops. They went from field to field, eating— eating *fast*—and then moving on, and there was nothing you could do about them. You could stomp them all you wanted, all day and all night too if it made you happy, but that wouldn't get you anywhere even close to making a difference. They ate the leaves off the plants first, and then the blooms, and then the bolls, and then that was that.

Army worms were the bane of every cotton farmer in Arkansas. Now, wouldn't you know, they barely cross anyone's mind; you just spray for them and forget about it.

That's not to say that modern farmers don't have plenty to worry about. They sure do, and they always will. But I bet they also have some of the same great pleasures that lit up my young life. When the cotton began to open in October, for instance, it was just beautiful. First there'd be lovely white blooms, and then, in about three days, they'd turn to pink, whole fields of them. What a picture that was.

That wasn't all, either. Under those pink blooms there'd be tiny, tender little bolls, and they were such a sweet treat. I used to pull them off and eat them while they were still tender like that, before they began turning fibrous, and I loved them. My mother kept telling me, "Don't eat that cotton. It'll give you a bellyache." But I don't remember any bellyache. I remember that taste. How sweet it was!

3 You know what a smokehouse is? Well, ours was a plain board building about twelve feet by twelve or maybe fourteen by fourteen—not a shack, a good, tight, solid structure—and that's where we smoked our meat. You had to smoke any meat you wanted to keep; without refrigeration, which of course we didn't have, it would spoil otherwise. Everyone who lived in the country had a smokehouse if they weren't too poor.

Apart from whatever meat we had hanging, there were only two things in our smokehouse: a salt box for salting down the meat that would be sugar-cured, as we called it—hams, pork shoulders, bacon— and, in the opposite corner, a little hot box Daddy had built. We'd keep strips of green hickory smoldering in there day and night when we were smoking meat, and in summer we had it going all the time, keeping out the insects and killing bacteria. The scent of hickory smoke always in

the air around the homestead is another memory gone deep in my bones.

And the smokehouse is where Daddy, grim and strange to me in grief and shock, took me and showed me Jack's bloody clothes.

Jack was my big brother and my hero: my best friend, my big buddy, my mentor, and my protector. We fit very well, Jack and I; we were very happy together. I loved him.

I really admired him, too. I looked up to him and I respected him. He was a very mature person for his age, thoughtful and reliable and steady. There was such substance to him—such seriousness, if you like, or even moral weight, such *gravitas*—that when he made it known that he'd felt a call from God to be a minister of the Gospel, nobody even thought to question either his sincerity or the legitimacy of his decision. Jack Cash would have made a fine minister; everybody in Dyess agreed on that. When I picture him at fourteen, the age at which he died, I see him as a grown-up, not a boy.

Jack had a very clear and steady understanding of right and wrong, but he was fun, too. He was a great fishing buddy and all-around play-mate, and he was very fit and strong, just about perfect physically, a powerful swimmer and fast runner. All we country boys climbed trees like squirrels, of course, but he was exceptional: he was strong enough to climb a rope without even using his feet.

That impressed me, because I was the weak one, scrawny and skinny and not very strong at all, and by the time Jack was fourteen I'd decided I liked cigarettes. I started smoking regularly when I was twelve—stealing tobacco from my Daddy, bumming cigarettes from older kids, and very occasionally buying a package of Prince Albert, or sometimes Bull Durham or Golden Grain, and rolling my own. I was pretty adept at that; I was a talented smoker. I knew it was wrong and self-destructive, both because the preacher said so and because it made sense. Even back then, no matter what older folks say now, every-body knew that smoking hurt you, but I've never been one to let such

considerations stand in the way of *my* road to ruin. Jack knew I smoked and didn't approve one bit, but he didn't criticize me. Putting it in today's terms, he gave me unconditional love. The year he died, I'd even started smoking in front of him.

It was May 12, 1944, a Saturday morning. My plan was to go fishing. Jack's was to work at the high-school agriculture shop, where he had a job cutting oak trees into fence posts on the table saw.

He kept stalling. He took one of the living-room chairs, balanced it on one leg, and spun it around and around and around. I had my fishing pole leaned against the porch. I started out the front door and said, "C'mon, Jack. Come fishing with me!"

"No," he said without much conviction. "I got to work. We need the money." He'd make three dollars for working all day.

I don't remember my father being in the house, just my mother saying, "Jack, you seem like you don't feel you should go," and him saying, "I don't. I feel like something's going to happen."

"Please don't go," she said, and I echoed her—"Go fishing with me, Jack. Come on, let's go fishing"—but he kept at it: "No, I've got to do it. I've got to go to work. We've got to have the money." Finally he set the chair down and very sadly walked out the front door with me. I remember my mother standing there watching us go. Nobody said anything, but she was watching us. She didn't usually do that.

The silence lasted until we got to the crossroads where one branch went into the town center and the other went off toward our fishing spot.

Jack started fooling around, imitating Bugs Bunny, saying "What's up, Doc? What's up, Doc?" in that silly voice, which was very unlike him.

I could see it was false fun. I kept trying: "Go fishing with me, Jack. Come on, let's go."

He wouldn't. "No, I've got to go to work," he said again.

That's what he did. He headed off toward the school, and I went on down toward our fishing hole. As long as I could hear him, he

kept up with that goofy, unnatural "What's up, Doc? What's up, Doc?"

At the fishing hole I spent a long time just sitting there, not even putting my line in the water. Eventually I cast, but I just played, slapping my line in the water, not even trying for a fish.

It was strange. It was as if I knew something was wrong, but I had no idea what. I wasn't even thinking about Jack; all I knew was that something wasn't right. After a while I took my line out of the water and lay down on the bank—just lay there. I stayed like that for a long time before I got up, picked up my fishing pole, and started back home. I remember walking very slowly, much slower than usual.

I saw my father coming as soon as I got to the intersection where I'd left Jack. He was in a car, a Model A I believe it was, the preacher's car. It stopped by me and Daddy said, "Throw your fishing pole in the ditch and get in, J.R. Let's go home."

I knew something was *very* wrong. I wanted to hold onto my fishing pole, but Daddy had such a desperate air that I obeyed. I just threw the pole in the ditch and got in the car.

"What's the matter, Daddy?" I asked.

"Jack's been hurt really bad," he said.

He didn't say anything else, and I didn't ask. When we got home, about a mile from the crossroads, he took a brown paper grocery sack from the back of the car.

"Come out here to the smokehouse," he said in a quiet, dead voice. "I've got something I want to show you." The bag was all bloody.

In the smokehouse he pulled Jack's clothes out of that grocery bag, laid them on the floor, and showed me where the table saw had cut Jack from his ribs down through his belly, all the way to his groin: his belt and his khaki government shirt and pants, all of them slashed and bloody, drenched in blood.

Daddy said, "Jack's been hurt on the saw, and I'm afraid we're going to lose him." Then he cried. It was the first time I'd ever seen or heard him do that.

He only cried for a little while. Then he said, "I came home to find you. Jack's in the hospital in the Center. Let's go back there and see him. We may never see him alive again."

We did see Jack alive. He was unconscious when we got to the hospital, knocked out with drugs for the pain, but he didn't go right ahead and die. On Wednesday, four days after he'd been hurt, all the church congregations in town held a special service for him, and the following morning he had an amazing revival. He said he felt good, and he looked good. There he was, fine as you please, lying in bed reading his mail—he'd gotten a letter from his girlfriend—and laughing happily. My mother and father and I thought we were seeing a miracle. Jack was going to live!

Old Dr. Hollingsworth knew better. He'd operated on Jack when they brought him in, and he kept telling us, "Don't get too much hope, now. I had to take out too much of his insides, and . . . well, there's nothing left in there, really. You'd better get all the family home that wants to see him before he goes." We did that—Roy was in Texas, I think, and my older sister, Louise, was in Osceola, Arkansas—but we still hoped.

Not for long. On Friday Jack took a turn for the worse, and that night we stayed at the hospital in beds Dr. Hollingsworth had arranged for all eight of us: Daddy, the three girls, the three boys, and Moma.

I woke up early on Saturday morning to the sound of Daddy crying and praying. I'd never seen him pray before, either. He saw me awake and said, "Come on in to his room. Let's say good-bye to him."

We went in there. Everyone was crying. My mother was at the head of Jack's bed with my brothers and sisters all around. Daddy took me up to the head opposite my mother, and there was Jack talking crazy—"*The mules are out, don't let 'em get in the corn, catch the mules!*" But suddenly he grew calm and lucid. He looked around and said, "I'm glad you're all here."

He closed his eyes. "It's a beautiful river," he said.

"It's going two ways . . . No, I'm not going that way . . . Yes, *that's* the way I'm going . . . Aaaaw, Moma, can't you see it?"

"No, son, I can't see it," she said.

"Well, can you hear the angels?"

"No, son, I can't hear angels."

Tears came from his eyes. "I wish you could," he said. "They're so beautiful . . . It's so wonderful, and what a beautiful place that I'm going."

Then he went into a rigor. He had intestinal poisoning, and that stuff came out of his mouth onto his chest, and he was gone.

Losing Jack was terrible. It was awful at the time and it's still a big, cold, sad place in my heart and soul. There's no way around grief and loss: you can dodge all you want, but sooner or later you just have to go into it, through it, and, hopefully, come out the other side. The world you find there will never be the same as the world you left.

Some things in this world don't change, though. I look around me in Jamaica at the poverty, the harshness of life for many of the people, their endless toil for little reward and even less hope in their lives, just dreams and fantasies, and that puts me in mind of what still depresses me the most about Jack's death: the fact that his funeral took place on Sunday, May 21, 1944, and on the morning of Monday, May 22, our whole family—everybody, including the mother who had just buried her son—was back in the fields chopping cotton, working their ten-hour day.

I watched as my mother fell to her knees and let her head drop onto her chest. My poor daddy came up to her and took her arm, but she brushed him away.

"I'll get up when *God* pushes me up!" she said, so angrily, so desperately. And soon she was on her feet, working with her hoe.

Lest you get too romantic an impression of the good, natural, hardworking, character-building country life back then, back there, remember that picture of Carrie Cash down in the mud between the cotton

rows on any mother's worst possible day. When they talk about how cotton was king in the rural South, they're right in more ways than one.

After Jack's death I felt like I'd died, too. I just didn't feel alive. I was terribly lonely without him. I had no other friend.

It got worse before it got better. I remember going on a bus to Boy Scout camp that summer of '44 and talking about nothing but Jack until a couple of the other kids shut me up: "Hey, man, we know your brother's dead and you liked him, so that's enough, okay?"

I got the message. I quit talking about Jack altogether. Everybody knew how I felt and how my mother felt; they didn't need us telling them. So yes: terribly lonely. That says it.

It eased up a little when some of my classmates started making special efforts to befriend me, especially a boy called Harvey Clanton, who became my best friend all the way through school. His friendship began the process of pulling me out of my time in the deepest darkness I'd known.

What *really* got me moving, of course, was sex. By about fifteen I'd discovered girls. They did a pretty good job with my loneliness. When the hormones started moving, so did I.

Jack isn't really gone, anyway, any more than anyone is. For one thing, his influence on me is profound. When we were kids he tried to turn me from the way of death to the way of life, to steer me toward the light, and since he died his words and his example have been like signposts for me. The most important question in many of the conundrums and crises of my life has been, "Which is Jack's way? Which direction would *he* have taken?"

I haven't always gone that way, of course, but at least I've known where it was. In other words, my conscience has always functioned just fine—even through all my years of inflicting destruction on myself and pain on others, even with all my efforts to shut it up. The black dog in me went ahead and did what he wanted (and sometimes

he still does), but he always had that clear little voice of conscience harassing him.

Something else about Jack. When I was growing up, older people talked about how "this new generation is going all to hell," just as modern grown-ups do about today's kids and my generation did about the kids of the '60s. I never believed it, now or then. I went by the evidence of my eyes and ears: Jack was right in front of me, and I knew there were a lot more boys like him. I don't think that's changed. It hadn't in the '60s when I wrote and recorded "What Is Truth?" and it hasn't today. So I simply don't buy the concept of "Generation X" as the "lost generation." I see too many good kids out there, kids who are ready and willing to do the right thing, just as Jack was. Their distractions are greater, though. There's no more simple life with simple choices for the young.

Jack has stayed with me. He's been there in the songs we sang at his funeral—"Peace in the Valley," "I'll Fly Away," "How Beautiful Heaven Must Be," all of them—and those songs have sustained me and renewed me my whole life. Wherever I go, I can start singing one of them and immediately begin to feel peace settle over me as God's grace flows in. They're powerful, those songs. At times they've been my only way back, the only door out of the dark, bad places the black dog calls home.

Jack comes to me in person, too. He's been showing up in my dreams every couple of months or so, sometimes more often, ever since he died, and he's been keeping pace with me. When June or John Carter or other members of my family appear in my dreams, they're usually younger than they are now, but Jack is always two years older than me. When I was twenty, he was twenty-two; when I reached forty-eight, he was fifty already; and the last time I saw him, about three weeks ago, his hair was gray and his beard was snowy white. He's a preacher, just as he intended to be, a good man and a figure of high repute.

He's still wise, too. Usually in my Jack dreams I'm having some sort of a problem or I'm doing something questionable, and I'll notice him looking at me, smiling, as if to say, "I know you, J.R. I know what you've *really* got in your mind . . ." There's no fooling Jack.

4

Cinnamon Hill has its own spirits, presences, and very personal memories.

From the spot where I sit at this moment, on the veranda at the north end of the house, shaded by jasmine, 280 feet above sea level, I'm just a few feet away from the quiet, gentle room in which I recuperated from my most profound encounter with the medical profession, emergency bypass surgery in 1988. It's the room through which people have been going to ground during hurricanes ever since the house was built in 1747, and what's now its bathroom was designed as both a hurricane shelter and a windbreak. Constructed of limestone four feet thick in the shape of a round-edged, slope-roofed wedge pointing north, into the hurricane winds, it directs the fiercest forces of the storms down the sides and up over the top of the house. It's very effective and, as far as I know, unique; I've never seen another like it anywhere in the world.

John Carter's young wife, Mary, has painted the interior walls with tropical fishes.

Even closer to me, right at my feet, is another memory, the skin of the rogue crocodile I killed back in 1976, eleven feet and 560 pounds of very tough, dangerous old creature, One-Eyed Jack we called him in his prime. I put three bullets from a rusty .30-30 into his brain—good shooting, even if I do say so myself, over open sights in the dark—until he quit thrashing around and we were able to drag him into the airboat with us, where of course he came right back to life. Not a good moment, that. My friend Ross Kananga, a professional in the affair, had to shoot him another five times with a pistol before he went quiet forever.

We did the local wildlife a big favor that night, and we, too, benefited. Crocodile tail meat is delicious when you cut it in thin slices, roll it in meal and spices, and fry it like fish.

I don't regret killing One-Eyed Jack, but I don't kill anything anymore. I just don't want to.

A lot has been created on this veranda, in this spot. Billy Graham wrote parts of three of his books here, and it's one of my own favorite writing places. And then of course it's possible that some of the descendants of the Barretts—the Barretts of Wimpole Street, the family of Elizabeth Barrett Browning, the original owners of the property—wrote some of their journals, prose, and poetry here. Certainly they experienced life here, and death; many of them are entombed in their own private cemetery in a lovely spot down the hill from the house, one of my favorite places in the world. Every one of the men, women, and children buried there lived and died in the house I now call mine.

On John Carter's first visit to the cemetery, when he'd just turned four, he said something to June as she opened the gate that she didn't understand at first: "Moma, my brother Jamie is here."

She was mystified, but then, as she was looking around, she bent down to read the smallest of all the tombs, one of those heartbreakingly tiny memorials you always know at a glance marks the grave of a

young child. The stone was worn on one side, so she couldn't make out the last number in the birth and death dates, but the first three numbers of both were 177–, and the young Barrett's Christian name was James. She still didn't understand, but there it was, and there it is today.

Perhaps we were meant to come here. I certainly felt a powerful tug when I first saw the house in 1974. I was rambling around the hills in a four-wheel drive with John Rollins, who owned the house and all the land around it, including Rose Hall, the greatest of all the great houses. As soon as we came up on Cinnamon Hill I fell in love with it. It was in disrepair but basically sound—a playboy was living there in just one room, with one electric light and one maid—and immediately I got the idea that I could renovate it into a wonderful vacation home. John thought that was a good idea, too, but he wouldn't consider selling it to me; he wanted it for himself in later years. If I wanted to fix it up, he said, I should go ahead and do that, and I could use it whenever I wanted.

I went ahead, and by the end of 1974, it was ready for our first Christmas in Jamaica. I'd never liked the idea of living in someone else's house, though, and at that point I *really* didn't like it. I badly wanted to own the place myself.

By that time John Rollins and I had become good friends. We'd taken to each other on first meeting, being of like mind and similar roots—he too came from the cotton fields; he'd had the same kind of life in Georgia as I'd had in Arkansas—and so he'd shared some of his secrets with me. The relevant one was about his approach to closing a really big deal, which is something he does well. He was already a very successful businessman in 1974, and he's come a long way since then. He operates in a financial sphere way beyond mine; last time I checked, his umbrella company owned about two hundred enterprises, everything from billboards in Mexico to truck lines in the United States to security services all over the world. For a while he was lieutenant

governor of Delaware, his home base today. I'm godfather to his son Michael.

To close a deal successfully, he told me, he'd put on his dark suit—his "sincere suit," he called it—and make his pitch, and when he was done he always said, "And if we can do that, I sure would appreciate it."

Now, I don't own a "dark suit," and didn't then, and all-black outfits in the Benjamin Franklin or riverboat-gambler style, my favorite kind of dress-up outfit at the time, are anything but "sincere suits," so I left out that part of the formula when I sat down on the porch with John right after Christmas.

"You know, John, I spent a lot of money on this place this year," I began. "I've got more invested in it than I should for just a place to come once in a while for a nice vacation. We've hired people to work here, got the place fixed up, got the grounds fixed up. We're about to put in a swimming pool. I think it's time you sold me this place."

"No," he said. "I can't do that." He still wanted it for himself.

I pressed. "Well, we've just about got to have this place."

Still no deal. "You've got it every time you need it. Just come on down," he said.

"Look, John, you know better than that. It just wouldn't be right to do it that way. I wouldn't feel right, fixing it up and having it still be yours. We've got our hearts here now. We've gotten dirt on our hands around here. We love this place. We need to buy it from you."

"I don't know . . ." he said.

"Well, say you sold it. If you did, what would you have to have for it?"

He told me his figure. Bingo. We were into it now. I was halfway there, at least. I thought about his price, concluded that it had some give in it, and made him my offer. Then I looked him straight in the eye and said, as soberly and sincerely as possible, "If we can do that, John, I sure would appreciate it."

He stared at me for a second, then started laughing. "All right," he said, "we've got a deal."

And so we did, and so June and I began the process of merging our lives with that of our new home.

The past is palpably present in and around Cinnamon Hill, the reminders of other times and other generations everywhere, some obvious, some not. For more than a century this was a sugar plantation worked by thousands of slaves who lived in clusters of shacks all over the property. All that remains of those people now, the metal hinges from their doors and nails from their walls, lies hidden in the undergrowth on the hillsides or in the soil just below the manicured sod of the golf course that loops around my house. I doubt that the vacationers playing those beautiful links have any idea, any concept, of the kind of life that once teemed where they walk—though perhaps some do, you never know. I've been out with a metal detector and found all kinds of things. A lot has happened here.

There are ghosts, I think. Many of the mysteries reported by guests and visitors to our house, and many that we ourselves experienced, can be explained by direct physical evidence—a tree limb brushing against the roof of the room in which Waylon and Jessi kept hearing such strange noises, for instance. But there have been incidents that defy conventional wisdom. Mysterious figures have been seen—a woman, a young boy—at various times by various people over the years. Once, a woman appeared in the dining room when six of us were present. We all saw her. She came through the door leading to the kitchen, a person in her early thirties, I'd say, wearing a full-length white dress, and proceeded across the room toward the double doors in the opposite wall, which were closed and locked. She went through them without opening them, and then, from the other side, she knocked: *rat-tat-tat, rat-tat.*

We've never had any trouble with these souls. They mean us no harm, I believe, and we're certainly not scared of them; they just don't produce that kind of emotion.

For example, when Patrick Carr was staying here, working with me on this book, he was awakened in the middle of the night by a knock on the door next to his bed—*rat-tat-tat, rat-tat*—and was struck by the thought, *Oh, that's just the ghost. Don't worry about it. Go back to sleep.* He didn't even mention the incident until the following evening, after we'd told him—for the first time—about the lady we'd seen in the dining room and that same knock we'd heard. At that point his wife revealed that she'd had the identical experience: same knock, same reaction. They'd both interpreted the event as such a natural occurrence that they hadn't even told each other about it.

So we're not frightened. The only really frightening story about Cinnamon Hill belongs in the realm of the living and serves to remind me that some of them—just a few of them, a tiny minority—are much more dangerous than all the dead put together.

The dark comes down. Here I sit in the Jamaican twilight with sad memories, somber thoughts.

Every night about this time, as dusk settles in, we go around the house and close and lock all the doors. Carl does it, or I do it myself. The doors are massive: thick, solid mahogany from the local hills of two and a half centuries ago, mounted into the limestone walls in 1747. They've survived a lot: hurricanes (by the dozen); slave rebellions (including the general uprising in 1831 that destroyed most of the other great houses on the island); even the occasional earthquake. They're secure. The presence of the guards, always at least two of them during the hours of darkness, makes them more so. The guards aren't family, but I trust the private security company they work for. One call to their headquarters from the walkie-talkie I keep at my bedside, and we could have an army up here.

After our house was robbed we did have an army up here, literally. The prime minister was very upset—and of course concerned that we might flee Jamaica for good and create tourist-discouraging publicity— so he ordered fully armed units of the Jamaican Defense Force into the

woods around our house until it was time for us to go back to the United States.

I've never talked at length about the robbery in public, or even among my friends. June has told the story in her book *From the Heart,* and she's been the one to tell it on other occasions. The way she and I are together, she does most of the talking when we're in company; I listen. It's interesting, isn't it, how two people's recollection of the same event can differ in so many ways? I don't know how many times I've heard June and the others talk about the robbery—well, it wasn't just a robbery, it was a violent home invasion—and I've found myself thinking, *I didn't know that, I didn't feel that, I don't remember it that way.*

I'm not saying that June's wrong and I'm right, just that people's experiences and memories are so subjective. It makes you wonder about the whole idea of "historical fact." I mean, I just finished reading *Undaunted Courage,* Stephen Ambrose's wonderful account of the Lewis and Clark expedition, and I really enjoyed it. But I was aware of how the other works I've read on that subject, some of them very authoritative and most of them based on Clark's journals, differed not just in detail and interpretation, but in matters of basic chronology and geography: what happened where, when, in what order, to whom. And once you get into the writings of other Lewis and Clark expedition members, events start slipping and sliding even more energetically— but everybody, every journal writer out there on the plains in 1820 or back in Washington or talking out his memories in his parlor, is quite certain of his facts. Which of course is only human. Sitting down with pen and paper (or tape recorder and Microsoft Word), the words "I don't remember" and "I'm not sure one way or the other" don't seem adequate, even if they do reflect reality more accurately than whatever you're about to write. This isn't an original thought, but I do like to keep it in mind.

The robbery as I remember it began at exactly six o'clock on the evening of Christmas Day, 1982. The people at home with me were my wife, June Carter; our son, John Carter; his friend Doug Caldwell;

Reba Hancock, my sister; Chuck Hussey, then her husband; Miss Edith Montague, our cook and housekeeper at the time; her stepdaughter Karen; Desna, then our maid, now our cook and household manager; Vickie Johnson from Tennessee, working specially for Christmas; and Ray Fremmer, an archaeologist friend of ours. There were no guards; we didn't have guards back then, or locked doors. We were in the dining room, a long, narrow space that runs the entire width of the house and is almost filled by a table at which twenty people can dine in comfort.

We were just sitting down to dinner, about to say the blessing, when they came bursting in: a synchronized entry through all three doors. One had a knife, one a hatchet, and one a pistol. They all wore nylon stockings over their faces.

Their first words were yelled: "Somebody's going to die here tonight!" Miss Edith fainted dead away.

They got us down on our stomachs on the floor. I looked across at June, saw her trying to hide her watch and ring, and prayed they wouldn't notice. They didn't. I hoped with all my heart that Ray wasn't carrying his gun that night, because if he was, he was sure to try something.

The one with the pistol said, "We want a million dollars, or somebody's going to die."

I was very calm. I'd realized right away that if we were going to survive, a steady and reasonable attitude was what would do it.

I raised my head and looked at the gunman. "You know your government wouldn't allow us to bring a million dollars into the country, even if we had it, which we don't," I told him, "but if you don't hurt us, you can have everything we've got."

"You've got money!" he insisted.

"Yes we do," I said, "but we don't have a million dollars." In fact, we had several thousand dollars in my briefcase under our bed, and of course June had her jewelry. These guys were going to make out okay if everybody kept it together.

So far, our group wasn't doing very well in that regard. Desna was panicking noisily and poor Miss Edith, once revived, began screaming, "I'm going to have a heart attack! I'm going to have a heart attack!"

Maybe she was, too. Our captors might have thought so, because they let her sit up and one of them told Desna to run to the kitchen for a glass of water. That was a telling moment, the first sign that perhaps these men weren't professionals, or at least they weren't killers. Real hard cases wouldn't have cared about Miss Edith's health or put up with her hysterics; they'd have used her as an example to the rest of us and just shot her, or split her head with that hatchet.

I'd noticed too that they were very young. The one with the gun might have been in his twenties, but the other two were just teenagers, and all of them were very nervous. That comforted me. Maybe it shouldn't have, but it did. I thought again, *If we're cool, we might get through this.*

June started losing it, or at least acting as if she were, when they started taking off our jewelry and watches. She sat up and said she was having chest pains, she had a heart condition. I *think* that's when the gunman pulled young Doug Caldwell to his feet, stuck the gun right up against his head, and said, "Everybody do as I say, or John Carter is going to die!"

Two quandaries there. First, should I tell him that he didn't have John Carter? I had *no* idea how to handle that. Second, was the gun real? This was my first good look at it, and I couldn't tell. I know guns—I grew up with them, and in my time I've owned hundreds—but this piece wasn't familiar to me. It was small and it looked pretty crude, but I knew enough to realize how little that meant: it could be a cheap but lethal junk gun just as easily as a convincing toy.

That question was unresolved, then—I just had to assume the gun was real, and the guy would use it if we spooked him too bad. Then the first issue settled itself. When we were ordered onto our feet to begin the second phase of our encounter, the gunman looked at John Carter

and realized his mistake. He shoved Doug away, then grabbed my son and stuck the gun to *his* head.

It was under those conditions that we began the real work, going from room to room through the house and transferring all our portable valuables to these scared, adrenaline-charged little thugs—and junkies, I was thinking. I knew even more about addiction than I did about guns. These boys had the feel.

We spent the next two hours going around the house, with one of them keeping the gun to John Carter's head while the others went through our things.

They were careful and even tidy, I noticed, not tossing the place as professionals would. They'd been pretty rough at first, particularly with the women, pushing Reba around until she was absolutely terrified and Chuck was dangerously angry; the one with the hatchet handled June so roughly that he took a clump of her hair off. By the time we reached the master bedroom, though, they were relaxing. They were almost chatty, in fact, asking us how long we were planning to stay this Christmas and so on. All along I'd talked to them quietly and told them the truth about where the valuables were, and that was paying off; now they were calling me "sir." At one point I'd asked the man, "Please take the gun away from my son's head," and though he didn't do that, the message in his response was clear: "Don't worry about it, man."

It got really strange in the bedroom. The gunman, who was standing up on the bed with his muzzle an inch from John Carter's brains, started asking him friendly little questions: "What do you do down here? What do you like to do in Jamaica? Do you snorkel?"

John Carter answered calmly and pleasantly, and when the truly weirdest thing happened, he handled himself beautifully. He was just eleven years old.

"This is a real gun I've got against your head, you know," the wild boy ventured.

"Yes, I know," said John Carter. "I go hunting with my dad sometimes. I know guns."

"Do you want a feel of my gun?"

I found out what it means when people say "my heart went into my mouth." I couldn't breathe.

John Carter didn't even miss a beat. "No, sir. I don't play with guns. I have a lot of respect for them. They're very dangerous."

The gunman nodded and grinned behind his stocking mask. "Hey, I like you, man!"

"Thank you, sir," said John Carter.

The tension wound down quite a lot after that. I think we could all see things ending without bloodshed, and the robbers could see getting away with a pretty good haul. Reba was the only one still outwardly distraught; the rest of us were busy trying to keep her fear contained.

When they'd got their loot bagged, one of the robbers told us, "We're going to lock you in the cellar." At that, the women started screaming again, but I thought it was a pretty good deal. It meant they weren't going to spring some nasty last-minute surprise, like killing us to get rid of the witnesses. I don't know how well *they* thought their stocking masks disguised them, but over the course of more than two hours under varying light conditions, I'd concluded that the masks weren't up to the job at all; I could probably have picked each one of them out of a lineup.

Ignoring the protests of the women, they marched us downstairs and, true to their word, locked us in the basement—or as June would have it, "the dungeon." They wedged a two-by-four across the door, and then they left.

Only for a minute, though. One of them came right back and slipped a plate of turkey under the door. "We want you people to have your Christmas dinner after all," he said. "We don't want to take *that* away from you."

John Carter and Doug were already eating by the time we heard our dogs, who had been silent up to that point, barking as the robbers took their leave.

It took us a while, but Chuck Hussey and I got that door broken down, and our sorry little group emerged from the basement to call the police.

Jamaican cops are action-oriented. They caught the gunman that night, with his loot, and he died resisting arrest. They caught the others, the kids, a few weeks later during another robbery in Kingston, and after a short while in prison they, too, died, trying to escape. My understanding is that the guards supplied them with a ladder for use in a work project, then happened to be waiting outside the wall when they came over.

I wasn't very surprised when I heard about it. The police had been very close-mouthed about the whole affair—they didn't even tell us about catching the first guy—but I remembered that on the morning after the robbery, a policeman had made it very clear that the robbers *would* be caught and they *would* be taken care of.

"Don't worry, Mr. Cash," he said. "These people will never trouble you or your family again. You can count on it." Looking back, I realize he was saying more than I understood him to mean at the time. Or perhaps I understood him just fine, but preferred to imagine otherwise.

So what do I think about all that? What's my stance on unofficially sanctioned summary justice in the Third World?

I don't know. What's yours?

How do I feel about it? What's my emotional response to the fact (or at least the distinct possibility) that the desperate junkie boys who threatened and traumatized my family and might easily have killed us all (perhaps never intending any such thing) were executed for their act—or murdered, or shot down like dogs, have it how you will?

I'm out of answers. My only certainties are that I grieve for desperate young men and the societies that produce and suffer so many of them, and I felt that I knew those boys. We had a kinship, they and I: I knew how they thought, I knew how they needed. They were like me.

* * *

I also knew, immediately, how I was going to respond to the threat they'd brought into my house. I wouldn't run from it.

A reporter raised the issue right after the robbery: "Are you going to leave Jamaica now?"

"No, we're not," I told him. "This is our *home*. This is *our* place. We have as much right to be here as anyone. We're going to keep coming. We're not going to let anybody run us off."

I meant every word, but that wasn't the whole picture. Doubt, guilt, and fear were just as strong in me as defiance. For one thing, I felt I'd been naive and foolish, keeping my loved ones in a wide-open house when the evidence of danger was all around us—in the local newspapers with their accounts of murder, mayhem, and fighting in the streets of Kingston; in the eyes of the police and the Rasta men and all the other factions in Jamaica's political struggles and ganja wars; and even in our backyard, virtually, at the scenic waterfall where James Bond capered in *Live and Let Die* and every day a loose federation of souvenir sellers, ganja dealers, and potential home invaders gathered to do business. I'd been coming to Cinnamon Hill long enough to feel like those characters were almost part of the family; I'd first seen some of them when they were six or seven year olds. Maybe the criminals who came to my house, and died for it, were boys I'd watched grow.

If they were, it would explain a lot of things: why the dogs didn't bark at them, how they'd known just when and where to catch us all together, how they were familiar with both the house and its occupants. The other two likely theories, that they were either total outsiders or intimate insiders, didn't wash. The local bad boys would have run outsiders off when they saw them scoping us out, and our insiders, Miss Edith and her family, were totally beyond suspicion.

It was a long time before I arrived at some sort of peace about the robbery. For quite a while I brooded, I felt victimized *and* guilty, I took sleeping pills, I carried a gun. In time, though, those reactions faded, leaving only my most sensible response: professional twenty-four-hour

armed security. I could live with that. Living with the loss of trust and innocence was harder, but I could do that, too. I'd always known how it goes when your safe place turns dangerous.

The other victims of the crime reacted variously, ranging from Reba's flat refusal to ever set foot in Jamaica again (she hasn't) to John Carter's apparent cool. "Yeah, that was quite a night" is about all he's ever said on the subject. June, I think, has found relief in the telling of the story.

Today I can look back and see that some good came from it all. When I take my walks and golf-cart rides down to the sea, I'm often stopped by local people who greet me warmly—"Respects, Mr. Cash, respects"—and I can't count how many times I've heard gratitude for my decision to stay in Jamaica. And since the robbery I've been more involved in Jamaican life in various ways that have been very good for me. Today I feel truly at home in this beautiful country, and I love and admire its proud and kindly people.

Here I sit in the gloaming, as my Scots ancestors would say, watching the gentle afterglow of sunset behind the hills above my house and listening as the sounds of the night creatures chase away the early evening's silence—nature's shift change, in progress here just as it is in New York and Washington, D.C., and will be in Memphis and Little Rock in another hour or so. I'm remembering my childhood again. I'm back on the front porch of that government house in Dyess Colony, with my Mom and Dad and brothers and sisters, all of us together, while my mother sings her sacred songs and plays her guitar, banishing fear and loneliness, bringing the black dog to heel, drowning out even the screams of panthers from the brush.

Those are sounds I'll never hear again, neither the panthers nor my mother's comforting voice. I still have the songs, though.

PART 2

The Road

1

I have a home that takes me anywhere I need to go, that cradles and comforts me, that lets me nod off in the mountains and wake up on the plains: my bus, of course.

I love my bus. I've had it a long time, and it rides better now than when it was new, probably because of all the weight we've added to it over the years. It's been very reliable: other than one new engine, it hasn't needed any major repairs in seventeen years, and it's taken us all over the United States and Canada without once stranding us on the highway. We call it Unit One.

It really is my home, too. When I make it off another plane and through another airport, the sight of that big black MCI waiting by the curb sends waves of relief through me. Aah!—safety, familiarity, solitude. Peace at last. My cocoon.

I have my own special space on Unit One, about midway between the front and rear axles, a comfortable place to ride. I sit at a table with bench seats on both sides, like a diner booth, with my newspaper or book—June and I both consume reading matter at a very high rate, everything from the Bible to pulp fiction—and when I need to sleep, the booth converts into a bed. All the amenities are at hand: bathroom, kitchen, refrigerator, coffee pot, sound system, video setup, and seating for company. Curtains on the windows let me keep out the world or watch it pass; a Navajo dream catcher and a St. Bridget's cross guard me in the world I can't see.

The rhythms of life on the road are so predictable, so familiar. I've been out here forty years now, and if you want to know what's really changed in all that time, I'll tell you. Back in 1957, there was no Extra Crispy. Other than that, it's the same.

That might give you an idea of what's really important in road life, and why things never really change. They get a little faster and bigger, and a fair bit more comfortable (if you keep selling concert tickets), but they always come down to the same old questions: "Where are we?" and "Who ate all the apples?" and "What's the show tonight?" and "How far to the next frozen yogurt?"

It's fun to imagine young musicians discovering all this, just beginning to learn the ways of a world that'll be theirs, if they're lucky, well into the twenty-first century. Myself, I've lived out here so long and know it all so well that I can wake up anywhere in the United States, glance out the bus window, and pinpoint my position to within five miles. Somebody told me that that's a talent, akin to the way I can remember a song I heard just once or twice long ago—back three or four decades, even five or six—but I don't believe talent has anything to do with it. I think it's just lots and lots of experience. Like the song says, I've been everywhere, man. Twice.

Today I'm in Oregon, rolling southwest out of Portland through close dark greens and soft misty grays in my cocoon of comforting bus noise, heading toward the open hills and wide, gentle valleys of north-

ern California. I know exactly where I am, of course. In this country it's the trees that tell you.

My mind wanders off, gets caught on a problem the band and I are having with our stage performance of "Rusty Cage," the Soundgarden song I recorded for the *Unchained* album, then resumes reflection on the story of my life. I begin thinking about Pete Barnhill, a friend I made when I was about thirteen. Pete lived two or three miles from our house, down on the drainage ditch near the spot where I went fishing the day my brother Jack got hurt, and he had a guitar, an old Gibson flattop. He also had what we called infantile paralysis, later known as polio, which had crippled his right leg and withered his right arm to about half the length of his left. He'd adapted well. I wrote about him in the liner notes for *American Recordings*:

> With his left hand he made the chords as he beat a perfect rhythm with his tiny right hand. I thought if I could play the guitar like that I'd sing on the radio someday.
>
> I was at Pete's house every afternoon after school and stayed until long after dark, singing along with him, or singing to his playing Hank Snow, Ernest Tubb, and Jimmie Rodgers songs. Pete taught me my first chords on the guitar, but my hands being too small, I didn't really learn to play them.
>
> The long walk home at night was scary. It was pitch dark on the gravel road, or if the moon was shining, the shadows were even scarier. The panthers sounded closer, and I just knew that in every dark spot on the road was a cottonmouth snake ready to kill me.
>
> But I sang all the way home, songs Pete and I had been singing, and with the imaginary sound of the Gibson acoustic I sang through the dark, and I decided that that kind of music was going to be my magic to take me through all the dark places.

Pete was an inspiration in more ways than one. I'd never been close to somebody playing the guitar except my mother when I was very

small, and I thought he was the best guitar player in the world. To me he was wonderful, the sound he made purely heavenly.

One day I said to him, "You know, Pete, you've got infantile paralysis, but you sure can play that guitar."

His reply made a deep impression on me: "Sometimes, when you lose a gift, you get another one."

From then on I didn't think of him as a cripple; I thought of him as having a gift. It hurt me when the other kids made fun of him. They'd see him hobbling the two or three miles from his house into town, and they'd start imitating him. I imitated him, too, of course, but not that way: he's where I got my guitar style, playing rhythm and leading with my thumb.

Pete was crazy for music the way I was—he was the first person I knew who was that way—and we were both crazy for the radio. It meant the world to us, literally. It goes without saying that we had no television, but neither did we have a record player or any other means of hearing music we didn't already know. The radio was vital, indispensable.

I clearly remember the day we got ours, a mail-order Sears Roebuck with a big "B" battery, bought with money from Daddy's government loan the year he and Roy began clearing our land. I remember the first song I heard on it, "Hobo Bill's Last Ride" by Jimmie Rodgers, and how the image of a man dying alone in a freezing boxcar felt so real, so close to home. I remember tuning in WLW from New Orleans, WCKY from Cincinnati, XEG from Fort Worth, XERL from Del Rio, Texas. I remember the Suppertime Frolics show at six o'clock in the evening from WJJD in Chicago, the Grand Ole Opry from WSM in Nashville on Saturday nights, the Renfro Valley Barn Dance and the Wheeling Jamboree from WWVA in Wheeling, West Virginia. I remember listening to Roy Acuff, Ernest Tubb, Eddy Arnold, Hank Williams. I remember tuning in all kinds of pop music—Bing Crosby, the Andrews Sisters—and gospel and blues, everyone from the Chuck Wagon Gang to Pink Anderson and Sister Rosetta

Tharpe. I remember being allowed an extra fifteen minutes on my midday break from the fields to listen to the Louvin Brothers' High Noon Roundup show from WMPS in Memphis. I remember how Daddy would go to bed every night at 8:05, right after the evening news broadcast, then yell at me and Jack: "Okay, boys, time to go to bed! You won't want to go to work in the morning. Blow that light out! Turn that radio off!" Jack would turn his oil lamp down and hunch over his Bible. I'd lower the volume on the radio and put my ear right up against it. The music I heard became the best thing in my life.

Daddy didn't like that. "You're wasting your time, listening to them old records on the radio," he'd say. "That ain't real, you know. Those people ain't really there. That's just a guy sitting there playing records. Why d'you listen to that fake stuff?"

I'd say, "But it's just as real as when they sang it and put it on the record. It's the same thing."

"But it ain't real, it's just a record."

"I don't care. It sounds good. I like it."

"Well, you're getting sucked in by all them people," he'd conclude. "That's going to keep you from making a living. You'll never do any good as long as you've got that music on the mind."

I hated hearing that, but maybe it served a purpose. I badly wanted to prove him wrong. I wanted to prove Moma right, too. She saw that the music was in me just as it was in her and had been in her father, John L. Rivers, who taught the shape-note system and four-part harmony singing and was the song leader in his church. They say he was a great singer, good enough to be a professional; people came from all over the county to hear him.

I remember him as a kind man. He and my Grandmother Rivers were both sweet souls, the salt of the earth, well loved and respected in their community. Long after Grandfather Rivers died, I went back to Chesterfield County, South Carolina, where he was born and raised. Though I really didn't expect to find any trace of him, when I walked into the office of the Rivers Cotton Gin and asked, "Is anyone here any

relation to John L. Rivers, who migrated to Arkansas when he was a young man?" everyone there answered, "We all are." Then they sent me down the road to the local genealogist, Edgar Rivers, and Edgar sat me down on his back porch and told me a story.

Several years after he'd been settled in Arkansas, Grandfather Rivers got a letter from back home telling him that the farms in Chesterfield County had been stricken by a blight and the farmers had no seed corn for next year's crop. If he had any extra, could he get it to them somehow?

He could. He scraped together all the seed corn he could spare, hitched up his wagon, made the trip from southwest Arkansas to South Carolina—a brutally long, hard journey in those days—and delivered the seed in time for spring planting. The farmers of Chesterfield County had a successful crop that year.

Edgar went into his kitchen when he'd finished the story and came back out onto the porch with a fresh ear of corn in his hand. He'd just picked it that morning, he said, the first corn of the year from his garden. He shucked it and showed it to me. It looked good: a big, long, healthy ear, bright yellow.

"That's John L. Rivers Yellow," he said, "the same corn your granddaddy brought from Arkansas. We still eat it today."

That was a good moment.

Moma inherited Grandfather Rivers's talent and his love for music. She could play guitar, and fiddle too, and she sang well. The first singing I remember was hers, and the first song I remember myself singing was one of the songs of faith she'd learned as a child. I was about four years old, sitting on a chair right beside her on the front porch. She'd sing "What would you give"—and I'd chime right in with my part, continuing the line—"in exchange for your soul?"

We sang in the house, on the porch, everywhere. We sang in the fields. Daddy would be by himself, plowing, and we kids would be with Moma, chopping cotton and singing. I'd start it off with pop songs I'd heard on the radio, and my sister Louise and I would chal-

lenge each other: "Bet you don't know this one!" Usually I knew them and I'd join in well before she'd finished. Later in the day we'd all sing together, hillbilly songs and novelty songs, whatever was going around at the time—"I'm My Own Grandpa," "Don't Telephone, Tell a Woman"—and then, as the sun got about halfway down toward the west and our spirits started flagging, we'd switch to gospel: first the rousing, up-tempo songs to keep us going, then, as the sun began to set, the slower spirituals. After Jack died, we'd sing all the songs we sang at his funeral. We closed each day in the fields with "Life's Evening Sun Is Sinking Low."

Moma had faith in me. She wanted me to have singing lessons, so she took in schoolteachers' laundry to pay for them. A whole day's work earned her three dollars, the cost of one lesson. I didn't want any part of it, but she insisted, and I was glad she did. When I showed up for the first lesson I found a good reason to go back for a second: the teacher was young, kind, and very pretty.

She wasn't meant for me, though. Halfway through my third lesson, after she'd accompanied me while I sang "Drink to Me Only with Thine Eyes," "I'll Take You Home Again, Kathleen," and all those other popular Irish ballads, she closed the lid on her piano.

"Okay, that's enough," she said. "Now I want you to sing to me, without accompaniment, what you like to sing." I sang her a Hank Williams song—I think it was "Long Gone Lonesome Blues."

When I was through, she said, "Don't ever take voice lessons again. Don't let me or anyone else change the way you sing." Then she sent me home.

I regretted not being able to see that pretty lady anymore, but I followed her advice, and now I regret that, too, in a way. It would have been good to have known more about the voice, how to protect and strengthen it over the years instead of abusing and damaging it as much as I did.

That puts me in mind of the day my voice broke and my mother heard my new bass tones for the first time. I was singing as I walked in

the back door, and she wheeled around from the stove in shock and said, "Who was that?"

I sang some more for her, exploring my new range, and as I found out how deep I could go, her eyes teared up and she said, "You sound exactly like my daddy." Then she said, "God has His hand on you, son. Don't ever forget the gift."

I don't think Moma really wondered who was singing; she knew it was me. And that was the first time I remember her calling my voice "the gift." Thereafter she always used that term when she talked about my music, and I think she did so on purpose, to remind me that the music in me was something special given by God. My job was to care for it and use it well; I was its bearer, not its owner.

2

I'm in San Francisco—we rolled in late last night from Portland across the Bay Bridge—and so far I've had a busy day. This morning a team from the BBC interviewed and photographed me in my suite, and that was draining. I don't enjoy answering questions about myself for more than a couple of minutes, let alone an hour. Then I ate with some people involved in a project with me—a working lunch, I guess you'd call it, or a "lunch meeting"—and that too was long and draining. I kept looking out the window, wondering how the air smelled, how the breeze felt, how good it would be if I could just walk down the street. Wage slaves get boxed up in offices and factories and workshops, away from their loved ones. Fame slaves like me get boxed up in hotels and studios and limousines, away from strangers.

Now it's time for my nap. I'm working tonight, and if I'm not rested, it will be a mess. I'll feel bad, I won't sing well, and the people won't get their money's worth. Billy Graham taught me that: if you have an evening concert, he said, take yourself to bed in the afternoon and rest, even if you don't sleep. It was the most valuable advice I'd had in years, maybe ever.

The show tonight is in Santa Cruz, a college town about two hours through the hills south of San Francisco, and I expect a very different crowd from the one back in Portland. That was about as close to an "average" audience as I get: mostly working people, mostly in their middle years. Tonight there probably won't be anyone over forty who doesn't have a Ph.D., and I won't be totally surprised if things get a little rowdy. Tomorrow I'll be shocked if they don't. We're playing the Fillmore, and it'll be nuts: rock 'n' roll, raunch and rave. We need to have "Rusty Cage" together by then; it'll be a "Rusty Cage" kind of crowd. It'll be exciting.

I'm thinking about my BBC experience. The interviewer was good, obviously an old hand, but even so, it was difficult to distinguish his questions from anyone else's in the chain of interviews I've done recently. They've all wanted me to talk about the same current work-related stuff, as they usually do—which makes sense, since they all get their information from the same press kit—and sooner or later, most of them have worked their way around to the same few questions people have been asking me for forty years.

There are three of them.

Question One: Why was I in prison?

I never was. That idea got started because I wrote and sang "Folsom Prison Blues," my 1955 hit, from the perspective of a convicted, unrepentant killer, and twelve years later I made a concert album, *Johnny Cash at Folsom Prison*. In fact, I've never served any time at all in any correctional institution anywhere. During my amphetamine years I spent a few nights in jail, but strictly on an overnight basis: seven incidents in all, different dates in different places where the local law decided we'd all be better off

if I were under lock and key. Those weren't very educational experiences, but I do remember learning in Starkville, Mississippi, that trying to kick the bars out of a jail cell isn't a good idea. I broke my toe that night.

There are those who just don't want to accept the nonfelonious version of me, and on occasion I've had to argue with people firmly convinced that whatever I might say, I once lived a life of violent crime. To them all I can offer is an apology: I'm sorry about this, but that line in "Folsom Prison Blues," the one that still gets the biggest rise out of my audiences, especially the alternative crowds—"I shot a man in Reno just to watch him die"—is imaginative, not autobiographical. I sat with my pen in my hand, trying to think up the worst reason a person could have for killing another person, and that's what came to mind. It did come to mind quite easily, though.

Question Two is tough: How do I write songs?

There is no formula, no set method; it happens all sorts of ways, and so the answer differs from song to song. For instance, I wrote "I Walk the Line" when I was on the road in Texas in 1956, having a hard time resisting the temptation to be unfaithful to my wife back in Memphis. I put those feelings into the beginnings of a song and sang the first two verses for Carl Perkins backstage before a show.

I keep a close watch on this heart of mine.
I keep my eyes wide open all the time.
I keep the ends out for the tie that binds.
Because you're mine,
I walk the line.

I find it very very easy to be true.
I find myself alone when each day's through.
Yes I'll admit that I'm a fool for you.
Because you're mine,
I walk the line.

BY JOHN R. CASH, © 1956 HOUSE OF CASH, INC.

"What do you think?" I asked. "I'm calling it 'Because You're Mine.'"

"Hmm," Carl said. "Y'know, 'I Walk the Line' would be a better title." Then he went on stage, and I finished the song while he did his set. It came fast and easy, almost without conscious thought.

The source of the feelings in the song is obvious. The source of the tempo and melody is more obscure: a reel-to-reel tape recorder in a United States Air Force barracks in Landsberg, Germany, in 1951.

A tape recorder was a real novelty in those days, high technology of the first order. I had the only one on the whole base, bought at the PX with savings from the eighty-five dollars a month Uncle Sam paid me to fight the cold war. It was a pretty fascinating piece of equipment, and central to the creative life of the Landsberg Barbarians: me, two other airmen with guitars, and a West Virginian with a mandolin he'd had sent over from home. We'd sit around together in the barracks and murder the country songs of the day and the gospel songs of our youth—we were all country boys, so we all knew them—and that tape recorder would let us hear the results. Amazing. I still have some of the tapes, transferred to cassette now. We were crude, but we had fun.

It was one of the Barbarian tapes that gave me the melody for "I Walk the Line." I was on the eleven-to-seven shift in the radio intercept room one night, listening in on the Russians, and when I got back to the barracks in the morning I discovered that someone had been messing with my tape machine. I put on a Barbarians tape to test it, and out came the strangest sound, a haunting drone full of weird chord changes. To me it seemed like some sort of spooky church music, and at the end there was what sounded like somebody saying "Father." I played it a million times, trying to figure it out, and even asked some Catholics in my unit if they recognized it from one of their services (they didn't), but finally I solved the puzzle: the tape had gotten turned around somehow, and I was hearing Barbarian guitar chords played backward. The drone and those weird chord changes stayed with me and surfaced in the melody of "I Walk the Line."

* * *

The air force taught me the things every military service imparts to its enlisted men—how to cuss, how to look for women, how to drink and fight—plus one skill that's pretty unusual: if you ever need to know what one Russian is signaling to another in Morse code, I'm your man.

I had such a talent for that particular line of work and such a good left ear, that in Landsberg, where the United States Air Force Security Service ran radio intercept operations worldwide, I was the ace. I was who they called when the hardest jobs came up. I copied the first news of Stalin's death. I located the signal when the first Soviet jet bomber made its first flight from Moscow to Smolensk; we all knew what to listen for, but I was the one who heard it. I couldn't believe that Russian operator. He was sending at thirty-five words a minute by hand, a rate so fast I thought it was a machine transmitting until I heard him screw up.

He was truly exceptional, but most of his comrades were fast enough to make the best Americans sound like amateurs, sloppy and slow. It didn't matter, though. Our equipment was so good that they couldn't make a noise anywhere in the world without us hearing it. Our receiver worked pretty well bringing in WSM, too. Some Sunday mornings I could sit there in Germany and listen to Saturday night at the Grand Ole Opry live from Nashville, Tennessee, just like at home.

I heard the enemy every day in the air force, but I never saw combat or even came close to it. I enlisted a week before the Korean War broke out, so I was already in the system, and once they'd discovered my aptitude, trained me, and assigned me to the Security Service, Korea wasn't an option. My only choice was between Germany and Adak Island, in the Aleutian archipelago off Alaska. That wasn't hard: frozen everything or food and Fräuleins? I chose Landsberg.

I'd ended up in the military the same way most other Southern country boys did, for lack of a better way out of the cotton fields. I tried the other common option, going north to find a factory job—in my case, hitchhiking to Pontiac, Michigan, and getting on the line at the Fisher Body Company running a press that punched holes in pads

for the hoods of '51 Pontiacs—but that hadn't worked out. The job itself was horrible, the accommodations no better: a boarding house crammed tight with men who drank and cussed and carried on more than my tender young country sensibilities could stand. Three weeks was all it took to send me hitching back home with more money in my pocket than I'd seen before in my whole life.

There was nothing at home. Our land was exhausted, producing barely half a bale of cotton to the acre. The only job I could get, in a margarine plant where Daddy had gone to work as a laborer, was far worse than punching holes in Pontiacs. At first they had me pouring concrete, but I was too puny for that, just a long tall bag of bones, so they set me to cleaning out tanks, working for low money in filth beyond belief and heat I'd never imagined possible. After that, a government paycheck and a clean blue uniform looked pretty good. I enlisted for a four-year hitch.

Recently, watching my hair turn grayer, my step get slower, and my energy level sink a little more each year, I've wondered about having given so much of the prime of my life to the United States Air Force and the cold war. At the time, though, it was the thing to do. We boys wanted to serve our country.

As I said, military service instructed me in the things it teaches everyone. Violence, for example.

I saw my first race riot in the air force. I was in a nine-story building in Bremerhaven, our temporary home after our voyage across the Atlantic from the States, when I heard a roar of angry voices. I looked down, and there they were, whites and blacks, comrades in arms—American military units had just been integrated—tearing at each other with everything they had. Men were being cut and beaten mercilessly; it's a miracle nobody died. Plenty of them ended up in the hospital and the stockade.

I'd known the fight was coming, because there'd been a lot of tension aboard ship and hard talk since we landed in Bremerhaven—men

jacking themselves and each other up for action the way they do—but I didn't want any part of it, and I didn't really understand why so many men did. I had no problem sharing a barracks with blacks, and I couldn't imagine hating them so much that I was willing to wage a private war on them. It's quite a thing, the innocence of youth; my views haven't changed since then, but I've certainly learned more about race hatred along the way.

One point about that fight. There in Bremerhaven you had a lot of men, black and white, who'd been very strongly encouraged to kill people (North Koreans, Chinese, Russians), then jam-packed together and told to behave like gentlemen for a long, hard, boring voyage followed by enforced idleness ashore. They were a boiler waiting to explode.

My own personal nonviolence didn't last long in Landsberg. Once I knew how to drink beer and look for a girl, it was no big thing learning how to drink the hard stuff and look for a fight. Finding one wasn't difficult, either. The United States Army didn't have any bases nearby, so we were denied the chance to do combat with our natural enemies, but the Germans obliged us willingly enough; someone would always rise to the occasion. It was just part of the evening's fun for angry young men and red-blooded guardians of democracy.

The air force broadened other horizons for me. I went to London and I saw the queen (her coronation, in fact, in 1953). I went to Oberammergau, home of the famous Passion Play, and fished (Bavaria has the world's best trout fishing). I went to Paris and watched the girls at the Folies-Bergère. I went to Barcelona and watched the girls everywhere. I heard flamenco guitars played in caves. I bought my own first guitar for twenty deutsche marks, about five bucks American at the time, and carried it back to the base with me through the freezing German winter. I'll never forget that walk, four miles though knee-deep snow; I was numb all over.

Up to that point I'd had to be content with just singing, and of course I sang all the time, both alone and with the other guys. In a way

it was just like it had been back in Arkansas, except that the context and the content were often a little different. At first, in basic training at Lackland Air Force Base in San Antonio, I really missed singing with everyone in church, but marching music was fun, too. I still remember the first song we sang that way, a group effort written collaboratively by my whole flight of fifty-seven men and sung on the march:

Oh, there's a brownnose in this flight
And his name is Chester White.
He's got a brown spot on his nose
And it grows and grows and grows.

My guitar survived until 1957, by the way, when my brother Tommy and one of my nephews, horsing around at my house in Memphis, smashed it to pieces by accident and neglected to mention the event until one day when I happened to notice it was missing. I didn't care; by then I had a Martin.

The air force appreciated my nonmusical talents and tried to hold on to me, promoting me just before my hitch was up—"We've made you a Staff Sergeant a little early, Sergeant Cash, and we would like for you to seriously consider reenlisting and making a career of this"—but it was far too little way too late. They'd kept me in Germany for three years with no home leave whatsoever and only three telephone calls back to the States, and on top of that they told me that if I stayed in the air force, I'd never leave the Security Service.

"What if I want to be in the air force band?" I asked.

"No way," they said. "You've taken an oath of secrecy. You can't go anywhere. You're still in, even after you're discharged." For one horrible moment I thought they were trying to tie me up for life, but they weren't; they let me go.

It was a good thing they did. The beer and the wurst were wonderful, but I was dying to be back in the South, where the livin' was easy; where the fish were jumpin', where the cotton grew high.

*　*　*

Question Three is simple: Why do I always wear black?

Strictly speaking, I don't. When I'm not in the public eye I wear whatever I want. I still wear black on stage, though, for a couple of reasons.

First there's the song "Man in Black," which I wrote in 1971. I had my network TV show at the time, and so many reporters were asking me Question Two that I saw an opportunity to answer with a message. I wore the black, I sang, "for the poor and beaten down, livin' in the hopeless, hungry side of town." I wore it "for the prisoner who has long paid for his crime, but is there because he's a victim of the times." I wore it for "the sick and lonely old" and "the reckless whose bad trip left them cold." And, with the Vietnam War as painful in my mind as it was in most other Americans', I wore it "in mournin' for the lives that could have been. Each week we lose a hundred fine young men. I wear it for the thousands who have died, believin' that the Lord was on their side."

The last verse summed it up:

> Well, there's things that never will be right, I know,
> And things need changin' everywhere you go,
> But until we start to make a move to make a few things right,
> You'll never see me wear a suit of white.
> Oh, I'd love to wear a rainbow every day,
> And tell the world that everything's okay,
> But I'll try to carry off a little darkness on my back,
> Till things are brighter, I'm the Man in Black.
>
> BY JOHN R. CASH, © 1971 HOUSE OF CASH, INC.

Apart from the Vietnam War being over, I don't see much reason to change my position today. The old are still neglected, the poor are still poor, the young are still dying before their time, and we're not making many moves to make things right. There's still plenty of darkness to carry off.

My other reasons for wearing black date to my very first public performance, in a North Memphis church before I'd made any records or even gotten in the door at Sun Records. I'd already hooked up with Marshall Grant and Luther Perkins, though, so in theory at least we were a band, and we thought we ought to look like one. Unfortunately, none of us had any clothes a "real" band would wear—I didn't own a suit, or even a tie—but each of us did have a black shirt and a pair of blue jeans. So that became our band outfit, and since the folks at the church seemed to like us and musicians are deeply superstitious—if they tell you otherwise, don't believe them—I suggested we stick with the black.

Marshall and Luther did so for a while; I did forever. My mother hated it, though, so after my first couple of hit records, I gave in and started wearing the bright, flashy outfits she made for me—I remember one particularly festive white suit trimmed in glittering blue—but that didn't feel good at all, so I went back to black. And ultimately, everything else aside, that was the real deal: it just felt right. I wore black because I liked it.

I still do, and wearing it still means something to me. It's still my symbol of rebellion—against a stagnant status quo, against our hypocritical houses of God, against people whose minds are closed to others' ideas.

3

Unit One hums through the night, leaning gently into the curves of the hill road from Santa Cruz back to San Francisco. Yes, I'm thinking, I've got a great little crew on this bus.

There are just two of them, Bob and Vicki Wootton, and they take very good care of June and me. They know what they're doing, and we know they know. Bob's been my guitar player since 1968, when he showed up at a date in Oklahoma and began filling the hole Luther Perkins left among us that year. Vicki, his wife, is newer to our little gang, but she drives as well as Bob does, and better sometimes—which he knows and doesn't mind too much. She's cool-headed, very smooth.

You need two drivers if you're serious about travel by private bus. There are all kinds of regulations about how far and how long one person can drive, not to mention the paperwork, and it's really not safe to drive with one hand and fill out forms in triplicate with the other. Back

in the old days, of course, we didn't worry about that kind of thing; we just swallowed as many pills as it took to get where we were going.

I myself don't drive, not a bus anyway. I tried one time, but Fluke absolutely would not allow it. He was so insistent that I believe he might have let it come to blows. He said I wasn't in a fit state to drive anything, let alone a vehicle that could flatten a Buick. He was right.

Fluke is W. S. Holland, my drummer since 1959, and he doesn't travel on Unit One. He and the other members of the band and crew—Earl Poole Ball on keyboards, Dave Rorick on bass, Larry Johnson and Kent Elliot on sound, Brian Farmer, my guitar tech, Jay Dauro, our program coordinator and stage manager, and, usually, my manager, Lou Robin—have their own transport and move independently as needs be. Altogether our show gets on the road in two all-black buses and one all-black tractor-trailer. Pitiful by some standards, magnificent by others; okay by me.

Tonight I had to get the musicians all together in Unit One for a while, because we really messed up "Rusty Cage." Fluke and I started into it on entirely different wavelengths—it felt as if we were trying to fax each other the rhythm—and Bob was caught in the middle, trying to figure out who to follow, so we didn't rock; we lurched. It was embarrassing. It was time for a band meeting. Hopefully we've got it straight now.

The audience was about the way I expected it to be, openly enthusiastic with a hint of wildness around the edges. Now and again as I sang I'd look out and see a sudden flurry, like the flash of a fish in moving water. After the show I was told there'd been a couple of "incidents."

There was one as we pulled out of the parking lot. I'd just settled in at my table when I felt us come to an abrupt halt—not Vicki's usual style; something was up. And then there were voices raised, the front door opened, someone outside was yelling, and Bob and Vicki responded, calmly at first but then with urgency building quickly into anger. I stayed put behind the curtains. I learned long ago that if you're

the one the people came to see, "the principal" as they put it in the security trade, the most foolish thing you can do in a potentially violent situation is involve yourself or even show yourself—so I had no idea what was happening. I was relieved when the door thudded shut and Vicki began easing us forward again. It felt like we'd been stopped a long time.

Once we were rolling, Bob explained. A kid had jumped out in front of the bus, shouting my name over and over and refusing to move no matter what. He (she? Bob couldn't tell) was right up against the windshield, not carried away in delirium, as benevolently overexcited fans can be, but demented in a slow, spaced-out kind of way (Bob could tell he or she was stoned). With no cops in sight and a crowd beginning to gather, Bob figured he had to do something decisive, quickly. He was threatening force and meaning it, showing the heavy-duty flashlight Vicki pressed into his hand, when the kid backed off and drifted away, shouting obscenities.

"How old was this kid?" I asked.

"Hard to say," said Bob. "Some sort of teenager. Late teens, probably. Could have been older, or younger." And he thought it was a girl. She rattled him; he'd been worried.

Vicki chimed in that she still thought it could have been a boy.

"Nope," Bob said. "That was a female. Whatever it was, though, it sure got my heart beating."

Then he looked at me and grinned. "Must have been just like old times for you, huh?"

"Yup," I said, even though in some ways it was and some ways it wasn't.

Picture this. This is why it was so great in my early days, why it was such fun at Sun.

It's late summer 1955. I've just had my first hit, "Cry, Cry, Cry," and I'm in Shreveport at the Louisiana Hayride, a Saturday night radio show much like the Grand Ole Opry but not as prestigious or powerful.

The Hayride's man in charge, Horace Logan, complains sometimes, grousing that he's just a talent scout for his opposite numbers in Nashville, and there's truth to what he says. Some of us who are spending this year's Saturday nights in Shreveport will sooner or later move on to the Opry and its bigger radio audience, just as others have done in the past: Webb Pierce, Faron Young, Hank Williams.

The Hayride is its own world, though, and Horace Logan runs a great show. He looks good tonight. He's in full cowboy costume, complete with the fancy gunbelt and twin nickel-plated Peacemakers Webb Pierce gave him. He sparkles.

There's high energy here. Most of us who play the Hayride love it. I look forward to the crowd, a mixture of local regulars and people drawn in from all over the show's broadcast area, and I look forward to the performers presented for their entertainment. Any Saturday night I might run into Claude King, Rusty and Doug Kershaw, Wanda Jackson, Jimmy C. Newman, Charlene Arthur, or Johnny Horton. Carl Perkins might have come down from Memphis with me. Elvis might be on the show.

It doesn't really matter. I know it'll be fun, and I know I'll feel good. Here, you see, I'm accepted as an equal, as one of them, and that's really something. This business I'm in is different. It's special. The people around me feel like brothers and sisters. We hardly know each other, but we're that close; somehow there's been an immediate bonding between total strangers. We share each other's triumphs, and when one of us gets hurt, we all bleed—it's corny, I know, but it's true. I've never experienced anything like this before. It's great. It turns up the heat in life.

So do the audiences. My record gets played a lot in Shreveport—it's the first place outside Memphis I ever heard myself on the radio, on Tommy Sands's show on KCIJ—and when I hit the stage and start into "Cry, Cry, Cry" or "Hey, Porter," I see the people start clapping and hear them singing along. Man, what a kick. What a thrill. They've been listening to my song on the radio, and they like it! I'm on this stage in

front of them, just me, and they're excited. They think I belong here the way Faron Young or Hank Williams did! What a deal this is.

I love being one of the new guys, getting a hit record, being a somebody in my generation, and having girls all over me, but it's also very satisfying to sing for the older people. They send requests backstage for their favorite country songs—"My Grandfather's Clock," "Sweeter Than the Flowers," or "Silver-Haired Daddy of Mine"—and I accommodate them with pleasure. I love being able to give them the music given to me by the radio in Dyess, and I feel close to older people. There's something extra between us.

So the whole Hayride experience is wonderful. For me it's everything good happening at once: being wanted, being appreciated, doing what I love, basking in a great big family, playing music with my friends. If my life is going to be like this, it sure will be a happy one.

When this Saturday night at the Hayride winds down, we brothers and sisters in music will go our separate ways. Sometimes Shreveport is our staging point for a week on the roads of Louisiana, Texas, Arkansas, and Mississippi. Other times, Luther and Marshall and I will wedge ourselves into my '54 Plymouth with all our gear (including Marshall's bass fiddle) and set out on the long drive home. We'll be rolling into Memphis as the sun comes up on Sunday, and won't that just be fine?

What the writers have always said about Memphis is true: musically speaking, it was the capital city of the whole Mississippi Delta, not just a river town in western Tennessee. There was no question it was where I needed to be. Ever since that Sears Roebuck radio came into our house, Memphis had been the center of the world in my head, the one place where people didn't have to spend their lives sweating bare survival out of a few acres of dirt, where you could sing on the radio. I took myself there as soon as I could after parting company with the air force.

In a way, I had to. Or at least I had to take myself somewhere. Quite apart from getting on the radio, I needed to be someplace I could

find a job to support myself, my new wife, and the family we wanted to have.

The first place I went looking for work was the police department, where my brother Roy had a connection and my work with the Air Force Security Service made me a likely candidate. But after talking a while with the chief of police, I decided that law enforcement wasn't really for me. The chief accepted that and suggested that I go over and see Mr. George Bates at the Home Equipment Company.

I've come to think of George Bates as one of those angels who appear in your life just when you need them, holding out a hand to you in the right place at the right time. He took me on as a salesman, sponsored a weekly fifteen-minute radio show for me ("Hi. This is John Cash for Home Equipment Company"), and loaned me money when I proved to be a total failure as a salesman. He advanced me cash every payday, and after almost a year of that he called me into his office.

"Do you think you're ever going to pay me back?" he asked.

"How much do I owe you?" I asked. He looked it up.

"Twelve hundred dollars," he said.

"Well, Mr. Bates," I told him, "one of these days I'm going to walk in here and give you a check for that full amount."

He was great. "Well, I just hope you will," he said. "I've taken care of you because I've believed in you. I believe you'll do something one day—but I'll tell you, I don't think you're going to be a salesman, ever." Even after that he let me stay on and do my bad impersonation of a young go-getter. I spent a great deal of time in my car, listening to the radio.

It was a good time to be listening. There was a lot of great country music in the early 1950s, and great blues, too. The blues were everywhere, and that was fine by me. I loved going to Home of the Blues, the record store. That's where I bought *Blues in the Mississippi Night*, the great anthology of Delta blues singers recorded by Alan Lomax, which is still one of my favorite albums (I borrowed a good song title there, too). I loved driving into Orange Mound, the black part of town, to sit

on Gus Cannon's porch and listen to him sing and play the guitar. Gus wrote "Walk Right In," which later became a big pop hit for the Rooftop Singers, and I thought he was wonderful even if he didn't buy a refrigerator (nobody did; they couldn't afford one or anything else I had to sell, and I didn't want to fool them into thinking they could). I loved Dewey Phillips's radio show on WHBQ, "Red Hot and Blue," which mixed everything up together—hillbilly, pop, blues, gospel— without regard to what anyone but Dewey had to say about it. Of course, he knew the big secret: that there were a lot of white people listening to "race music" behind closed doors. Of course, some of them (some of us) were quite open about it, most famously Elvis.

Elvis was already making noise in Memphis when I got there in '54. Sam Phillips had released his first single, "That's All Right, Mama," with "Blue Moon of Kentucky" on the "B" side, and it was tearing up the airwaves. The first time I saw Elvis, singing from a flatbed truck at a Katz drugstore opening on Lamar Avenue, two or three hundred people, mostly teenage girls, had come out to see him. With just one single to his credit, he sang those two songs over and over. That's the first time I met him. Vivian and I went up to him after the show, and he invited us to his next date at the Eagle's Nest, a club promoted by Sleepy-Eyed John, the disc jockey who'd taken his name from the Merle Travis song and was just as important as Dewey Phillips in getting Sun music out to the world.

Sleepy-Eyed John didn't like Sam Phillips, though, so while he'd always put Sun singles on the air, usually he'd preface them with some disparaging remark: "Here's another Sam Phillips sixty-cycle-hum record," or "This record don't belong on here, but you people asked for it—which was a sorry thing for you to do—so here it is."

Sleepy-Eyed John said and did anything he wanted on the air. He'd let new singles play halfway through, then jerk them off the turntable and throw them into his trash bin. "That guy ain't worth a hoot!" he'd say. "Let's find something worth playing. All right, here's Bud

Deckleman's new one. Now there's a record!" He was right about that, too: Bud Deckleman, obscure today, was a really good country singer.

Despite his act, Sleepy-Eyed John knew exactly what was going on. He saw the rock 'n' roll turnaround coming and he helped it along. He was a nice guy, too, handsome, just a few years older than me, happy-go-lucky and friendly, a good man to have minding the gate to the listeners.

Dewey Phillips was quieter, more reserved and relaxed than Sleepy-Eyed John, but on the air he was a maniac, one of those midnight howlers like Wolfman Jack; that was his act. He was good to talk to about music and good to me, and he worked his tail off at that station. His "Red Hot and Blue" show went on at midnight, but he was on the air during the day too.

I remember Elvis's show at the Eagle's Nest as if it were yesterday. The date was a blunder, because the place was an adult club where teenagers weren't welcome, and so Vivian and I were two of only a dozen or so patrons, fifteen at the most. All the same, I thought Elvis was great. He sang "That's All Right, Mama" and "Blue Moon of Kentucky" once again (and again), plus some black blues songs and a few numbers like "Long Tall Sally," and he didn't say much. He didn't have to, of course; his charisma alone kept everyone's attention. The thing I really noticed that night, though, was his guitar playing. Elvis was a fabulous rhythm player. He'd start into "That's All Right, Mama" with his own guitar alone, and you didn't want to hear anything else. I didn't, anyway. I was disappointed when Scotty Moore and Bill Black jumped in and covered him up. Not that Scotty and Bill weren't perfect for him—the way he sounded with them that night was what I think of as seminal Presley, the sound I missed through all the years after he became so popular and made records full of orchestration and overproduction. I loved that clean, simple combination of Scotty, Bill, and Elvis with his acoustic guitar. You know, I've never heard or read anyone else praising Elvis as a rhythm guitar player, and after the Sun days I never heard his own guitar on his records.

That night at the Eagle's Nest, I remember, he was playing a Martin and he was dressed in the latest teen fashion. I think his shirt came from the National Shirt Shop, where you could get something loud and flashy or something in a good rich black for $3.98 (I did), but perhaps by then he'd started shopping at Lansky Brothers on Beale Street. If he hadn't, it wasn't long before he did. I was in there myself two or three times in '55 and '56.

Elvis and I talked about music, but I never spoke to him about Sun Records or any other connection into the music business. I wanted to make it on my own devices, and that's how I set about doing it.

Buoyed by Marshall's, Luther's, and my performance in that North Memphis church, I began getting in my '54 Plymouth, driving out to the little towns around Memphis, finding the local theater manager, and pitching myself and the boys (who at that point didn't have a name; they became the Tennessee Two later). Given a job, we'd have posters made up promoting the show, then get out our black shirts on the appointed night and go do it. We performed a mixture of material, most of it gospel-oriented: "Peace in the Valley," some of Red Foley's songs, "He'll Understand and Say Well Done," sometimes black gospel blues songs like "I've Got Jesus and That's Enough," and always "I Was There When It Happened," the sacred song Jimmie Davis had made a hit (Marshall sang on the chorus of that one). Often I sang what was then my favorite among my own songs, "Belshazzar."

I found Marshall and Luther through my brother Roy, who worked with them at Automobile Sales Company Service. Marshall and Roy were the two ace mechanics, the ones who handled the biggest, most complicated jobs, while Luther worked on radios in the back. They'd been asking Roy to introduce them to me, and when he did we hit it off pretty well. I liked them both, but from the first I felt instinctively closer to Luther. He was a radio technician, for one thing, so we had that interest in common. Then, too, we were both guitar players (using the term loosely), while Marshall played the bass. Luther was one of those men who've never met a stranger. When I first met

him after coming back to the States from the air force, he welcomed me like an old friend from home—while Marshall was a little more reserved.

We got along beautifully. We really enjoyed working together. We'd go to Luther's or Marshall's house or my place and sit out on the porch and play music until the yard was full of neighbors, and it was great. I feel very fondly about those days.

Roy was a big part of things then; in fact, he'd been a major factor in my musical life for a long time. When he was a senior in high school back in Dyess, he and some buddies got together in a string band they called the Dixie Rhythm Ramblers, and they even broadcast a few times over KLCN in Blytheville, Arkansas. That, more than anything, got the idea of singing on the radio planted in my head as something I might really do, and Roy encouraged it. He'd always believed in me. Even when I was little, he'd tell me, "J.R., someday you're going to be somebody. The world's your apple, and you're going to peel it," and because I looked up to him so much, I believed that. Sadly, Roy's musical career didn't work out. He was the only one of the Dixie Rhythm Ramblers to survive World War II, and after that he lost the heart for it. He still kept encouraging me, though. While I was in the air force he and I corresponded a lot, and that in fact is how he first told me about Marshall and Luther. I was set up to meet them before I even got back to the States. Once we all got together, Roy was one of the gang. He came along on dates with us to help drive, set up, and do whatever needed doing.

Looking back, then, Roy was very significant in my life. He went on to have his own career, first as a master mechanic and then, for twenty-five years, as Mid-South Regional Service Representative for the Chrysler Corporation, with his own office in the Sterick Building in Memphis. But all the way through he kept his eye on me. When I got into the amphetamines so badly, he didn't ignore it or downplay it the way some people did; he was there to ask me—to beg me—to take care of myself. His attitude toward me never changed. He never looked down on me or condemned me, no matter how low I went. That meant

an awful lot to me. Roy died peacefully just a few years ago on his couch in Memphis. The official cause of death, I believe, was exhaustion. He was just worn out.

When I made my first move on Sun, I told Sam Phillips on the telephone that I was a gospel singer. That didn't work. The market for gospel records, he told me, wasn't big enough for him to make a living producing them. My next try didn't work, either—that time I told him I was a country singer. In the end I just went down to the Memphis Recording Service one morning before anyone arrived for work and sat on the step and waited.

Sam was the first to appear. I stood up and introduced myself and said, "Mr. Phillips, sir, if you listen to me, you'll be glad you did."

That must have been the right thing to say. "Well, I like to hear a boy with confidence in him," he replied. "Come on in."

Once we were in the studio, I sang "I Was There When It Happened" and "It Don't Hurt Anymore" for him. I sang "Belshazzar." I sang Hank Snow songs, a Jimmie Rodgers song, a couple of Carter Family songs, whatever else I'd taken into my repertoire from among the popular country songs of the day. Sam kept directing me back to my own repertoire: "What else have you written?" Though I didn't think it was any good, I told him about "Hey, Porter," and he had me sing it for him.

That did it. "Come back tomorrow with those guys you've been making the music with, and we'll put that song down," he told me.

I was really nervous in the studio the next day, and the steel guitar player, Red Kernodle, another mechanic at the Automobile Sales Company, was even worse; he was so jittery he could hardly play at all. The results were predictable: the first track we recorded, "Wide Open Road," sounded awful, and it didn't get any better. After three or four songs, Red packed up his steel and left. "This music business is not for me," he said, and I didn't contest the point. After that we settled down a little and managed to get a respectable take on "Hey, Porter."

Sam liked it. "That's going to be a single," he declared.

"What do you mean, a single?" I asked. I thought we were still auditioning.

"We're going to put out a record," Sam replied.

What a wonderful moment that was! I hadn't thought we had a chance, and now there I was, about to become a Sun recording artist.

"Now," Sam continued, "if we had another song, a love song we could put on the other side, we could release a record. D'you have a song like that?"

"I don't know," I said. "I'll have to think about it."

"Well, if you don't have one, go write one. Write a real weeper."

That's what I did. A couple of weeks later I called him with "Cry, Cry, Cry" in hand, and he had us come back in and cut that, too.

We had to do thirty-five takes before we got "Cry, Cry, Cry" right, mostly because Luther couldn't get his guitar part worked out. I kept changing the arrangement on him, and he kept messing it up. It was a comedy of errors until finally I told him to forget about the guitar break we were trying for and just chord his way through it. That worked out fine, I thought. The *boom-chicka-boom* instrumental style suited me, and it came naturally to us. Marshall Grant was mostly right when in later years he said that we didn't work to get that *boom-chicka-boom* sound—it's all we could play. But it served us well, and it was ours. You knew whose voice was coming when you heard it kick off.

Marshall and Luther limited me, it's true, especially in later years. Songs would come along that I'd want to record, but I didn't because I couldn't figure out the chords myself, and neither could anyone else in the studio. "City of New Orleans" by Steve Goodman was one of those. Kris Kristofferson sent it to me before anyone else got a shot at it, and if I'd taken the time and made the effort to learn it, I might just have had myself a major hit. Instead I let it pass and just kind of drifted along with Marshall and Luther (and, after '59, Fluke). I can't blame Marshall and Luther, of course. There were plenty of people I could

have called to come in and show us what we needed to know, but I didn't bother (it's only in the last few years, in fact, that I've learned a couple of new chords). I took the easy way, and to an extent I regret that. Still, though, the way we did it was honest. We played it and sang it the way we felt it, and there's a lot to be said for that.

4 My feelings about Sam Phillips are still mixed. I think he was another of those angels who appear in your life, but I'm not sure he treated me properly in a financial sense (I'm not sure he didn't, either). Mainly, though, I'm still annoyed that he never gave me a Cadillac. He gave Carl Perkins one when Carl sold a million copies of "Blue Suede Shoes," but I never got one when "I Walk the Line" became such a huge hit. I don't know. Maybe it was because Sam saw Carl as his future in rock 'n' roll—he'd sold Elvis to RCA by then—whereas I was country, and you just don't give Cadillacs to country stars. It's a rock 'n' roll thing.

I still think I should have that Cadillac, though. I should just call Sam and tell him to send one over: black, with dark black trim and maybe a light black interior. I don't know what they cost now, but in 1956 you could get one that was top of the line for thirty-five hundred dollars.

I'm calling the man Sam, but back then I called him Mr. Phillips. We all did, even though he told us not to—he wasn't that much older than us, after all. I think it was Elvis, just nineteen when he signed with Sun, who got it started, and the rest of us followed along. The women at Sun, Marion Keisger and Sally Wilburn, reinforced it. We'd take our questions and problems to them: Where were our royalty checks? Could we change the song we'd just recorded? They'd listen and then say, "We'll have to talk to Mr. Phillips about that." I was well into my forties before I changed my ways. I started worrying that if I kept calling him Mr. Phillips, he might start calling me Mr. Cash, and that would make me very uncomfortable. Mr. Cash was my daddy, not me.

Sam Phillips was a man of genuine vision. He saw the big picture, which was that the white youth of the 1950s would go crazy for music that incorporated the rhythms and style of the "race" records he produced for artists like Howlin' Wolf, Bobby Bland, B. B. King, Little Milton, James Cotton, Rufus Thomas, Junior Parker, and others (a list of names at least as impressive as those of the young white rockabillies with whom he is more famously associated). He also had a fine eye for talent and potential in individuals, even if it hadn't been pulled out of them before. In my case he saw something nobody else had seen and I hadn't even realized myself.

He didn't run with the pack, either (which almost goes without saying, given the originality of his accomplishments). He wasn't one of those many music businessmen/producers who make their living forcing singers and musicians to sound like whatever is selling. He always encouraged me to do it *my* way, to use whatever other influences I wanted, but never to copy. That was a great, rare gift he gave me: belief in myself, right from the start of my recording career.

I liked working with him in the studio. He was very smart, with great instincts, and he had real enthusiasm; he was excitable, not at all laidback. When we'd put something on tape he liked, he'd come bursting out of the control room into the studio, laughing and clapping his hands, yelling and hollering. "That was *great!* That was wonderful!"

he'd say. "That's a rolling stone!" (by which he meant it was a hit). His enthusiasm was fun. It fired us up. And he really did have a genius for the commercial touch, the right way to twist or turn a song so that it really got across to people.

A case in point was "Big River," which I'd written in the backseat of a car in White Plains, New York, as a slow twelve-bar blues song and sung that way on stage a few times before I took it into the studio and sang it for Sam. His reaction was immediate: "No, no, we'll put a beat to that." He had Jack Clement get out his J200 Gibson, tune it open, take a bottleneck, and play that big power chord all the way through, and that was just great. I thought it was fabulous. The groove he'd heard in his head was so much more powerful than mine, and I'll always be glad he felt at liberty to push ahead and make me hear it, too.

He did have strong ideas. Sometimes I didn't like it much when I felt that his mind was closed to something I wanted to do—he had a way of ruling out ideas, seemingly without even thinking about them—but ultimately I never had a real problem with that. I don't think it ever caused us to lose any good work, and anyway, he listened to me most of the time. By no means—that is, by no remote stretch of the imagination—was he one of those producers who like to impose their own "style" on artists who come into their studio. Sam's basic approach was to get you in there and say, "Just show me what you've got. Just sing me songs, and show me what you'd like to do."

And basically he and I saw eye to eye. We both knew up front that my music had to stay simple, uncomplicated, and unadorned, and we both felt that if the performance was really there at the heart of the song, it didn't matter much if there was some little musical error or a glitch in the track somewhere. There are mistakes on several of my Sun records—Luther fumbling a guitar line, Marshall going off the beat, me singing sharp—and we all knew it. Sam just didn't care that much: he'd much rather have soul, fire, and heart than technical perfection. He did care when something I did challenged his notions of good and bad music, though. Then he was quite frank.

"That's awful," he'd tell me. "Don't do that."

I'd say, "All right, I won't," unless I disagreed strongly. Then we'd work it out between us.

It was truly a beautiful day when Marion Keisger handed me my first royalty check. The amount was tiny—$6.42, I believe—but to me it was like a million dollars. Maybe I wouldn't have to keep pretending to sell those refrigerators or get any other kind of job I really didn't want; maybe by the end of the year I could pay the rent on the little house I shared with Vivian and Rosanne; maybe, if I could keep borrowing from my father-in-law and George Bates at the Home Equipment Company, I could stay afloat until the end of the next royalty pay period, when Marion had told me I might get a much bigger check. Maybe, just maybe, I could make a living at this! Elvis was doing okay, after all. He was running around buying his own Cadillacs.

The euphoria faded as I began to learn, slowly and often quite accidentally, how the business of music worked. It's embarrassing remembering how ignorant I was about business back then. It's even worse to admit that I'm not much better today. I've been forced to learn some basic rules during forty years on the job, but I've resisted fiercely and effectively; only the most unavoidable home truths have gotten through. I've always resented the time and energy business takes away from music—lawyers desperately needing decisions when the song in my head desperately needs to come out; accountants telling me I need to go there and sing that when I really want to stay here and sing this. The concepts don't match up. A businessman looks at a song and sees a pile of money surrounded by questions about its ownership; I see one of my babies. I remember how strange it felt sitting in a meeting in the '80s, looking down a long list of my own songs whose copyright was finally available for me to acquire, and seeing the title "Wide Open Road" among them. I was suddenly overwhelmed with a vivid memory of exactly how it felt thirty years before on the cold, rainy morning when I sat in the barracks in Germany with my five-dollar guitar and conjured that song up out of the air. How could anyone but me *own* that?

I don't know. I've cancelled the vast majority of my meetings with lawyers and accountants, and whenever I've found myself forced into one, my strongest urge has always been to get out of it as quickly as possible, muttering something like, "I just want to sing and play my guitar."

I feel bad about not being fluent in music *and* money, and I look up to people who are. Jack Clement has no difficulty thinking and talking and doing business, but he still enjoys playing a G chord. He's been that way all the years I've loved and fought and worked with him, and I've always admired him for it.

Still, I've always tried to be straight with money and pay what I owe. After my very first tour as a Sun recording act I walked into the Home Equipment Company office with the money I'd saved and paid George Bates every penny I owed him. And as I'd promised Vivian, I didn't buy a star car until we had our own house.

It wasn't a new Cadillac, either. It was Ferlin Husky's very slightly used Lincoln, the Car of the Year for 1956. That car was gorgeous, and just right for me: rock 'n' roll pink and Johnny Cash black.

I'm thinking now about Sam Phillips, concerned that I might have created an impression of discord between us. That's not so. Whatever differences I had with him, they've been long resolved. I bear no grudge against the man who did so much for me.

In 1984 the citizens of his hometown in Alabama held a dinner and roast for him, and Jack Clement and I drove down from Nashville and spoke. It was like a love-fest: a lot of hugging, a few tears, some old stories, and some struggles to get them right, the way they really happened.

I have so much respect for Sam. He worked so hard and did so much good for people like me. If there hadn't been a Sam Phillips, I might still be working in a cotton field.

5 It wasn't money that took me away from Sun. Money, in fact, has never had much to do with my relations with record companies. For me it's always been more about music and the control of it, all of which can be reduced to a single question: How much freedom will I have to make whatever music I want?

With Sam Phillips the issue was gospel. I wanted to record gospel music, and I wanted it badly. He refused to let me for purely financial reasons.

"You know, I love gospel music," he told me. "I love gospel singers, but I can't make money recording it. Unless you're Mahalia Jackson, or somebody that established, you can't even cover the cost of recording."

To record sacred music by a new country singer like me—and some of it original music, songs I'd written myself, that nobody had

ever heard—was something he just couldn't do. That didn't sit well with me, and when I started thinking in terms of other hard-sell music—the ideas that led eventually to my *Ride This Train* album—I got more restless still. When Don Law, a Columbia Records producer, called me and said he'd like to come down to Memphis to talk with me about a new recording contract, that's what came immediately to mind: Would Columbia let me make a gospel album? They would, said Law, no question about it. How about the concept album? Well, he said, he'd be very interested in hearing about that. So he came down, our talk went well, and I signed an option to go with Columbia when my Sun contract expired.

I don't know why I found it easy to lie to Sam about it, but that's how it was. He heard about the option somewhere and asked me if it was true. No, I told him, it wasn't. I hadn't signed any option.

Roy Orbison told him the same sort of lie around that same time, and as it happened Roy was at my house when Sam, who'd found out the truth, telephoned to confront me. Sam was pretty angry and wanted to know why I'd lied.

Well, I said, he hadn't been truthful with me about a few things (which itself wasn't true; he'd always told me the truth, but I'd been too ignorant to know what it meant), so I thought I'd just pay him back a little.

That made him even madder. He got Roy on the phone and really let him have it. "Why, you little so-and-so. You can't sing! I had to cram the microphone down your throat just to pick you up, your voice is so weak!"

Roy just laughed at him. He thought that was pretty funny. So did I.

I didn't find it so hilarious when I got a letter telling me that, in order to fulfill my contract with Sun, I still had to record a number of songs and therefore I'd be at the studio on such-and-such dates to do just that. I was quite seriously annoyed, but I did as I was told, and in retrospect I'm glad I did. One day I walked into the studio and only

two people were there, Jack Clement and another young guy sitting at the piano putting some of his songs on tape for me. It was Charlie Rich, who'd just signed with Sun, and after I'd listened a little while I realized how lucky I was. Nobody would have to force me to record *those* songs. "The Ways of a Woman in Love," "You Tell Me," "Story of a Broken Heart"—I became a Charlie Rich fan right there and then. To my mind, he was the best thing to hit Sun since Elvis. He and I never got to be buddies, though.

Roy and I did, and we were friends for the rest of Roy's life. It was a particularly close friendship, too. We became like brothers right from the start, when we'd tour together and Roy would come over to my house in Memphis, and we stayed that way until the end. By the time of his death in December 1988, we'd been next-door neighbors on Old Hickory Lake for twenty-plus years. While most of the time we passed like ships in the night, the way traveling entertainers must, that didn't distance us; we were close enough that when our schedules coincided, he'd drop by for breakfast and be more than welcome. I really loved Roy. He was a very kind, considerate man, sweet-natured and good-humored; funny, too. The tragedies in his life seemed so unfair. Talk about bad things happening to good people: I can't think of any man much better than he was, and I can't think of anything at all that could be worse than having to endure the death of your children just two years after the death of your wife.

Claudette Orbison was Roy's first wife, killed when he and she were riding their motorcycles together in 1966. Roy D. and Tony Orbison, the two youngest of their three young sons, died in 1968 when their house—the house next door to mine—burned while Roy was on the road in Europe. I, too, was gone at the time.

As far as the fire marshalls were able to tell, the fire started when the boys, in their room behind a closed door, were playing with matches and an aerosol can, squirting it and igniting the spray. The inevitable followed. The fire flared up so fast and strong that when their grandparents heard something and went to investigate, it blew

them all the way across the house as soon as they opened the door. There was no way they could reach the boys, though they both got burned trying; they were lucky to save themselves. The house was consumed. When Roy got home only the chimney was left standing.

June and I cancelled our tour dates as soon as we heard the news and chartered a jet to get us home quickly, but there was nothing we could do for Roy. We heard that he didn't want to talk to anybody, so we just stayed home until the funeral, looking out the window now and again at that blackened chimney.

I couldn't even approach Roy at the funeral—for the first time in my life I was at a total loss for words, gestures, anything—and it was a week or more before I found it in myself to call him; then I just told him that I loved him. He said he'd be all right, but I couldn't imagine how he could be.

I didn't see him for a long time after that. He'd moved in with his parents, who lived across the road, and they'd put a "No Visitors" sign on the door. I asked his father about him from time to time, but the answer was always the same: he was there in the house, but he stayed shut up in his bedroom.

Eventually I had to act. I crossed the road, told his father I had to see him, and went to his room. And there he was: so pale that he could have been dead himself, just sitting in bed with his shades on, facing a large-screen television with the sound turned all the way down. He didn't get up from the bed when I came in. I don't know if he was crying because I couldn't see his eyes. I don't know if he even looked at me. He didn't speak.

I was still at a loss for words that seemed anywhere close to adequate, so I said what I could: that I loved him and that I wouldn't know how to handle it if I lost my own son that way.

"I don't know how to handle it, either," he said, and that was all. I left.

The next time I saw him, he'd emerged from his room and decided to build a new house on a lot adjacent to the old one. I walked up to

the construction site one day and was happy to find him almost his old self. We talked about the new house, and then he told me that he'd like June and me to have the old lot. Sure, I said. We worked it out and I bought it from him, and then I told him I'd never build on it or sell it to anyone else, even though it was the most valuable land in the neighborhood. I'd plant a vineyard and an orchard there, and their first fruits each year would always be his. He liked that; I think he was glad that strangers wouldn't live where his children died.

Roy married again and we became close with the new Orbison family. Today June and I are godparents to two of Barbara Orbison's sons, and we act like we're godparents to all of them. Sadly, we lost Roy to a heart attack in 1988, seven years after the bypass surgery that saved him the first time around (which happened to Marty Robbins, too, so I was more than a little worried when I reached my own seventh year after surgery).

Roy's death was sudden and shocking, but something wonderful did occur before it happened. The day before Roy was taken, he went to see his surviving son from his first marriage, Wesley, and closed the distance that had grown between them. They hugged, said they loved each other, and sat up singing and writing songs late into Roy's last night on earth. Wesley says it was the most wonderful night of his life.

Wesley is still within our circle. A few years ago I started seeing him leaning against the fence bordering the place where his brothers died, where the home of his childhood once stood. One day I stopped and asked him what he was looking at.

"Oh, I like to come up here sometimes and look at this lot," he said. "It gives me a little comfort."

Well, I told him, there were some mighty good fruit trees and grapevines in there and whenever the fruit was ripe he should just go on in and help himself. Bring a basket. "Okay," he said. "Thank you. I will."

It was June who got the idea to give him more than the fruit. I agreed, and without any further fuss we signed the lot over to him free

and clear. Now when I see him leaning on the fence I know he's think-ing about the house he wants to build there someday, and I don't feel like I lost a thing in the deal. I feel like old Roy smiled down and said "Thank you, John."

There was a time when Roy and I should have gotten together, but didn't. It was in Dublin some years after I'd bought the lot from him, a ships-in-the-night affair when he was playing one place one night and I was playing another the next. He called me, but I was so high on amphetamines that June had already cancelled my show. I put him off.

"I'm not in very good shape, Roy," I croaked. He didn't care, he said, he was coming over anyway.

I wouldn't let him in. I just lay there in silence, so wired that my whole bed was shaking, listening to him at the room door and waiting for him to go away. He knocked and waited, knocked louder and waited, knocked louder still and waited again; then he gave up and left. What a hard, sick few minutes those were.

It was months before I saw him again, in Tennessee on one of those days when we both happened to be home at the same time. "I'm really sorry about Dublin, Roy," I told him. "I heard you knock, but I couldn't face you. Knowing the grief you've gone through, I didn't want to see you hurt, and I know you'd have been hurt if you'd seen my face." I was so full of shame and ego, so sick of letting people down and worried about what they thought of me.

Roy reacted like a friend. "Oh, man, don't worry about it," he said. "I've been that way too." He was a good man.

The last time I saw him was a few months before he died, and my favorite Roy Orbison story begins then. Among other things, we talked about hair. I told him I'd always admired the way men dressed and styled themselves in Thomas Jefferson's and Andrew Jackson's day, and now I really wanted to wear my hair as Jefferson wore his, in a ponytail tied off with a black ribbon. "I'll see if I can talk June into let-ting me grow enough hair to do that," I said.

Roy thought that was a grand idea. "Tell you what," he said. "I'll do it if you do it."

It *was* a grand idea, but I chickened out, and I never talked to Roy again. I saw him, though, when I took Wesley down to the funeral home where they'd laid Roy out for his friends and relatives. Wesley didn't want to see his father dead and wouldn't approach the casket, but I did. I walked up and leaned over to get a good last look at my old buddy. When I saw him I couldn't help myself; I started laughing. That son of a gun had done it! There, sticking out from under his head, was a neat little ponytail, and it was tied with a black ribbon.

6

I miss Roy. I miss him coming over for breakfast.

He had total recall, you know. Around Roy, you didn't dare tell a story about something in which he'd been involved without asking, "Is that the way it was, Roy?" He'd tell you exactly why you were wrong, or right. He could repeat twenty-year-old conversations word for word. He could tell you what you were *wearing*. It was almost scary. Roy was just my buddy, but sometimes I'd look at him and wonder.

I once gave him some terrible advice. "You know, Roy," I told him when he was despairing of ever getting a hit record at Sun, "you need to do two things: change your name and lower your voice."

That was fairly typical of my commercial judgment, the firm grip on market realities and public tastes that has graced my whole career. It was I, for example, who insisted that Jack Clement's "It'll Be Me"

was a far stronger song than "Whole Lot of Shakin' Going On," which of course proved to be Jerry Lee's first big hit and is now recognized as one of the great moments of rock 'n' roll recording. For my little buddy Jerry Lee's sake, I even went to Sam Phillips and begged him not to push that song to the radio stations. Sam, to his credit, listened to me just as if I were making sense, and then went ahead and pushed the song as he had planned.

We Sun singers got along well. There was never any great tension between Carl and Elvis, Roy and Jerry Lee, or any combination of us. About the only disagreements I recall were centered on Jerry Lee, who often objected to what you might call perceived threats to his supremacy. Even that wasn't serious, because nobody would fight with him. If we were all on the same bill and he couldn't handle the idea of going on stage before Carl or even opening the show (perish the thought!), Roy would just defuse it all by offering to open the show himself. He didn't care. He laughed at Jerry just as he laughed at Sam; people who took themselves seriously struck him as pretty amusing.

Jerry Lee did indeed take things seriously. He'd just left Bible school when he first got to Sun, so we had to listen to a few sermons in the dressing room. Mostly they were about rock 'n' roll leading us and our audiences to sin and damnation, which Jerry Lee was convinced was happening every time he sang a song like "Whole Lot of Shakin' Going On."

"I'm out here doing what God don't want me to do, and I'm leading people to hell!" he'd declare fervently. "That's exactly where I'm going so long as I keep on singin' this kind of stuff, and I know it." Then he'd tell us we were all going to hell with him.

Carl would disagree strongly, and the two of them would start into it, with Jerry Lee quoting chapter and verse and getting more and more worked up. Then I'd jump in, trying to mediate.

"Maybe we just ought to sing whatever we sing, if they like it, and get their attention that way. Then sing them gospel," I'd suggest.

Jerry Lee would have none of that. "No, that ain't the way!" he'd protest. "You're leading them to hell first. You can't lead them to hell, then get them out again and lead them to heaven!"

That happened a lot. The argument just kept coming up in one form or another and going round and round behind stages, in motels, and along highways all over North America. I believe Jerry Lee still sees it as a red-hot issue. And he may be right.

The thing about Jerry Lee is, while you may think he's conceited and self-centered, it's just that he knows he's talented, he's always known it, and he'll tell you so in case you needed to know. And of course he can be a genuine wild man. We all knew that at Sun. When the British press got themselves so worked up about Jerry Lee's marriage, in 1959—to Myra Gail—and some American radio stations refused to play his records, I wasn't very surprised. I knew what an outrageous person he could be, how unpredictable. I hadn't known he was contemplating matrimony, so the news was a surprise to me, but I'd probably have had the same reaction if I'd heard he'd decided to run for President: "Well, how about that? That's my buddy!"

The "blacklist" didn't scare me, by the way. I never gave it a second thought. I didn't have to worry about it anyway—I was country, not rock 'n' roll. No free Cadillacs, but no outraged guardians of public morality either.

Elvis certainly took a lot of abuse from that crowd. He had his problems with gossip, too, and rumor and lies. He was very sensitive, easily hurt by the stories people told about him being on dope and so on. I myself couldn't understand why people wanted to say that back in the '50s, because in those days he was the last person on earth who needed dope. He had such a high energy level that it seemed he never stopped—though maybe that's why they said he was on dope. Either way, he wasn't, or at least I never saw any evidence of it. I never saw him use any kind of drug, or even alcohol; he was always clear-headed around me, and very pleasant. Elvis was such a nice guy, and so talented and

charismatic—he had it all—that some people just couldn't handle it and reacted with jealousy. It's just human, I suppose, but it's sad.

He and I liked each other, but we weren't that tight—I was older than he was, for one thing, and married, for another—and we weren't close at all in his later years. I took the hint when he closed his world around him; I didn't try to invade his privacy. I'm so glad I didn't, either, because so many of his old friends were embarrassed so badly when they were turned away at Graceland. In the '60s and '70s he and I chatted on the phone a couple of times and swapped notes now and again. If he were closing at the Las Vegas Hilton as I was getting ready to open, he'd wish me luck, that kind of thing—but that was about the extent of it.

I've heard it said that here at the end of the century, we all have our own Elvis, and I can appreciate that idea, even though *my* Elvis was my friend, flesh and blood in real life. Certainly, though, my Elvis was the Elvis of the '50s. He was a kid when I worked with him. He was nineteen years old, and he loved cheeseburgers, girls, and his mother, not necessarily in that order (it was more like his mother, then girls, then cheeseburgers). Personally, I liked cheeseburgers and I had nothing against his mother, but the girls were the thing. He had so many girls after him that whenever he was working with us, there were always plenty left over. We had a lot of fun. We had a lot of fun in general, not just with the girls. It was nice that we could make a living at it, but every one of us would have done it for free. And you know, Elvis was so good. Every show I did with him, I never missed the chance to stand in the wings and watch. We all did. He was that charismatic.

Which is not to say that he always blew everyone else away. I distinctly remember, for instance, one night in Amory, Mississippi, when he had to take a backseat to Carl Perkins, even though he was the headliner. At the time Carl hadn't yet had his big hit, but he'd had "Movie Mag," he'd played the venue several times before on his own, and they loved him. He went on first and tore the place up; the fans went absolutely nuts.

When Elvis went on, he got a fabulous reception too, but he wasn't even all the way through his first song when half the audience started shouting for Carl. It was so bad that he only did one more song before giving up. He left the stage and Carl came back on to thunderous applause.

I heard later that after that night in Amory, Elvis said he'd never work with Carl again. I didn't hear him say it myself, and to me it doesn't sound like Elvis—he wasn't that small-minded—but that's what some people passed along, and it's certainly true that Carl stole his show.

I went up to Carl after the show. "You did really good tonight, Carl," I said. "I've been to Elvis's shows and I've done a couple of them with him myself, and I'll tell you, I never thought I'd ever see anyone outshine him."

"Yeah," he replied, "but there's one thing missing."

"What's that?"

"He's got a hit record, and I don't."

There was no arguing with that, and it got me thinking. A little while later that night, I told Carl about C. V. White and the blue suede shoes. C. V. White was a black airman from Virginia I'd known in Landsberg—he told us the initials stood for "Champagne Velvet," but none of us ever knew the truth—and one night he said this one thing that really struck me. When we got a three-day pass we'd get out our best uniforms, polish our brass, and spit-shine our shoes.

C.V. would come by and say, "How do I look, man?"

"Like a million dollars," I'd tell him, and it was true. "You look great, C.V. You look really striking."

One night he laid the line on me at that point. "Well" he said, "just don't step on my blue suede shoes!"

"They're not blue suede, C.V. They're air force black, like every-one else's."

"No, man. Tonight they're blue suede. Don't step on 'em!"

I told Carl that story and how I'd thought it had a song in it, and he took it and ran with it. He didn't record it the way I'd been thinking. My idea had been to adapt a melody from a nursery rhyme (taking a leaf out of Jack Clement's book), but I'd say Carl's version worked out pretty well.

A lot has been made over the years of a rivalry between Carl and Elvis, and of course the story of "Blue Suede Shoes" does lend itself to that interpretation. According to the story, after Carl was put out of action by a terrible car crash while his hit was riding up the charts, Elvis recorded it himself and capitalized on Carl's success. It's one of those "What If" questions. If Carl had been able to ride the wave of "Blue Suede Shoes" all the way and follow up on it properly, could he have become as big a star as Elvis, or even bigger?

I don't think so. I believe that without the accident Carl could have become a real superstar in the pop/rockabilly world. However, neither he nor anyone else could have become the star Elvis was. Ain't nobody like Elvis. Never was.

Carl is very special to me, very close, and we've been that way since we first met. If memory serves, that was on my second visit to Sun, when I went in to record "Hey, Porter." We all went next door to the cafe on the corner and had a hamburger, and it was like meeting my own brother for the first time. Carl grew up in Lake County, Tennessee, right across the river about thirty miles from me, and we both had that black Delta mud in our bones. We'd been raised on the same music, the same work, the same religion, everything, and beyond all that, we were just in tune with each other. Friends for life.

Carl is countrified and country-fried, as country as country can be. Listening to him, you can still place him exactly, if you know what you're hearing: southwestern Tennessee, just as I still sound like a combination of southwestern Arkansas, where my parents grew up, and northeastern Arkansas, where I myself was raised. It's rubbed off a bit because we've both been to town, but it's still there. So is the need to

keep going back to our basics, one way or another: to the fundamental Christian values with which we were both raised, to the music, to the land itself, and of course to the food.

I myself can't go too long without real Southern fried chicken, skillet cornbread, and all the other wonderful staples of my home food. It's one of the disadvantages of a life spent traveling internationally that that particular kind of cooking isn't much exported. You can find a burger almost anywhere in the world and dine well on French or Italian or Chinese food, but just try finding fried okra or black-eyed peas or skillet-cooked cornbread in Sydney or Singapore or Stuttgart. Some of my clearest memories of Carl and myself in the Sun days, then, are of the food on the road. When we could, we'd stop at restaurants on the highway and invariably we'd order fried chicken, roast pork sandwiches, creamed potatoes, fried okra—real country food. In a hurry, not stopping for lunch, we'd pull off at a store and stock up on bologna and cheese and crackers and Cokes.

We shared a lot in the Christian values area, too. Neither of us was walking the line as Christians, but both of us clung to our beliefs. Carl had great faith, and at his depths, when he was drunkest, what he'd talk about was God and guilt—the same subjects I would bring up when I was in my worst shape.

Whenever Carl drank, he'd get drunk, and he drank often. It seemed like the Perkins car couldn't keep enough whiskey in it. And when he was drunk he would cry. He'd talk about how good his wife was, how his poor kids were back at home with nothing while he was out on the road spending all his money on whiskey. The next night there would be a show, though, and it would be, "Where's that bottle? Ah, there it is!" All the same, he was a man of his word. If you asked him for help and he agreed, he'd be there without fail. If he borrowed money from you and told you he'd pay you back Monday, that's when you got it.

Carl, as all rockabilly fans know, had a family act. His brothers, Jay B. and Clayton Perkins, were in his band. Originally, in fact, Jay B.

was the singer and Carl solely the guitar player, but once they got into the studio at Sun, Jay B. couldn't come up with anything to sing, so Carl took over and they recorded "Movie Mag" and "Turn Around," Carl's first single. The only nonfamily member of the band was Fluke, W. S. Holland, on the drums.

Jay B. Perkins was the tall, quiet guy who stood to the left of Carl on stage, playing rhythm on a Martin guitar. He was terrific; everybody loved him. He hardly spoke at all, just laughed, and he had plenty to laugh at because his brothers and Fluke were real characters, the greatest jokers you'd ever want to meet.

Clayton, the youngest, was the funniest and the wildest. He'd do whacked-out stuff like stop at a gas station and stick a cigarette in his ear. The attendant would come over:

"Hi. What can I do for you?"

Clayton would look up at him say, "Fill up my tank and give my ear a light, will ya?"

He was the only one who drank more than Carl, and when he drank he was pretty funny up to the point where he started getting mean. While he was still funny he'd take over the mike from Carl and start singing outrageous parodies of popular songs that he'd make up on the spot. I remember a lurid version of Ferlin Husky's "Poor Little Joe" in which he wept and moaned all over the stage. Often, usually in fact, the new lyrics would be dirty enough to get anyone banned from any stage anywhere, which is pretty much what happened to the Perkins boys. Once word got around about Clayton's act, which by its nature was a spontaneous, unpredictable, and therefore uncontrollable event, the number of places they could play contracted greatly. Still, life in the company of Clayton Perkins *was* a ball. You paid for it, though. He could be very unpleasant on the other side of that bend in the road he took when he drank.

All the Perkins brothers, plus Fluke and Poor Richard, another Memphis deejay, were in the car when the accident happened, on their way to do the Perry Como Show in 1956. Fluke and Poor Richard were

thrown clear, but everyone was hurt to some extent. Jay B. had his neck broken. When everyone else had recovered well enough to go back on the road, he went along in a neck brace, often in agony. In those days, laughing at his brothers' antics would sometimes hurt him so badly that he'd cry at the same time.

It wasn't long before he developed brain cancer, and that's what finished him. The last time I saw him was the day when Carl, Marshall, Luther, two or three other boys, and I decided to take him on a fishing trip to lift his spirits and just be with him one last time; he was about to become bedridden. We went out in two boats to just below the dam at Peakwood, Tennessee, where you could find giant catfish, fifty or sixty pounds or more, and we fished for them with big three-prong hooks baited with a whole chicken's guts and weighted down heavily to drop through the fast, turbulent water under the dam. Getting those monsters up off the bottom felt like reeling in Sherman tanks, but we got us a few good ones, took them back to Carl's house in Jackson, and had ourselves a big fish fry. I don't remember any drinking; Carl didn't drink around his wife and children. I do remember a lot of fun with Jay B.

A month or so later we went to the Ellis Auditorium in Memphis and did a show in memory of him. Carl was drunk that night. So were Clayton and a couple of other Perkins family members. I took my uncle Russell, whom I picked up in Rison on my way through Arkansas in my wonderful almost-new Lincoln. It was mid-July, a hundred degrees. I started up the car and turned on the air conditioner, and we went on down the road.

After a while Uncle Russell said, "Boy, I'll tell you what. If I didn't know better I'd think it's getting cold in this car." I told him the car was air-conditioned.

"What's that?" he asked. It meant nothing to him.

I explained. "Well, I swear, I never saw anything like it!" was his conclusion, and on we drove to mark the death and loss of Jay B. Perkins.

I noticed a change in Carl after the accident. He kept on drinking and he got more morose. I think he really felt that the accident had taken away his shot at the top (which it had), and he was bitter about it. And of course Jay's death was a sad, terrible thing in his life. I tried to be sympathetic. I know how deep that wound goes.

7

It all blends together after a while. Yesterday seems further behind me than 1955, last week's tragedy or triumph neither more nor less troubling or thrilling than one in 1949, or 1969, or 1989. Here I stand in a smart hotel in San Francisco in the 1990s, gazing out toward the Pacific Rim, remembering these skies, these hills, this town in other, almost interchangeable times: one decade, two decades, three, four. It's five now, isn't it?

Here's a story from the '60s, the latish '60s I think, about Fluke flapping his mouth too hard at a San Francisco cabby and all of us ending up on a real ride.

The cabby was the silent type. Fluke kept talking to him, but the cabby wouldn't talk back, so Fluke decided to taunt him.

"I bet this cab won't go down these hills fast," he said. "Will it?"

No answer. He tried again. "Why don't you air it out? Let's see what it'll do."

He'd picked the wrong man. The guy didn't say a thing; he just chose his moment and floored it. We flew down that hill like a runaway freight, picking up speed as we went, blasting through the green lights—the driver had timed it just right—and spraying sparks everywhere. We grounded out at every intersection, just like in the movies. I'll bet we did some flying, too. It certainly felt like I spent time airborne, bashing my head into the roof and listening to June scream her lungs out above the roar of the engine and the grinding of metal on asphalt. I really thought we were all going to die.

We made it to the bottom alive, though, and the driver finally spoke. Even then he didn't have much to say. He just turned around, looked straight at Fluke, who like me was shaking with fear and adrenaline, and asked mildly, "Was that fast enough for you?"

I tend to remember that story at appropriate times, for instance when Unit One is struggling up or edging down some unholy downtown San Francisco gradient. A tour bus can gain an awful lot of momentum very quickly on those hills, so for long, long minutes you find yourself contemplating the state of your brakes, and perhaps also the strength of your transmission, with unusual intensity.

Another odd little story of the traveling life comes to mind, this one from the mid-1950s when Marshall and Luther and I, plus Carl and his band, were headed out of Oregon in the opposite direction from the route that brought us here to San Francisco two nights ago. We were on our way to Alaska, as I recall. I think it was during that tour that we had a box of Bill Justis's new singles in the trunk of my '54 Plymouth. He'd asked us to distribute them for him, and that we did. We stopped at a beautiful scenic overlook on Mt. Hood and distributed those big, brittle old 78s by hand, one by one. They flew really well. That record became a hit, too; we were always proud of being the first to distribute it.

And here's another one, this one set in Dublin, Ireland, in the '40s and told to me in Hollywood in the '60s by Merle Travis, another very dear friend now departed.

It's about Gene Autry. Merle, the source of the guitar style called "Travis picking" and a whole lot more—songs, stories, wit, wisdom, advice, encouragement, humor, pleasure, fun in all its forms—worked with Gene in his glory days, which by all accounts were indeed glorious. Gene, the king of the singing cowboys, was one of the biggest stars in the world. People of my vintage, myself included, remember him as being wildly popular, probably the best-loved public personality on earth, a wonder of straight-shooting strength and virtue and an inspiration to children everywhere.

His arrival in Ireland, Merle recalled, produced a reaction that would have put Beatlemania to shame: two million people were jammed into the streets of Dublin around his hotel making a sound like nothing Merle had ever heard before. Somehow the entertainers had managed to get from the airport to the hotel and in through a back door, and then Gene had invited Merle up to his room for a drink. Merle did like to drink. So did Gene. Gene himself was a touch earthier than the character who sold the movie tickets.

They had several shots of whiskey without saying a word to each other, just sitting in the room listening to that incredible noise surge in through the open windows. Finally Merle spoke. "Gene, maybe you should go out on the balcony and let the people see you."

Gene grunted. "Hmm. You think I should?"

"Yes I do."

"Well, let's have another drink first."

They had another drink, and then another, and by that time the crowd was even louder—a constant roar, people frenzied for a glimpse of the hero.

Merle was getting uneasy. "Gene, I really think you should go out there on that balcony and wave your white hat to those people. Let them see you."

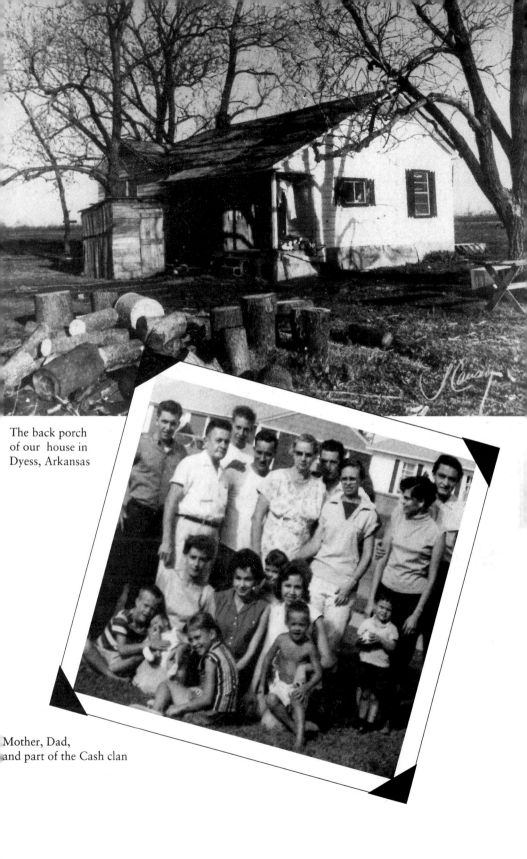

The back porch
of our house in
Dyess, Arkansas

Mother, Dad,
and part of the Cash clan

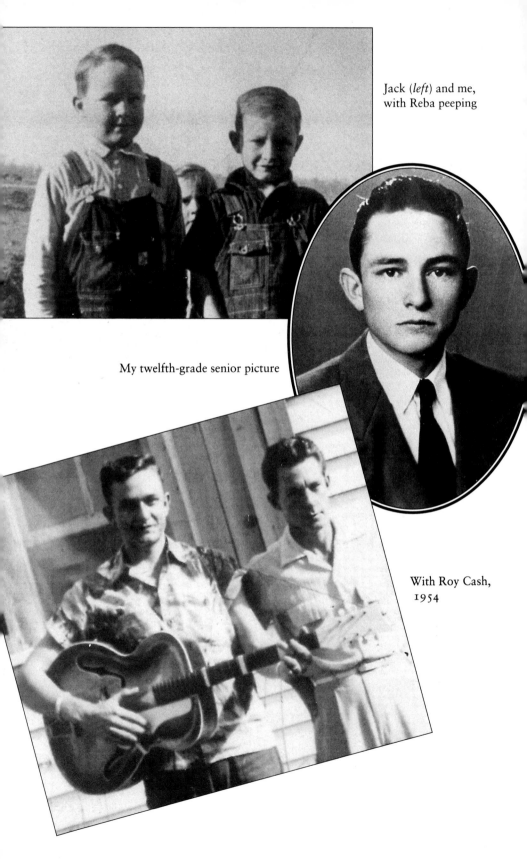

Jack (*left*) and me,
with Reba peeping

My twelfth-grade senior picture

With Roy Cash,
1954

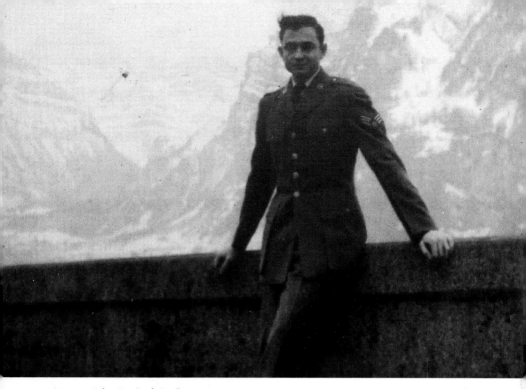

Airman John R. Cash in Germany, 1952

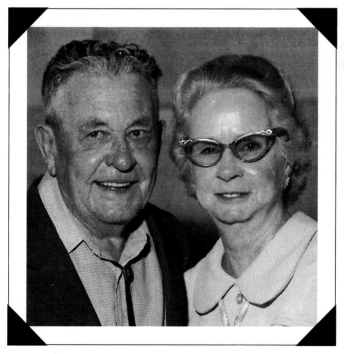

My parents,
Ray and Carrie Cash

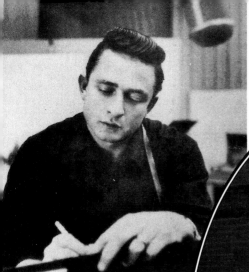

Rewriting in the studio

June Carter performing at
the Grand Ole Opry, 1958

Luther, me, and Marshall

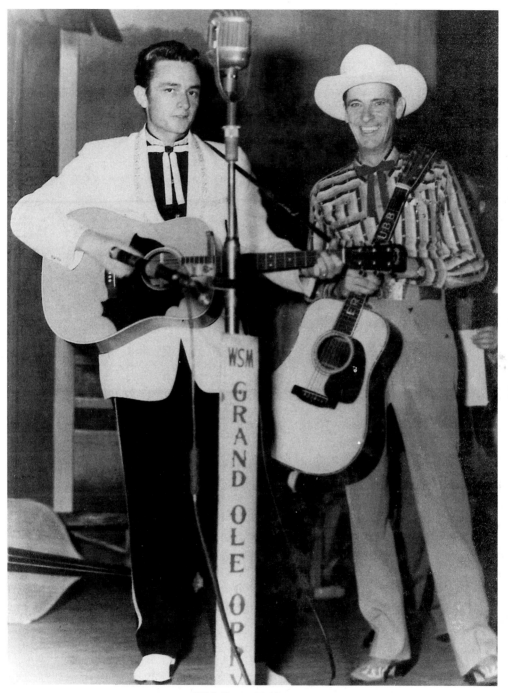

With Ernest Tubb, 1956.
My mother made the suit.
That's the only reason for a white coat.

On the road, backstage with Elvis

From the movie *Five Minutes to Live* (a.k.a. *Door-to-Door Maniac*) with Cay Forrester, 1961

Johnny Cash and the Carter Family Show, in the 1970s. From left to right, Luther, W. S. "Fluke," Marshall, Maybelle, Helen, me, Anita, June, Harold, Phil, Don, and Lew.

From the "Ride This Train" session at Gene Autry's movie ranch, 1959

"Johnny Reb"

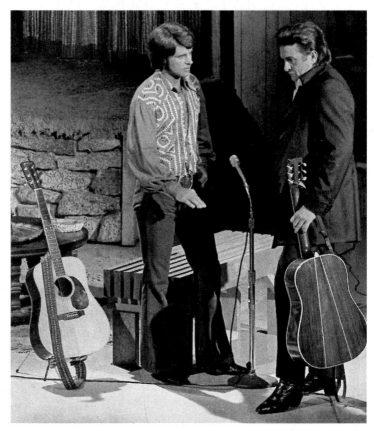

With Rick Nelson, 1969

Carl Perkins, W. S. Holland, and me, 1970

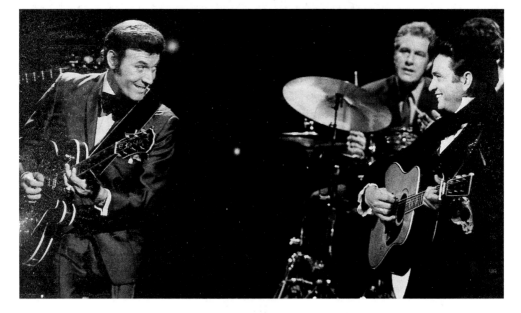

"You think I should?"

"Yes, I think you should."

"Well, let's have one more drink before I do."

They got themselves another drink, and Gene settled down again, not making a move. Finally, Merle couldn't stand it.

"Gene, come on. Come on and go out on the balcony and wave to those people!"

Gene bestirred himself. "By God, I will!" he said, and strode to the balcony. He got out there and whipped off his hat, and the noise exploded. He waved the hat toward the people to his left, and hundreds of thousands of voices roared and screamed. He waved the hat to his right, and a million more yelled even louder. It was amazing. The din was stupendous. Then he replaced his hat, turned around, came back into the room, poured himself a fresh glass of whiskey, and sat down.

Gene finished his drink in silence and poured another. He was almost through with that one when he said, "Travis, you know something?"

"What's that, Gene?"

"Damn Irishmen love me."

Legends and lies, fools and drunks, old friends and angels. They all belong in this book. My worry is that I'll leave some out that should be in. An awful lot of people have been important in my life.

Johnny Horton, there's a name. He was another friend like Carl and Roy, more of a brother than just a man I knew and liked. I met him at the Hayride, from which he'd refused to graduate to the Opry even after "Battle of New Orleans" was such a big hit for him in 1959, and we were drawn to each other immediately. I liked his wife, too: Billie Jean Horton, previously Billie Jean Williams, the widow Hank Williams left when he died on New Year's Day, 1953. She married Johnny after she lost Hank, and she and I stayed friends after we both lost Johnny.

He died badly but very quickly, killed in a frontal collision into which his car had hurtled at almost a hundred miles an hour. That wasn't unusual for him; he loved to drive fast. It wasn't a drinking or drugging thing with him, and in fact he was sober as a judge at the moment of his death. You could say that drinking killed him anyway, though, despite his teetotaling ways. The driver of the other car was drunk when he veered across the centerline and plowed head-on into Johnny. Tillman Franks, the Hayride bass player who'd become Johnny's manager, was in the right front seat, and Tommy Tomlinson, his guitar player, was asleep in back. They were both injured, but they survived.

I loved the words Billie put on the tombstone: *Here Lies My Husband, the Perfect Man.* So simple and, though Johnny was a human being and therefore incapable of complete perfection, so close to the truth. He really was a wonderful husband and friend, faithful and true.

He was a wonderful fisherman, too. When they called him "The Singing Fisherman," that wasn't just a catchy gimmick. He was the best. He could put that bait exactly where he wanted it. If it needed to be three inches from that one particular stump across the river, that's precisely where he'd put it. He could cast over tree limbs hanging above the water, then start reeling his lure back in and, at exactly the right moment, give it just the right jerk to make it jump over that limb and fall back into the water just so.

He and I fished together a lot, and I even had a small interest in a company he'd formed to sell a lure he'd designed. Ole Fireball, he called it, and it was indeed a ball of fire. That thing drove the bass crazy; they just couldn't stay away from it. He and I hauled in droves of them the last few times we fished together, and the same happened to everyone else who tried it, too, even if not many people got the chance to; just a few dozen fishermen in Louisiana had become Ole Fireball enthusiasts when Johnny got killed. I still have a few lures locked away in my safe. I'm tempted to try one on the bass in

Tennessee, which to my knowledge has never been done, but I'd feel awful if I lost one, and I know I surely would.

Johnny took Billie Jean fishing once for a whole year, or perhaps you could say that she took him. It was when she got her settlement check from the Hank Williams estate—just thirty-five thousand dollars, a ridiculous figure, but it paid for them to go to Alaska and fish just about every stream from there to Mexico. Hank would have approved, I think. Billie Jean's marriage to him, just three months' worth, hadn't been too happy—how could it be, with no peace in his life, just the pain and the morphine and the booze?—and though I never knew Hank, I can't imagine him begrudging Billie Jean the happiness she found with Johnny. Those two made such a great couple, and a great family. They had three daughters, Jerry, Nina, and Melody. I named an instrumental I wrote after them, "Jerry and Nina's Melody," recorded with the Tennessee Two in 1961. Melody was just a baby when her dad got killed.

He knew he was going to die. In the last few months he told me several times that it wouldn't be long. "You can count my time to live," he said. "Watch out for my little girls when I'm gone, will you?"

"Yeah, I will," I replied, "but what if I'm the first to go? Will you watch over *my* girls?"

"No," he said. "You won't be the first. I'm going to die soon. It's just a matter of days now."

And he was right. We were together in Saskatchewan when he told me that. He died less than two weeks later, when I was at the Disc Jockey Convention in Nashville the night before we were to meet in Stuttgart, Arkansas, and go duck hunting. I didn't make the trip to Stuttgart; his ended on that road in Texas.

Johnny didn't know just that his death was coming. He also knew it was going to be sudden and violent, and he thought that most likely it would happen on the road—which raises interesting questions, to say the least. I don't have the answers to any of them, but I do believe there's no chance that he willed his death. There wasn't any darkness about him.

He was into autosuggestion, though, and he'd use it to hypnotize me. He'd tell me that I was going to relax so completely that I couldn't raise my right hand, and when I was into it he'd say, "Now you're so relaxed you can't even move. You can't even raise your hands. You absolutely cannot raise your right hand. Try to raise it. You can't." And I couldn't. I was perfectly alert, quite aware of what was going on around me—this wasn't deep-trance stuff—but there was nothing I could do to raise my own hand. Once I was in that state, Johnny would start opening up my memory to me. That's how I was able to complete the writing of "I'd Still Be There," the song I heard Webb Pierce singing in a dream.

I'd written some of it down as soon as I awoke, but I hadn't been able to remember the whole thing, and I told Johnny that. He hypnotized me, then said, "Okay, get out your pencil and paper now. We're going into your mind, back into that dream." I went there, listened to Webb sing the lines I was missing, wrote it all down as fast as I could, and had the song. It was pretty good, one of the forty or fifty you hear for every really great one that comes along: good enough to record, but not the kind of song that stays with people, not one of the titles I hear called out every night I take the stage. It sounded so much more like a Webb Pierce song than a Johnny Cash song that I was afraid Webb would cover me on it, but he didn't. It just sat there on the "B" side of "Ring of Fire" and began to be forgotten (or was never heard in the first place).

From Johnny I learned how to hypnotize myself, and these days I use that knowledge when I'm in pain. It's not a technique that has anything to do with the occult—I've never dabbled in the paranormal or had anything but an average amount of idle curiosity about that whole spectrum of experience—but it is a spiritual kind of technique, a way of traveling into myself to find God's peace.

I find a place where I know I'm not going to be disturbed, sit down, go quiet, and then count down slowly from ten to one. That takes me away to where the pain can't follow. It's a very specific place, chosen

because I think of it as the most beautiful environment I've ever experienced on this earth: a little spit of sandy ground in Alaska where two pristine creeks, Painter Creek and Salmon Creek, come together. I can sit on that ground and feel the sand between my toes and taste the salt in the air on my lips. The wind's blowing in from the sea, the Gulf of Alaska just a few miles away. About a hundred yards up the bank of Painter Creek, peeking out from behind a grove of trees, I can see one wing of the little float plane that brought me here. Salmon are jumping, and a beaver splashes into the water and swims across the creek, then dives beneath the opposite bank to the entrance of his lodge. I see seven wild ducks—always seven; I count them every time. The sun is warm on my skin. The air is crisp. Somewhere out on one of the Aleutian islands, a volcano is active, and I watch the faraway streak of smoke it sends into the air and think about how the water in Painter Creek comes from a volcano, too, inland from where I sit. This is water purified by fire; this is a place so clean and right and elemental that it feels sacred.

In my mind's eye I stand up and music starts playing—that began about a year ago; before, there were just the sounds of nature—and it continues as I walk, barefoot, over the sandy ground and then across patches of little pebbles which hurt my feet, up the bank of the creek toward the airplane. A male voice, I don't know whose, is singing "You'll Never Walk Alone" accompanied by a full-orchestral arrangement of very great skill and beauty. The song of course has meaning.

The song ends and I stop, then turn around to retrace my steps, and it begins again, so that when I get back to the meeting place of the two creeks, I've heard it twice all the way through. That takes about ten minutes. Ten minutes in beauty, beyond pain.

What's happened here is that only my body feels pain, not my spirit, and in going with my spirit to Alaska I've left my body behind. The next step, I think, is to take the pain with me and leave it there. Bury it by Painter Creek. Leave it with God.

8

We did okay at the Fillmore. We all pulled in the same direction through "Rusty Cage" and put it across without embarrassment, even with spirit, and the crowd liked us, and I liked that. I love playing for country people, with their graciousness and quiet appreciation, but I also thrive on the blast of raw adrenaline coming at me from a charged-up crowd of city kids (or, more accurately, people in young adulthood who have chosen the intensity of a city like San Francisco—not, of course, that there *are* any cities like San Francisco). A crowd like that can get a pretty good show out of me, and last night they did. It was tiring, especially so since the preshow ritual of meeting and greeting was unusually protracted, featuring people from my publishers and my record company as well as the usual complement of friends, music business acquaintances, and local radio personalities who come to me wherever my show rolls into town.

Tonight I stood there in that funky little dressing room, doing exactly what so many musicians have done ever since Bill Graham got the place cranked up back in the Summer of Love. I felt like an impostor playing a king receiving courtiers—but I felt, too, like just a man meeting others. I prefer to meet people before my shows, not after. When I walk off that stage I'm no longer the character I was in the songs I sang—the stories have been told, their messages imparted—but often it's a while before I'm J.R. again. When I meet people, it's important for both of us that I'm J.R.

Exhaustion is calling now, though the energy from the show still runs in me. That's a vaguely uncomfortable sensation even after the thousands of times I've experienced it, but I know there's nothing really wrong. Tonight was good. I did well. The band did well. I like my band; we fit. When we're all doing our job, we can sound exactly the way my music should.

As Unit One climbs away from the Fillmore toward Nob Hill, I hear Bob Wootton's voice from up front, talking navigation with Vicki, and I start thinking about him, thinking about guitar players and me.

I haven't worked with many of them, but I sure have liked the ones who stuck, particularly Bob, Marty Stuart, and of course Luther. Carl Perkins also played guitar in my band for several years, but I hesitate to call him "my guitar player." I loved having him with me on the road and he was an amazing opening act, but I was never very comfortable having him standing behind me on stage, literally in my shadow. He is after all *Carl Perkins*. I'm not well enough acquainted with the field to know whether music historians and rock 'n' roll fans celebrate Carl the way they should today, but if a hundred years from now he's not recognized as a great master and prime mover, somebody will have messed up badly.

There's certainly a sense that Carl stands in the shadow of Elvis, Jerry Lee, and me. You can see that when people talk or write about the so-called Million-Dollar Quartet session, the only time to my knowledge that all four of us sang together. Somehow Carl's name always

seems to come last in the list of participants, but in fact it was *his* session that day. Nobody else was booked into the studio. I was there—I was the first to arrive and the last to leave, contrary to what has been written—but I was just there to watch Carl record, which he did until mid-afternoon, when Elvis came in with his girlfriend.

At that point the session stopped and we all started laughing and cutting up together. Then Elvis sat down at the piano, and we started singing gospel songs we all knew, then some Bill Monroe songs. Elvis wanted to hear songs Bill had written besides "Blue Moon of Kentucky," and I knew the whole repertoire. So, again contrary to what some people have written, my voice *is* on the tape. It's not obvious, because I was farthest away from the mike and I was singing a lot higher than I usually did in order to stay in key with Elvis, but I guarantee you, I'm there. I forget exactly when Jerry Lee came in, but I remember clearly when Elvis invited him to take over at the piano and he launched into "Vacation in Heaven." That was the first time I ever heard Jerry Lee, and I was bowled over. He was so great that the next thing I remember, Elvis and his girlfriend were gone. The thing I remember after that, apart from going next door for coffee and cheeseburgers, is seeing the now famous "Million-Dollar Quartet" photo in the *Memphis Commercial Appeal* and wondering what happened to Elvis's girlfriend. She'd been sitting on the piano when the photo was taken.

If you're wondering why Elvis left right after Jerry Lee got started, the answer is simple: nobody, not even Elvis, ever wanted to follow Jerry Lee. And no, I don't remember Jerry Lee ever saying anything disparaging about Elvis. He didn't have an attitude about Elvis especially; he just had an attitude.

Now that I've contributed that grist to the rockabilly history mill, I'll add an opinion—Carl Perkins is the Rockabilly King—and get back to the subject of people I *can* call my guitar players, beginning at the beginning: Luther Monroe Perkins.

He was a gracious man, about five years older than me. He was a good driver, and he enjoyed it; he'd stay up at the wheel all night, not

making a sound, while I crashed in the backseat of the Plymouth, then the Lincoln, then the others. When I first met him, in 1954, he had a Fender Telecaster that had lost the plate where the heel of your hand rests and a little Fender amplifier with an eight-inch speaker, the rig he used on my records at Sun, laying his right hand on the strings to mute them as he played. That's where *boom-chicka-boom* came from, Luther's right hand.

As I've said before, Luther wasn't anything like an expert musician and sometimes it would take him quite some time to learn a new song, but once he had it, it was locked in. He'd never alter his part, either to change it radically or embellish it slightly; he always played it straight down the line, and it always, always sounded right. It was unorthodox, the way we worked it so that his guitar line matched my vocal, but it was effective and people liked it. Once the records started getting around, guitarists all over the world began copying the Luther Perkins style, and he became a kind of cult hero. Keith Richards came to one of our English shows, at a U.S. military base in the early '60s, but he wasn't interested in me; Luther was the one he couldn't wait to watch.

Luther accepted it all very politely once he understood that these people weren't making fun of him, and it never went to his head. He knew his style was unique, but also that it originated in his technical limitations—which is often the story of original sounds in popular music, even if some of us aren't comfortable having it go down in history that way.

Luther was a very tolerant man in the usual course of things. I have a clear memory of him during the time when my amphetamine insanity was expressing itself in destructive acts. As I chopped a new doorway through the wall between my motel room and Marshall Grant's with a fire ax, he just sat and watched, grinning and saying, in a tone of genuine wonderment, "Well, I'll be damned. I'll just be damned."

He did have a temper, though, and he did express it. A fair number of amps got kicked in frustration over the years, and often the air

around him filled up with curses. He had it under control a little better than I did, but we shared that edge of nervousness.

In my very worst times, Luther's house was one of the ports in my storm. I could go over there at any hour of the night, and Luther and his wife, Margie, would get up and make coffee, listen to me, and try to make me feel okay. Dixie Dean, who'd just arrived from England and was to become Tom T. Hall's wife, was another person who extended that kindness to me. It was during such an act of mercy that she played me a demo of Tom singing "I Wash My Face in the Morning Dew," his first record, and I realized what a great gift he was going to be sharing with us all. Well, perhaps not with me; by that time I had my doubts about my staying in this world much longer.

Luther passed on in 1968, the victim of another house fire on Old Hickory Lake. My belief is that he went to sleep on the couch with a lit cigarette in his hand and was overcome by smoke. When Margie found him, there was a catfish in the sink in the kitchen and a note saying, "See, I told you I could catch catfish." She'd been telling him that the trot line he'd run out into the lake would never work, but obviously it had, and he was pleased about it. That doesn't sound like the final act of a man about to kill himself, which is what the police said they suspected—that or "foul play."

Luther didn't die right away, but we knew he was going to. When Marshall and Carl Perkins and I went down to the hospital, one of the doctors came out and said, "Well, he looks good. He's in good shape, if he'd only wake up." We knew that wasn't the deal as soon as we saw him; it hit each of us immediately that he was as good as gone.

The only good thing to come of the loss of Luther, I believe, was Bob Wootton. After showing up that night in Oklahoma the way he did—dropping out of the sky, it seemed, just when we needed him, ready and able to play every song in my repertoire note for note exactly as Luther had recorded it—he stepped right in and came as close as any man could to filling the hole Luther had left.

9

Thinking about Marty Stuart, who played in my band for several years just before launching his solo career, always cheers me up. Marty cheers *everyone* up. He's one of those characters who has an electric kind of effect on the people around them. He's not so much a power source as a power booster and a connector, a unit that fires up the creative energies in a group of people, puts them all together, and gets the power flowing in the direction it really wants to go. That's not his only talent, of course; he's also a master musician in every sense of the word, an artist in his own clear right. He's funny, good-looking, and he knows exactly how to dress and act and present himself. He's kind of amazing, really.

More than that, he's a person country music really needs, not just because he's got such a great collection—all those country music artifacts he's found, rescued, bought, and traded for over twenty-plus

years—but because he's a tale-teller. He carries stories, he builds legends about people, and he *knows*—knows everybody in the business and what they mean to the music, knows the history of the music, knows what's important and what isn't.

I don't remember exactly where or when I first met him. It was probably when he was playing mandolin in Lester Flatt's band, which he joined when he was just thirteen. I remember when I hired him, though. He came to one of my shows when he was in his early twenties and showed me what he could do with his guitar. I took him off the market immediately.

He became much more than the multi-instrumentalist in the band. He was a great public relations man, a great soother of conflict, a great key to the musical resources of Nashville and beyond. He knew where to look for the good songs, the good pickers, the good studios, everything, and of course he was a great man to have on hand in a recording session. He could play *anything*. And as if all that weren't enough, he loved his mother. He still does: Hilda Stuart, a beautiful woman.

Just as Marty has a favorite story about almost everybody in country music, we have our favorite stories about him. Mine, though, is really more about myself. It centers on a guitar he had, a horribly scruffy, beat-up old thing, worse looking than even Willie Nelson's infamous instrument. It was probably a wonderful guitar, one of the best Martins ever made—he certainly treasured it as if it were—but its ugliness was beyond dispute. I took exception to it.

One night on stage somewhere in Minnesota, I stopped in the middle of the show and told the audience, "You know, Marty Stuart started in this business when he was twelve years old. Mr. Lester Flatt hired him and saw that he was a young man who could go far. Marty really appreciated that, so ever since then, at least once a year, he has tried to pick out a twelve- or thirteen-year-old boy and do something nice, the way Lester did for him."

As I said all this, I had my eye on just such a person, a boy sitting in the front row.

I took the plunge. "There's a young man sitting in the front row tonight," I said, "and Marty would like to give that young man his guitar."

Before Marty could do a thing about it, I took that ugly guitar away from him and held it out to the boy in the front row. The boy couldn't believe it. He was so happy. He got up and went over to Marty and hugged him, thanking him repeatedly. Eventually he let go, and I shook his hand before he left the stage. "Learn to pick it, son," I told him. "Learn to pick it like Marty."

I looked over at Marty and his face was scarlet with anger. I thought for a moment he was really going to lose it. I just kept looking at him. I held his eye and started grinning, and then his face broke and he started grinning back.

Marty has such a great wit. He was playing outdoors at a state fair one night, decked out in one of his louder, more beautiful Manuel outfits, all vivid colors and sparkling rhinestones. As it happened, the stage was close to an enormous, fully lit Ferris wheel looming over one side of the concert ground. About halfway through his show he sauntered up to the mike between numbers. "Don't y'all be concerned if you see me keep kinda leaning over to the left tonight," he drawled. "I keep getting pulled that way." Then he pointed up at the Ferris wheel. "My suit thinks that's its mother."

Marty knows me well. Once when he was still working for me, he came up to me and asked, "Are you taking pain pills?"

"No, not yet," I replied.

He looked at me and grinned. "Does your foot hurt?" he asked.

I raised my left foot and stamped it down onto my right. "It does now," I said, and took a pill.

The time came for Marty to go out on his own, as we all knew it would. Even before he came to the decision himself, we were prodding him: "Hey, Marty, who're you gonna take to open your show?" "Better

enjoy that paycheck, Stuart. You're gonna be the one giving them out before long." Eventually he got to where he needed to be about it all and came to me one night. "Do you think it's time for me to make a move?" he asked. Only he knew that, I told him, but in my eyes he was ready. I told him that if he made the decision to go for his own career, the first thing he'd have to do was stop making Johnny Cash his number-one priority. And that's how he left, under his own steam with my thanks and blessings.

He's been back, of course, from time to time. He was a vital component of my *Unchained* album, acting in the studio as the link between me and my world and the musical language Tom Petty and the Heartbreakers speak. That's by no means a long-distance link, since Tom and his band and I have known each other a long time (they're family, in fact: Howie Epstein and Carlene have been living together for years), but neither is it so close that it couldn't be strengthened by Marty's fluency in all the American musical languages. He did really well in those sessions. So did Tom and the Heartbreakers. Making that album was the best kind of fun.

Marty, as some of you may know, was once married to my daughter Cindy, though now he's not. It doesn't matter to me. He's still my friend and he always was. I'm like that with my sons-in-law, or at least I'm like that with the ones I like. Long ago I took the position that the marital affairs of our family's younger generation(s)—all of them, including June's girls and the ever-growing corps of grandchildren—are no business of mine. When Cindy and Marty divorced and I started hearing stories about who did what to whom, I turned a deaf ear. I wanted no part of it. As I told Cindy once, "I didn't recommend that you people get married, I didn't bring you together, and I'm not the reason you're divorcing." It's not that I couldn't see problems in their marriage or that I didn't feel for them; it's just that I didn't want their troubles. *Don't give me your troubles, I've got troubles of my own . . .*

The same went for Carlene and Nick Lowe, and Rosanne and Rodney Crowell. I always liked both those men, and I still do. They're

friends of mine and friends of the family, and that's absolutely no problem between Carlene and Rosanne and me. Just imagine the mess if it were any other way. Also, we're talking about a lot of people, and not just any old people, either. If you could corral my collection of sons-in-law, present and past, onto one record label, you'd have the best roster in town, plus all the great songs you could ever need and a band to burn the house down. Add my daughters, June's daughters, and our son, and you could just tell your stockholders to retire right there and then. Isn't bragging about your kids a pleasure? It's about one of the best feelings life offers.

When Marty left to go on his own I hired Kerry Marks, a very fine guitarist who now plays lead in the *Prime Time Country* band on TNN. He stepped right in and came about as close as anybody could to filling the hole Marty had left.

Waylon Jennings even played guitar for me once. I was booked to play five days in a theater in Toronto, but Bob got sick at the last minute and there I was, up the creek. I *really* didn't want to cancel the dates, but I had no idea who might be able to fill in for Bob. Was there even anyone who knew my material well enough? I didn't have an answer for that question because I'd never been plugged into the music scene in Nashville. I'm still not—less than ever in fact—but on the other hand, I knew someone who was. Waylon, my dear old friend and former roommate, knew every picker in town and just what each of them could and couldn't do. I called. He answered. He'd get right on it, he said.

He called me back the next day and said, "I found you a good guitar player."

"Who's that?" I asked.

"Me," he said.

"No, no, no," I said. "You're kidding. You can't do that. I can't have *you* playing guitar for me. That's just not right, a star of your magnitude standing out there playing guitar for me."

He wouldn't bend. "Well, Hoss, I'm going with you. I'm going to be there. I'm off the next five days, so I'm going to play guitar for you in Toronto, and that's all there is to it. I ain't going to be great, but I'll do the best I can."

I took him up on it, thankfully, on the condition that we'd do a couple of duets together in addition to my regular show.

It went really well. When we got on stage in Toronto, I had him stand way back out of the lights for the first few songs, then gradually move forward a little at a time. As he began to emerge, people started noticing that it wasn't Bob up there. Then they saw something familiar about the man, the way he stood, the way he moved, the way he held his guitar. They started nudging each other, whispering and pointing. I could see them, and it was fun. Finally he was fully lit, and even the people who couldn't make out his face could see the black-and-white tooled-leather Telecaster that'll always shout *WAYLON!!* to country music fans.

At that point I confirmed it. "Well, you're right," I said into the mike. "I've got the greatest guitar player in the world on stage tonight. This is Waylon Jennings."

When the applause died down, he stepped forward and we talked a little, telling the story of how he came to be on my stage, and then we carried on with the show. And so it went for almost a whole week.

Waylon hung in there every night, and when it was over he wouldn't take a penny for it.

That all says something about the kind of friend Waylon has been to me. Put simply, he's another of my brothers. I keep looking for something good to do for him sometime. The thing about it is, I know that if either one of us is hurt or in trouble, we can call on each other. We both feel that bond, even though we haven't talked in a while. We know that we're still almost blood brothers. Our friendship has had some rough spots, some ups and downs, things that could have tested it and even ended it, but I think as kindly of Waylon today as I ever did. We both have good reasons to be cranky—we've suffered a lot, him

with his carpal tunnel syndrome, me with my jaw, both of us with major heart problems—but I'm sure that the next time I hear his voice on the phone, it'll be like it's always been: no complaints about how long it's been, just "What are you doing, John?"

"Nothing much, Waylon. Want to come over?"

10

We're edging into the heart of winter now, and I'm in Texas. Unit One is rolling, eating up an endless undulating double strip of blacktop through the scrubby high-plains country northwest of Dallas, a landscape of worn, low hills, stunted trees, and life lived close to the bone without much to spare either in nature or in the human sphere. You can't grow much of anything in the soil, and if there ever was any money in these parts, it seems to have been blown away by the winds coming down off the Great Plains all the way from Canada or to have drained off into the magnetic field of the wealth in Dallas and Fort Worth. You can drive for a hundred miles here, up toward Oklahoma and the Panhandle, as we've just done, and see nothing along the highway except truck stops and mobile homes.

I've been places since I was in California. I've been to Chicago, I've been to Toronto, I've been to New York. I've been to Philadelphia, I've

been here, I've been there. I've even been home once or twice. I haven't been to London to see the queen, exactly (I won't see Europe until the spring), but I've done the American equivalent: I've been to Washington and seen Mr. Clinton. They got me up there to present me with a Kennedy Center Award and, apart from being exhausting and dangerous for my ego, that was very gratifying, a big deal. It was quite wonderful, sitting there with the president of the United States and the first lady as my famous friends and family honored me from the stage, on TV, in front of an audience of the most powerful people in the world. Every time somebody said something really nice and deeply flat-tering about me, which was quite often, they'd all look straight at me and applaud.

Wouldn't that turn *your* head? Luckily, as all that praise and admiration washed toward me, I kept thinking about something Ernest Tubb told me in 1955, the first time I met him. That was a big-deal night, too. I'd just encored on the Grand Ole Opry several times and now I was meeting Ernest Tubb, the Texas Troubadour, live and in person! He looked straight at me and told me in that grand, gravelly voice I'd been hearing on the radio, "Just remember this, son. The higher up the ladder you get, the brighter your ass shines."

The day after the Kennedy Center show, I came further down to earth when my daughters got together with me and voiced some very deep feelings they'd had for a very long time—told me things, that is, about the lives of girls whose daddy abandoned them for a drug. That was very hard.

Now I've got a cold progressing into something more serious. The inside of my head feels just like the gray sky on the other side of the bus window. Next up, fever and laryngitis. When it gets like this they quit trying to figure out its component parts and call it "exhaustion."

And Faron killed himself. That's been the news the last couple of days. Faron—nobody who knows country music needs to add the surname, Young—shot himself, lingered a while in a coma, and then slipped away from us. He'd had serious health problems, and emo-

tional problems too, and of course he drank a lot. June and I really loved him.

He left behind a thousand outrageous stories, because he really was as colorful a character as they say he was, but at this moment my strongest memory of him is from one Christmas a few years ago when I talked to him before the big day and asked him his plans. Oh, he said, he guessed he'd just stay home and cook himself an omelet or something. We made him come over to our house for the big family Christmas we always have—and we've got some family, so it really is *big*—and that day he was a prince. He could be so nice, such a dear and gentle man.

We were sad when he died, but not terribly surprised. Over his last ten years or so June and I had been to visit him in the hospital more than once—I'd gone by myself, too—and we'd talked to him about alcohol. I'd tell him he had to get off it or he was going to die, but he'd come back with, "Didn't you ever hear my song, 'Live Fast, Love Hard, Die Young'?" I'd say "Sure, but you're not taking that seriously, are you?" and he'd admit that, no, it was just brave talk. My last contact with him was a message that he was sick and to please call. I did, but there was no answer at the number I was given, and then I had to leave, get on the road again, and I never followed it up.

Faron's birthday was the day before mine and Liz Taylor's is the day after. Over the years he and I had a lot of fun with that. He'd call me or I'd call him, and we'd talk about Liz Taylor. And even after I actually got to know Liz and started exchanging birthday greetings with her, too, we kept that up. So now, I guess, every time I get that birthday card from Liz I'll think of Faron Young. Even loving him the way I did, I believe I'd prefer to think about Liz Taylor.

There are thousands of stories about him. People in the business will be telling them for years to come, just as they have been for decades past, and doubtless some of them will filter out to a wider audience. I'm not in the mood to get hilarious, though, so I'll share just one in the hope of conveying how far out Faron could get.

We were on our first tour together, checking into a motel in Birmingham, Alabama, when he decided to do something. The doorman and the bellmen at this motel were wearing white gloves. Faron glanced at them, then went over to the counter and started pounding on it, demanding to see the manager. Somebody went and found him.

"Yes, sir, can I help you?"

Faron snorted. "Why—*why*—have you got those bellmen and that doorman wearing those white gloves?" he demanded. "They've got to handle all that dirty luggage. This is the most terrible thing. You people are so unkind, making those bellmen and that doorman wear those gloves when they have to get so much *dirt* on them! What do you do when that happens? Do you *fire* them when their gloves get dirty?"

"Well, no, sir, of course we don't."

"You're lying. I bet you do. I bet you fire those people!"

The manager was completely at a loss. He couldn't figure out how to deal with this. Who could? Faron didn't let up, either. He was still raving at the poor man when I hurried off to my room, glad to be away from it.

I got him pretty well one time, in the area of profanity. He was in the hospital after a car accident in which—don't ask me how—his tongue had ended up wrapped around the steering wheel, which had just about separated it from his mouth; they said it was hanging by a thread when they brought him in. Which was very strange, since just a couple of weeks before the accident I'd told him, "Faron, if you don't stop talking filthy, God is going to jerk the tongue out of your head."

There he lay, then, with his face all swollen up and his mouth full of stitches and dressings. I just strolled up to him, grinned, and said, "Say 'shit,' Faron."

"*Huttthhhh Guuuooo.*" I guessed he might be trying to say something ending in "you."

Faron is one I really will miss.

* * *

We're in Wichita Falls now, and I almost made it. We're actually parked at the backstage entrance of the auditorium, with our equipment set up on stage and people starting to come in through the doors, taking their seats. I can't do it, though. I've got a temperature, my head is congested, my throat is closing up, and I'm weak and dizzy.

I'm giving up. I just told Lou, my manager, to cancel the show and start the process of giving the people back their money, and he's gone off to do that. He didn't argue, as many managers might have. He's known me well enough for long enough to have it clear that I don't cancel shows frivolously (and never have), that for me it's a very big deal. We'll be sure to come back here and make this date up to the fans I've disappointed. Now I need to get this bus turned around, head it back to the airport, and take a flight to Tennessee.

I love the road. I love being a gypsy. In some important ways I live for it, and in other ways it keeps me alive. If I couldn't keep traveling the world and singing my songs to real live people who want to hear them, I think I might just sit myself down in front of a TV and start to die. Right now, though, *this* road goes no farther. I've given it everything I've got, but it wants more, so that's enough. I'm going home.

Sometimes you have to surrender so that when your time comes, you can fight again—or in my case, play again. For ultimately, even with its little hardships and major challenges, that's what the road really means to me. It's adventure, companionship, creativity, freedom. It's the voice of a very old, beloved friend, perhaps a boy back in Arkansas or a young man in Memphis, still fresh and clear despite the years, calling: "Come on, J.R., let's go *play!*"

PART 3

Port Richey

1

A postscript about Faron. His wishes were that he be cremated and his ashes scattered over Old Hickory Lake, so shortly after the funeral we got a call from his son Robin. He wanted to come out to the house, have a small ceremony, and release the ashes into the lake from our boat dock. We said that would be fine and that we'd be honored. My only regret was that I'd be gone on tour.

The day came and the ceremony proceeded as planned, up to the point where some of the ashes were to be scattered on a semiformal part of our garden that we'd decided to dedicate to Faron, with a small brass plaque in his memory.

Things went a little wrong (or right, depending on how you look at it; Faron himself probably would have loved it). Just as the ashes emerged from the urn, at *exactly* the crucial moment, a sudden gust of wind came up and blew them back into the yard toward the mourners.

There they were with Faron in their faces, Faron on their coats, Faron on their shoes, Faron in their hair. Later, when I came home and got in my car, I found I had Faron on my windshield, too. I turned the wipers on. There he went, back and forth, back and forth, until he was all gone.

Today I'm in Florida with June at the little house she inherited from her parents, Ezra and Maybelle Carter. Ezra was the brother of A. P. Carter, leader of the original Carter Family, which has been hailed as "the first family of American folk music." I dedicated *Man in Black* to the memory of Ezra, who died in 1975. Maybelle, whose singing and musicianship were so important to the group's sound, followed him in 1978. I became their friend in 1962, when June and the '60s version of the Carter Family joined my show.

Their house is in Port Richey, a community identified by *Consumer Reports* in 1961 as the best and cheapest place to live in the whole United States. That's what prompted Ezra, or Pop Carter as we all called him, to come looking for property, find this house on the river, and begin negotiating. After about a year he'd talked the owner into a good deal.

Naturally, many other citizens followed the beacon lit by *Consumer Reports,* and in short order Port Richey began growing at such an explosive rate that very soon it lost many of the qualities that made it so desirable in the first place. These days it's just one in a string of little coastal towns that have blended into a solidly urbanized strip running forty miles, north to south, between U.S. 19 and the Gulf of Mexico. The highway is so clogged with traffic most of the time that people talk about it the way Californians talk about earthquakes or New Yorkers talk about crime, and in some of the souvenir shops you can buy T-shirts boasting *I Survived U.S. 19.*

Still, once you're on our little street, on Pop Carter's front porch with the river right across the pavement from you and your boat bobbing at the dock, waiting to zoom you out into the open waters of the

Gulf just a few hundred yards away, all that stuff could be in another country. Here you have the tide, the meeting of fresh water with salt, the seabirds and marsh birds and land birds. The weather cooks up its sudden subtropical tempests out over the horizon or, on the landward side, takes the whole afternoon to build one of those immense, imposing fortresses of thunderheads, and then, as afternoon begins its long transition to evening, turns the whole towering edifice purple-gray and brings it all tumbling and crashing down on you, transforming everything into wind and water. Mostly that's a summer treat, so I don't experience it very often, for like other nonnatives with enough money and sense, we go elsewhere during Florida's months of eighty percent humidity. Whenever I see it, though, it always makes me marvel: at the sheer scale, power, beauty, and complexity of God's creation, at the simplicity and strength of my human root in nature.

The house itself is quiet and comfortable, and it's not at all grand in the manner of Cinnamon Hill or our main home on Old Hickory Lake. It's just a regular Florida family bungalow from the early part of this century—1912, I believe—wood-framed, with painted clapboard and a big screened porch in front. It reminds me a lot of the farmhouses you see in the hotter, more northerly parts of Australia. Unlike out there, though, our neighbors here are close. Next door is only twenty feet away. That helps us feel less like celebrities, and the people in the neighborhood help in that regard, too. They're friendly, but they allow us our peace and quiet. Strangers knock on our door sometimes, wanting to say hello or get an autograph, but not often enough to bother us.

The house inside is a maze. The rooms aren't very big, and most of them are decorated and furnished very much like they were in Pop and Maybelle's day, with many of Pop and Maybelle's things still in place. Which is good; it feels right to have such a palpable connection to them and their days. At times when our money has gotten tight, we've seriously considered selling the place (as we have Cinnamon Hill), but we've never absolutely had to, and I'm glad we've always decided to keep it. It belongs in the family.

The same goes for the Carter Family house in Maces Springs, Virginia, which we bought from June's Aunt Theda about fifteen years ago. June, John Carter, and I own it now. We've updated the paint, the electrical system, and the heat and air-conditioning and added another bathroom, but apart from that we're keeping it as close to original as possible. It's on the Virginia Registry of Historic Homes because it's where Maybelle Carter lived and June Carter was born. It has its own special feeling: a simple white house sitting on the side of Clinch Mountain, with a spring-fed stream running through the yard and boxwoods clustered around it. It smells wonderful there, and the water is cold and pure and good.

Down the road about a mile from the house is the Carter Family Fold, built by A.P.'s son Joe Carter and daughter Jeanette and two of their offspring, Dale Jett and Rita, with contributions of all kinds from various other members, relatives, and friends of the Carter clan. It's a performance facility dedicated to mountain music: a stage with its back to the road and seating for a thousand or so tiered up the side of the hill. Every Saturday night, fans of traditional acoustic music, which today is a very healthy, thriving art, fill the place up to hear the bands and watch the cloggers. In that part of Virginia they do a kind of clogging they call flat-footing, which is a little different from anything else and looks like a lot of fun. People of all ages get into it, down to two- and three-year-olds, and it brings big smiles to all their faces. You can have a pretty good time at the Carter Family Fold— and yes, that's a commercial. Jeanette gets a small grant from the Rockefeller Foundation and I do a free show there once a year, but what really keeps the place alive, and thereby helps musicians keep working in the rich and beautiful traditions of mountain music, is people coming through the doors. So go there. You'll have a good time. I sure do. On my last visit I saw the Red Clay Ramblers, and they were great.

I have special status there: mine is the only musical unit allowed to use amplified instruments. I get away with it on the grounds, a little

dubious I think, that I was already plugged in when June met me. I'm not about to argue. The last time I played there I didn't even bring Bob and Fluke and the boys; it was just June and me with acoustic instruments and the band that was booked in there, which worked out really well. They backed me up on practically anything I wanted to do: my own songs, a Carter Family song, a Bayles Brothers song, a Merle Travis song, a Bill Monroe song, a Bradley Kincaid song. My kind of music.

I grew up on the Carter Family. Beginning in 1927, when they made their first recordings for Ralph Peer, a talent scout for the Victor Recording Company of New York, in an improvised studio in Bristol, Tennessee, their music filled the air in the South (and elsewhere). It's difficult, in fact, to overemphasize their importance and influence in American country, folk, and pop music. Their albums, the first to popularize Southern folk music on a large scale, were a mixture of original compositions and songs collected from rural communities and reworked by the group's original leader, A. P. Carter. Many of them became permanent pieces of the heart of country and folk music and are still performed and recorded today—even more often, perhaps, than they were in the original Carter Family's heyday: "Keep on the Sunny Side," "Bury Me Under the Weeping Willow," "I'm Thinking Tonight of My Blue Eyes," "Hello, Stranger," "Worried Man Blues," "Wildwood Flower," "Will the Circle Be Unbroken," and hundreds more.

The Carter Family's music was a major source of inspiration for the folk revival of the late 1950s and early 1960s, and today's "alternative" country movement takes its name, No Depression, from their "There'll Be No Depression in Heaven." They and Jimmie Rodgers, who auditioned for Ralph Peer that same day in Bristol, were the first great stars of country music—though unlike great stars since (and unlike Rodgers) they never saw the pot of gold at the end of that rainbow. They did better than they had when A.P. was making all his money selling fruit trees in southwestern Virginia, but they were never

rich—and anyway, the term "star" doesn't fit any of them even loosely. They were stellar makers of music, certainly, but they never wanted or participated in the kind of ego glorification at the core of the whole star concept.

The quartet that joined my show in 1962 wasn't "The Original Carter Family." That had been A.P., his wife, Sara, and Maybelle. By 1962, A.P. had passed on and Sara had retired, leaving Maybelle to carry on the family act with her girls: Helen, June, and Anita.

At this point I want to address a subject about which I've kept my mouth shut for a long time. It's been said in some circles at various times, by some of my singer friends as well as a few music critics and more than the occasional record company executive, that working with the Carter Family has been a detriment to my career. It's been implied that they and I shared stages and recordings for so many years simply because I married into the family.

Well, hogwash. It's not so, and it never was. From day one, back in '62, it was a great feeling for me to have their support out there on the stage, a great honor and opportunity. As I said, I grew up on Mother Maybelle's singing, and having her in my show was a powerful confirmation and continuation of the music I loved best. It kept me carrying on the traditions I come from, keeping the circle unbroken, and that has always been very important to me, and rewarding. Then, too, of course, I got to sing with the great Anita Carter not just once or twice or now and again in my career, but every night I walked on stage. I bet you that if you went around to the people who really *know*, the small number of musicians, singers, and fans who have heard enough to make a judgment based on all the evidence, not just the work readily available via radio and record, you'd find a fair number of them willing to endorse Anita Carter as the greatest female country singer of them all. Others might make a case for Connie Smith, but either way, that's all I have to say about *that*, and I hope it's clear enough.

Well, maybe that's not all. I should add that the main reason you can't go out and buy an Anita Carter solo recording no matter how

hard you look (the duet hits she had with Hank Snow in the early '50s don't count) is that she has always devoted her time and energy to the Carter Family, to holding it together, keeping the tradition alive. I really admire her for that. In fact, the same goes for June, and for Helen. Many times I've seen them begin to take a separate course with some record deal or other, and then say, "Well, I have to have my sisters singing with me on this," and it would end up being a Carter Family record.

About the closest any one of them ever got to making a genuine individual album was June's *Appalachian Pride*. And June, you know, is one of the most neglected artists in country music. Quite apart from being a fine singer and songwriter (her compositions include "Gone," "A Tall Lover Man," "Ring of Fire" with Merle Kilgore, and "Kneeling Drunkard's Plea" with her sisters), she's a wonderful comedienne and a very talented writer of prose. She plays guitar, mandolin, autoharp, and banjo—autoharp just like Maybelle did, and banjo in the old flailing style Uncle Dave Macon used. Moreover, she's been on stage in the heart of professional country music longer than just about any other living performer. She started at the age of nine and has spent more years on the stage than even Bill Monroe had when he died. Sadly, I think her contribution to country music will probably go underrecognized simply because she's my wife; it certainly has been up to now. That's regrettable—my only regret, in fact, about marrying her.

It's always been such fun for me, working with the Carter girls (then women, now ladies). They have an enormous storehouse of traditional songs in their heads, which I've often been able to access just by singing one line I might have remembered from somewhere. I'd put that line out and one of the Carters, most often Helen, would come back at me with the whole song. Other times I'd be taken by a whim on stage and feel like singing some old favorite of mine that I hadn't sung in years, even decades, not even one of my own songs. I'd just announce it—"I'd like to sing a song for you now that was one my

mother liked a lot, 'Life's Railway to Heaven'"—and by the second verse they'd be singing their parts right along with me, in harmony, on key, with the words down pat. They could just pull it out of the air; it was wonderful. And of course they'd been on the road forever, since they were just little girls, so they knew everything there was to know about the traveling life, the music business, the whole thing. Helen was there right at the start, literally; she was in the womb when Maybelle, Sara, and A.P. traveled down out of the mountains in A.P.'s Model A Ford to meet Ralph Peer in Bristol and record "Wildwood Flower." Covering the country with Maybelle and her girls was a wonderful way to go.

Maybelle was especially sweet to work with, the last person in the world who'd ever be a problem to anybody. She had a great attitude. If we had a thousand-mile car ride coming up, something we *really* weren't looking forward to, her approach was "Well, let's get on the road." That was her way of dealing with difficult things: *Let's do it.* The gypsy life was never better for me than it was in those years.

Mother Maybelle was a great character. She was a quiet, unassuming, good-hearted Christian woman, but she was also very worldly, and she loved to laugh. She seemed tireless, though I'm sure she wasn't. After a whole day out on the Gulf in the sun, we'd all come back to the house, hose down our rods and reels, stand them up on the porch to drain, and then more or less collapse. Not Maybelle. She'd go straight into the kitchen and start cooking. She didn't care how many people she had to cook for; if there were a dozen or more, that was fine with her, just as long as she knew how many mouths she had to feed. Ezra was like that, too. He'd be right in there with her, and then, after dinner, those two would hunker down together and play a card game they called "Don't Get Mad." I still have no idea how it worked, but it certainly got them excited. The whole house reverberated with their yelling and hollering at each other.

Maybelle was my special fishing buddy, just the right kind of friend for the times when you want to get your line in the water and sit there

and be quiet and easy until something bites. She was a worm baiter; she wasn't afraid to pick that worm up and get the hook through it, the way so many people are. It upset me that she caught more fish than I did, but then I had to drive the boat, so she got more fishing time than I did. That was my excuse, anyway.

I used to run a shrimp boat out of here, or at least I used to own one, the *Mister J.C.,* which was operated by my friend Bill Riffle. I bought it to replace his previous boat, which was neither big enough nor good enough. He'd been taking me out shrimping with him for years, so getting him a new one seemed like the best way of making sure I could still get on board with him and help out when I wanted to. I loved that. It's hard work and it can get dangerous, but it's one of those things that's another world, with its own customs and laws and language, its own unique rules about how you do things and unique reasons why. There's nothing anywhere else exactly like shrimping off the west coast of Florida.

We were after bait shrimp, not table shrimp. We'd go out at night with our lights and radio, drop our trawls and let the nets drag for a few minutes at a time, then haul them back in and dump the catch into big bins on the deck. Then we'd use an ice pick to separate out the things in the bins that were going to hurt you—moray eels, squirrel fish, anything else that would bite or stick—and throw them overboard before we put our hands in to pick out the shrimp. The variety of life I saw in those bins amazed me. I did that for years until eventually the boat started wearing out, and I did too. Shrimping has more to recommend it than picking cotton, but it's still a hard challenge to muscle and bone, even if you're doing it for pleasure.

They don't run shrimp boats out of here anymore. Sport and recreational fishermen won their fight against the shrimpers, whom they said were responsible for failing fish populations, and the state of Florida legislated them out of business. So I don't get to watch them anymore and relive all those memories. I *do* get to watch the latest

innovation, a gambling boat controversial for its size as well as what goes on aboard it—it's bigger than any vessel that's ever navigated the river mouth before. I guess I don't like it much. On the other hand, whenever I see it I can't help but imagine how it would have lit Mother Maybelle's fire if she'd lived to see it cruising out from right in her back-yard, more or less. That brings a smile.

Gambling was Maybelle's vice, but it wasn't much of one. She never played for high stakes, she never lost big, and she always enjoyed herself. Slot machines and bingo were her enthusiasms. Whenever we got into Las Vegas or Reno or Lake Tahoe, she'd head straight for the nickel slot machines and stay at it all night, but she always knew the deal. "If you could beat the house, there wouldn't be a house," she'd say.

She was a truly humble person, almost absurdly so. She never grasped how important she was to the music, how revered by everyone from Pete Seeger and Bob Dylan to Emmylou Harris and Michelle Shocked. We'd tell her time and time again, but she'd just say, "Naw, that's just stuff I did a long time ago." You'd find yourself wanting to argue with her, even getting annoyed about it, but it never did any good.

I used to try to get her to open up and tell me about some of the people she'd known and the things she'd seen, but she was very reti-cent, especially if there'd been any whiff of scandal or gossip about the people involved. When I asked her about Jimmie Rodgers, her responses were typical. I knew they'd done some recordings together in Louisville, Kentucky, in '32 or '33, as well as that first encounter in '27, so I thought that must have given her the opportunity to get to know him somewhat. I was really interested in him—for a while he was almost an obsession with me—so I asked her what kind of man he was. Did she really know him?

"Well, I guess so," she replied, reluctantly. "I worked with him a lot."

"So what did you think about him? Did you like him?"

She paused a moment. "Well, he was kind of a smart-aleck some-times."

Knowing her as I did, I concluded that Jimmie Rodgers had prob-ably made a pass at her. She'd never say it, of course, but she did fill in a little of the background.

"Well, you know, he was really sick then. He had TB and he was dying, and everybody knew it, so we all took that into consideration. He was taking drugs and drinking because of the pain, and it just made him a little bit crazy."

I switched to purely musical matters. "Did you like his guitar play-ing?"

"Oh, yes," she said, "I loved it. I played with him, and I even played guitar for him on a couple of his records, I forget which ones, when eventually he wasn't able to play the guitar himself."

What she was telling me was as significant as, say, John Lennon admitting that he had filled in on guitar for Bob Dylan on *Highway 61 Revisited* and just didn't happen to have mentioned it until now—though in purely musical, not cultural, terms, Maybelle was more influ-ential than either Lennon or Dylan. She figured out a way to pick the melody on the lower strings of her guitar while she strummed chords on the higher strings, thereby creating the most influential guitar style in country and folk music.

"Well," I queried, "Did you get along all right?"

"Oh yes, we got along fine at the recording sessions."

And that was that on the subject of Jimmie Rodgers and the Carter Family. Very frustrating.

Maybelle's husband, Ezra (Pop) Carter, was another good, solid, self-effacing country person, and he, too, was the soul of kindness and tol-erance toward me during my drug abuse. He was also a Bible scholar, a self-made theologian, and that was a significant part of the relationship he and I developed; we became pen pals, writing back and forth mostly on matters of poetry and theology. Like Maybelle, he was no hater of

fun. He was an accomplished practical joker, legendarily so among his family and friends, and he appreciated that talent in others. It was he who told me my favorite story about the Carter Family in the early days.

He, Maybelle, Sara, and A.P. were driving in the Model A Ford, encountering rough going—I believe it was when they were on their way to Bristol to meet Ralph Peer that first time—when they had a flat while fording a creek. (As Maybelle remembered it, A.P. had a flat just about every time he climbed in that car.) Tire technology wasn't what it is today; neither were road surfaces.

A.P. drove up out of that creek, cursing, and stopped the car. He and Ezra climbed out to get the patch kit and fix the tire, and as they did so, A.P.'s wallet fell out of his pocket. Sara picked it up and noticed immediately what couldn't be missed: the circular shape of a condom impressed into the leather from inside. That was a common thing back then: you carried a condom in your wallet as a signal to other men, and yourself, that you were one of the boys, a rake at the ready, whether or not you had any genuine intention of using it.

Sara understood perfectly. "Well now," she said, plucking the condom out of the wallet and holding it up for Maybelle to see. "What *does* he think he's going to do with this?" She herself had no confusion on that point. She grasped it firmly in both hands, stretched out its mouth, and rolled it over the ivory ball on the gearshift protruding from the Model A's floorboards.

"There," she said, with a brisk little nod of satisfaction.

Still fuming, A.P. came back to the car, found his wallet on the driver's seat, stuck it in his pocket, and climbed back in. Pop said he'd never forget the look on A.P.'s face when he laid his left hand on the steering wheel, depressed the clutch, and dropped his right hand onto the gearshift.

"Whoooooaaaah!!" was all he said. Then, computing instantly what must have happened, "Sara, why did you *do* that?"

"Just to let you know I knew," she said. They drove on in silence, nobody quite daring to laugh.

* * *

Maybelle finally quit the road when a Parkinson's-like tremor she'd developed grew to the point where she was afraid she'd mess up on the autoharp. She never *did* mess up. She was playing just as well as she always had, but she didn't like having to be apprehensive that way, so she retired from the stage and took to the bingo halls. She died on October 23, 1978.

Sadly, I don't think there's any hope that Anita and Helen will ever be able to rejoin my show; their health just isn't up to it. The family tradition continues, though. Rosie Carter, June's younger daughter, shares our stage frequently, as does John Carter. Others have in the past and might in the future, notably Helen's son David and Anita's daughter Lorrie. So between however many Carters we have onstage and the voices that are always there—those of Bob, Dave, and Earl— June always succeeds in doing justice to the Carter Family songs during her segment of our show. I pitch in too from time to time, but mostly I'm content—happy—to listen to the old songs of home, hers and mine, and let them take me back. I'm offstage during her portion of the show, but I always have a speaker in the dressing room and I always listen.

That's all I really have to say, for now anyway, about the Carters, except perhaps for one final note about Pop, whose chair I'm sitting in at this moment, and Maybelle, who sat with me here in this Port Richey house many a time. They were good Christian people, tolerant and kind. They were very important in my survival and recovery from the worst years of my life, which are the focus, however shifting, of the next part of my story: not just the worst years of my life, but survival, recovery, and the hope of redemption.

2 I clearly remember the first mood-altering drug to enter my body. When I was just a kid, probably eleven years old, I was wrestling at school with a friend of mine, Paul East. Paul was a big guy, with big feet in big clodhopper shoes, and in the process of rolling over, his heel caught me in the side and broke a rib. It hurt really bad at first, but after a little while it didn't hurt at all, and I had no idea my rib was broken—until, that is, I woke up in the middle of the night. I had turned over, and that rib had gone ahead and broken in two or splintered and was sticking me in the lung. The pain was terrible; every time I took a breath, I screamed.

Daddy hitched up the mules, wrapped me up in blankets and pillows, put me on the wagon, and drove me the two and a half miles to the Dyess Hospital and old Doc Hollingsworth. At that point I wasn't screaming with each breath, but only because I was working so hard

not to; the pain was still excruciating, worse than anything I'd ever felt. Doc Hollingsworth took one quick look and went straight to work. "Well, we'll stop that, right quick," he declared, giving me an injection that killed the pain just as soon as the needle went in. Not only that, but I started feeling *really* good. That's what morphine did, said Doc Hollingsworth; it worked well.

I thought, *Boy, this is really something. This is the greatest thing in the world, to make you feel so good when it was hurting so bad. I'll have to have some more of that sometime.* Strangely enough, though, I didn't think about morphine again until many years later, when I was given it for postsurgical pain. *Then* I remembered how good it felt, and in time that got to be a problem.

And as I've said before, all mood-altering drugs carry a demon called Deception. You think, *If this is so bad, why does it feel so good?* I used to tell myself, *God created this; it's got to be the greatest thing in the world.* But it's like the old saying about the wino: he starts by drinking out of the bottle, and then the bottle starts drinking out of him. The person starts by taking the drugs, but then the drugs start taking the person. That's what happened to me.

I took my first amphetamine, a little white Benzedrine tablet scored with a cross, in 1957, when I was on tour with Faron Young and Ferlin Husky, and I loved it. It increased my energy, it sharpened my wit, it banished my shyness, it improved my timing, it turned me on like electricity flowing into a light bulb. I described the new world it opened to me in *Man in Black:*

> With all the traveling I had to do, and upon reaching a city tired and weary, those pills could pep me up and make me really feel like doing a show. . . . Those white pills were just one of a variety of a dozen or more shapes and sizes. . . . They called them amphetamines, Dexedrine, Benzedrine, and Dexamyl. They had a whole bunch of nice little names for them to dress them up, and they came in all colors. If you didn't like green, you could get orange. If you didn't like orange, you could get red. And if you

really wanted to act like you were going to get weird, you could get black. Those black ones would take you all the way to California and back in a '53 Cadillac with no sleep.

And so it went. The journey into addiction has been described so often by so many people in recent years that I don't believe a blow-by-blow account of my particular path would serve any useful purpose. Perhaps in the late '50s or early '60s, it could have. Now it's just one tale among many, the details different but the pattern, the steps, the progression the same as any other addict's. So while I do have to tell you about it, I'll try to avoid being tedious. Hit just the lowlights, so to speak.

The first and perhaps the worst thing about it was that every pill I took was an attempt to regain the wonderful, natural feeling of euphoria I experienced the first time, and therefore not a single one of them, not even one among the many thousands that slowly tore me away from my family and my God and myself, ever worked. It was never as great as the first time, no matter how hard I tried to make it so.

That doesn't mean it didn't feel good, though, and for a while the pills did their job just fine without too many obvious consequences. Doctors were prescribing them freely in those days for just the reasons I said I wanted them—to drive long distances, to work late hours—and though in truth I was taking them for the feeling they gave me, I started by taking them only when I had to travel and/or do shows. People in the music business, the people I worked with, got the idea right from the start that I was high all the time, but that was only because I was high all the time when I was around *them*. In fact, in those early days I was the equivalent of what alcoholics call a "binge drinker." I don't know what addicts call it.

It felt great while I was high, but even in those first days the mornings after weren't so hot. I'd wake up and the guilt would slap me in the face. I'd remember something truly stupid I said to somebody, something insane and destructive I did. I'd realize that I'd forgotten to call

home and say goodnight to my girls. Of course, sometimes that would feel so bad that I'd have to take another pill or two just to feel okay again. The amphetamine would kick in and I'd start feeling okay, and then it would kick in a little more and I'd start feeling good, and then I'd start feeling *good,* and so on into the next cycle. Gradually the binges grew longer, the crashes worse, the periods of sobriety shorter. Everything just got ratcheted relentlessly up its scale.

It wasn't long until the crashes got really bad. As soon as I woke up, I started feeling little things in my skin, briars or wood splinters, itching so badly that I had to keep trying to pluck them out; I'd turn on the light to see them better, and they weren't there. That kept happening and got worse—they started to be alive, actually twitching and squirming in my flesh—and that was unbearable. Then I *had* to take more pills. I talked about it to other people who used amphetamines, but nobody else had the problem for the simple reason that nobody else was taking as many pills as I was. I tried cutting back a little, and it quit happening. So I thought, *Okay, I'll push my doses right up to the line, but no further.* Sometimes I managed that. Other times I'd forget— well, I never forgot; I just didn't *care*—and I'd go ahead, get as high as I wanted, and end up trying to pull little creatures out of my body.

Some people were trying to steer me away from what they could see was self-destruction. On the road there were performers like Sonny James and Jimmie C. Newman, both of whom warned me repeatedly that I was killing myself. I'd humor them. My feeling was that I knew a whole lot more about drugs than they did and about whether or not I was killing myself, and so I really didn't have to pay much attention to what they said. I went along and agreed with them, then did what I wanted.

With Vivian it was harder, just as it's difficult for me to describe now. Many parts of my life are painful to recall—this book is hard on me in that respect—but as you'd expect, my first marriage is especially tough to speak about. I've made my apologies to Vivian and tried to

redress the damage I did, and these days I don't carry any guilt about those days, so I *can* tell the stories (which wasn't always so). But still I find myself resisting. Old pain dies hard.

I met Vivian at a skating rink in San Antonio, Texas, before I shipped out overseas with the air force and began a romance that grew by mail. We wrote to each other almost every day, and as time went by more and more passion and intimacy went onto the paper—every word of mine written in green ink, a color reserved just for her. Vivian still has those letters in a trunk in her house, all but twenty-four of them; last Christmas she gave six to each of our four girls. That scared me at first, but I guess it's fitting.

By the time I came home from the air force on July 4, 1954, ex-Sergeant Cash and Miss Liberto knew two things: we were going to get married and have a family, and I was going to be a singer. She encouraged me all the way in both ambitions, even though the only singing she'd heard me do was on a disk I'd made in a booth at the railroad station in Munich for one deutsche mark—my first record, an unaccompanied rendition of Carl Smith's "Am I the One?" She wore it out. Unlike the Barbarian tapes, that one's not in the archive. "Am I the one who'll always hold you, 'til the end of time . . ." In retrospect it's strange that I chose a Carl Smith song; he was June Carter's husband at the time.

Vivian and I were married on August 7, 1954, by her uncle, Father Vincent Liberto.

Between then and mid-1955 we had a good time. Vivian would come along on the dates I'd arranged for Luther and Marshall and myself around the Memphis area in places like Lepanto and Osceola, then farther afield in Tennessee, Arkansas, and even Mississippi, and that was fun. Marshall's wife, Etta, and son, Randy, came along too, and so did Luther's wife, and we were at each other's houses all the time, a happy gang. Vivian learned to make cornbread, buttermilk, navy beans, pork chops—farmer food, the kind that'll make you fat if you're not out there plowing all day—and I began learning how to live with a wife. We were okay.

The first big problem between us began on August 5, 1955, the night I played the first big concert of my career, at the Overton Park Band Shell, with Elvis headlining. I still have the newspaper ad, framed. THE ELVIS PRESLEY SHOW was in big bold type with *Extra— Johnny Cash Sings "Cry, Cry, Cry"* down below. The show went well, and Elvis asked me to go on tour with him. I accepted and took Vivian along, as usual, and it scared her. Once she saw how women went nuts over Elvis and realized that I was heading into that world, she cooled considerably on the whole idea of my recording and touring career.

By the time our second daughter, Kathy (Kathleen), was born, I was well on my way to living the life of a rambler, and although life is a matter of choices, I didn't feel I had any control over that. Being a recording artist meant you had to tour, which meant you had to leave your family. My kids suffered—Daddy wasn't there for school plays, Fourth of July picnics, and most of the smaller but more significant events in the lives of children. Although Vivian handled it really well, being as much of a sister as a mother to the girls and taking very good care of them, my absence was a loss that can never be made up.

The pills were of course a big issue. She saw them as deadly right from the start, when she'd get up in the morning in the little house on Sandy Cove in Memphis and there I'd be, wide awake and red-eyed after staying up all night in the den, writing and singing and putting things down on tape. She urged me not to take them, and of course that just drove the wedge deeper between us. I shrugged her off. Then, as my habit escalated, she actually begged me—"Please, *please* get off those pills. They're going to destroy us both!"—but I hunched up into myself and let it roll off my back.

By the time we left Memphis for California in early 1959 we had three daughters and a marriage in bad trouble. At first I rented a house on Coldwater Canyon; then I bought Johnny Carson's house on Havenhurst Avenue in Encino when he left for New York to start *The Tonight Show*—$165,000 then, worth a few million today—and finally, because Rosanne was allergic to the smog, coming home from

school every day with tears running off her chin, we moved to the Ojai Valley about fifteen miles inland from Ventura. I built a house for us and bought one for my parents, and I loved it there. It was beautiful land. "Ojai" means "to nest." Nesting wasn't what I did, though.

Touring and drugs were what I did, with the effort involved in drugs mounting steadily as time went by. As well as with increasing demand I also had to deal with diminishing supply. In the early 1960s the American Medical Association began waking up to the perils of prescribing unlimited amphetamines for anyone who wanted them, and getting drugs started getting to be work, especially for a traveling man. It got harder than simply calling the hotel doctor and having him send over sixty pills. If I was going on a ten-day tour, I had to plan accordingly, and that could be complicated. How many prescriptions did I have? Four? Four times sixty divided by ten, make that twelve just in case, is . . . hmmmm, maybe not enough. Maybe I needed another local source. Maybe I should call another doctor before I left. Maybe I should drive to that druggist forty miles away and get a hundred or two under the counter. Maybe I should call a friend, or friends, and ask *them* to go get a new prescription. Ultimately, I might have to rely on whatever I could find on the road.

By 1960, Vivian's resentment against my commitment to the music business was very strong. Our experience together at the Disc Jockey Convention in Nashville that year was typical. I wanted to go room hopping, dropping into all the various record companies' and song publishers' hospitality suites, hanging out with my friends, singing songs and playing guitar, having fun and doing what you do, but that wasn't Vivian's idea at all. *She* wanted to be my priority. We had one of our worst fights that night. It didn't help at all that June Carter called our room to say that she and Don Gibson were singing and writing songs together, and why didn't I come over and join them? "Sure," I said, and hung up, planning to go, but Vivian threw a fit (which wasn't surprising, given how it all turned out between me and June and her). I ended up room hopping anyway and stayed up all night.

That was the night I heard about Johnny Horton getting killed. I took a lot of pills and I drank a lot, too. I was a mess, and the light of the following day made it worse. Hungover, strung out, in shock, full of remorse, my best friend dead, my wife hurt and sad and bitter and angry . . .

3 It was a sad situation between Vivian and me, and it didn't get better. I wasn't going to give up the life that went with my music, and Vivian wasn't going to accept that. So there we were, very unhappy. There was always a battle at home. It was hopeless for her because I just *wasn't* going to do what she wanted, and it was hopeless for me because she'd sworn that I'd never be free from our marriage. She was a devout Catholic; she said she'd die before she'd give me a divorce.

Everything just got more difficult as time went on, with Vivian and with drugs too. Amphetamines are hard to handle, and once you're into them to any extent you find out very quickly that you have a pressing need for other chemicals. I soon had to drink alcohol, usually wine or beer, to take the edge off my high if it got too sharp or knock myself out after being up for days, and after a while I got into barbiturates, too.

I wasn't high *all* the time. Sometimes nothing I did would keep me in pills, and I'd be stuck somewhere out on the road, having to go clean. I feared that more than I feared my own death, but when it happened, I'd begin to feel pretty good after two or three days without drugs. Then, though, I'd get home, usually on a Monday, and I'd find the stress of my marriage so hard that I'd drive to that druggist, get two or three hundred pills, head out into the desert in my camper, and stay out there, high, for as long as I could. Sometimes it was days.

Vivian, my preacher, and some of my friends fought for me, trying to make me save myself, but that just infuriated me, and I started staying away from home even more. I'd go out on tour and stay out when it was over. All the time my habit just got worse, never better.

I knew that, but it wasn't something I wanted to admit to myself. The crashes were coming closer together and I was burning myself out more often, going up to and past the point of total exhaustion, doubling and tripling and quadrupling my intake and getting a smaller and smaller margin of advantage. That would all reveal itself to me, as would the logical destination—death—when I got to the end of a binge and found myself shaking, sweating, cramping, hurting, and scared beyond the ability of any chemical on earth to take away my fear. Those states were temporary, though. The alcohol and barbiturates would knock me out eventually, and after a while, hours or days, I'd be able to get high again.

I'll tell you about my camper. I called it Jesse, after Jesse James, because I was an outlaw and it had to be one, too. I imagined my Jesse to be a free, rebellious spirit, living to ramble in the back of beyond and carry me and himself away from people and their needs and their laws. I painted his windows black so I could sleep in him during daylight, but also because I just liked to spray-paint things black.

I can't remember how long I'd been up when I wrecked him the first time. It was certainly more than a couple of days. I was alone in the night, driving down a deserted road near Santa Maria, California,

at about forty miles an hour, when suddenly everything was quiet and still and crooked, and my jaw hurt. I'd run up on a berm of earth, and Jesse had flipped over and slid down the highway before coming to rest on his side. I'd been knocked out and cracked my jaw; he'd been scraped and dented. No big deal.

Ditto for the next little disaster. Luther Perkins and I were approaching the covered porch of the old Sahara Hotel in Las Vegas, when it occurred to me that Jesse was higher than the space into which we were heading.

"Luther," I said, "this camper won't go under that porch."

He was busy talking. He didn't pay any attention at all to whatever it was I'd said.

"Hey, Luther! This camper *won't go under that porch!*"

He kept talking.

"*LUTHER!!*"

He was looking at me, startled and a little aggrieved by my tone, when we plowed into it. It was obvious right away that we'd done major damage.

Not to ourselves, though, and not to Jesse either. The Sahara people pulled us from the wreckage dazed but unscathed, then let enough air out of Jesse's tires to lower his roofline a few inches, and pulled him out, too. The porch was destroyed, but they were very nice about that. They just tore it down, built themselves a new one, and never came after us for a nickel.

The U.S. government wasn't as forgiving. They charged me plenty for the consequences when Jesse met his final fiery end. In fact, I'm the only citizen the government has ever successfully sued, and collected from, for starting a forest fire.

I'd been aware of the squeaky wheel for a while before I pulled to a stop in the Los Padres National Wildlife Refuge, over the hills from Ventura, California, but it really caught my attention once Jesse was stationary. Oil from a cracked bearing dripped onto the wheel, which by that time was red hot, and it set fire to the grass. The fire spread

quickly in the wind, and there was nothing I could do about it. It swept up the nearby mountainside, and soon a major conflagration was in progress.

My mind went to work. I grabbed my fishing pole from the back of the truck walked down to a creek, figuring that even though there was only three inches of water in the creek, I'd act like I was so engrossed in my fishing that I just hadn't noticed the fire eating up the scenery and my camper up the little hill behind me.

I sat there while the fire-fighting crews arrived and headed up the mountain with their shovels and axes and chain saws, and then the fire-bomber planes swooped in to drop their loads of boron. I was still sitting there when a man from the forestry service walked up to me and, despite the fishing rod in my hand, asked me, "Did you start this fire?"

I couldn't lie, but I tried. "My truck did," I said.

He asked me my name and address, and I told him. He wrote it all down and said, "Well, you'll be hearing from us." Then he started walking away.

"Wait a minute," I said. "How am I going to get out of here?" My truck had burned up; I was temporarily without transportation. It was a long way back to civilization.

He didn't seem to think that worrisome. "I don't know" is all he said, and then he and his comrades packed up their gear and left.

I slept on the bare ground that night. Early in the morning I thought it was all going to be okay, because I heard a truck engine on the dirt road. I ran up there, and sure enough, along came a man in a long flatbed truck. I flagged him down and described my plight, and he seemed sympathetic. Moreover, he was going my way. The cab was full—he had two other men with him—but he was willing to take another. "You can ride on the back," he said.

I looked into the back of the truck. His cargo was beehives, about a dozen of them, active ones, full of bees—a *fog* of bees. If I'd climbed in there I'd have been stung to death within seconds. *Hmmm,* I thought, *better not.*

The truck drove off and I started walking. The whole day passed before I encountered someone willing to give me a nonlethal ride, but eventually I did and I lived to tell the tale.

As it turned out, Jesse and I had picked a bad spot to burn. The three mountains scorched by our fire were part of a wildlife refuge area for, among other species, endangered California condors. A count of fifty-three had been made before the fire; after the fire, it went down to nine.

I was such a mess that I didn't care. I went into the depositions full of amphetamines and arrogance, refusing to answer their questions straight.

"Did you start this fire?"

"No. My truck did, and it's dead, so you can't question it."

"Do you feel bad about what you did?"

"Well, I feel pretty good right now."

"But how about driving all those condors out of the refuge?"

"You mean those big yellow buzzards?"

"Yes, Mr. Cash, those yellow buzzards."

"I don't give a damn about your yellow buzzards. Why should I care?"

And so on. It was just ugly, that's all. They decided to sue me, and I ended up paying them $125,000 in 1964 money, about $1 million today.

The next camper-related story turns on a tank of propane gas I bought for Jesse when he was new and dumped in the trunk of my 1958 Cadillac, the car I'd bought to replace the Lincoln I bought from Ferlin Husky to replace the '54 Plymouth with the bass fiddle on the roof. I was high when I bought the propane, and still high as I drove over Coldwater Canyon into Beverly Hills and started smelling propane. The smell matched the sound of the tank rolling around in the trunk, but my mind went to work and I convinced myself it would be okay, that I could make it home without having to stop.

I was wrong. There's a stretch of straight road about four blocks long on Coldwater Canyon, and then the road curves. If you don't

curve with it, you'll hit a big old palm tree. That's where I was, heading into that curve, when the car exploded.

I'd been thinking it might happen, so I was ready. I already had my hand on the door as the propane tank blew, and as soon as I felt the concussion I yanked down on that handle and rolled.

I hit the pavement, tumbled all the way across the street, and landed in the middle of somebody's lawn in time to get a great view of the fireworks. They were spectacular. When that Caddy hit the tree, the flames shot up a hundred feet or more and burned until the whole propane tank was empty. The valve had been wide open, knocked loose when the tank started rolling around in the trunk.

I was okay: bruised and cut and scraped and burned—my skin looked like an alligator's—but basically sound. They covered my face with vitamins A and E and I healed up nicely, with no scarring at all.

I looked terrible at first, though—so bad that when a friend of mine visited me in the hospital with his pregnant wife, she got very upset, and later that evening she miscarried.

You might have been thinking my wrecks were pretty amusing in a live-fast, die-young, hell-bent kind of way. What *I* think is that the life inside that woman was too young to die. I also think it's a good idea to dwell on the literal meaning of "hell-bent."

4 I've done no direct physical violence to people, but I certainly hurt many of them, particularly those closest to me, and I was hard on things. I kicked them, I punched them, I smashed them, I chopped them, I shot them, I stuck them with my bowie knife. When I got high I didn't care. If I wanted to let out some of my rage, I just did it. The value of whatever I destroyed, the money it cost, or its meaning to whoever owned or used it didn't matter one bit to me, such was the depth of my selfishness. All it cost me was cash (if that), hands off. Somebody else, usually Marshall Grant, had to actually face the people and do the paying.

As to the particulars of all those acts, I'm not going to go over them again. I've written about them before and talked about them many times in interviews, and I'm done with them. Frankly, I'm tired of having to tell those same old stories, particularly since I'm now working on

my third generation of questioners. It's disturbing, too, to confront the fact that, in many eyes, the kind of motel vandalism I pioneered is now a kind of totem of rock 'n' roll rebellion, a harmless and even admirable mixture of youthful exuberance and contempt for convention. That's not what it was for me. It was darker and deeper. It was *violence*.

It also wasn't the whole picture, because we displayed our share of youthful exuberance, too. I pulled all kinds of stunts that weren't harmful or destructive, and so did my companions. Stu Carnall, who'd teamed up with Bob Neal from Memphis to handle my affairs once I'd settled in California, was very talented in that area. While Bob, a gracious, nonjudgmental man, counseled against my craziness (and my growing drug habit), Stu, who came out on the road with us while Bob stayed back at the office, decided after a while that he'd join me rather than fight me. He took a different route, preferring alcohol to pills and stopping short of destruction and vandalism, but he was very creative. He liked to put on a top hat and a long black cape, march up to desk clerks, and request his rooms. If perchance they didn't have reservations for a Baron von Karnal, which of course they didn't, he'd rap his cane on the desk and shout, "Young man, I *demand* my suite!" Amazingly, or perhaps not so, he got it more often than not and was given special service, too. He only did that in the big cities, of course. It would never have worked in the smaller places. We really missed Stu and his contributions to our entertainment when he decided to end his partnership with Bob and open his own office.

Gordon Terry was another lively character. The women loved him, and he loved them, despite the fact that he also loved his wife, Virginia, and his two daughters, Betsy and Rhonda. They were a nice family and Virginia was a great cook, one of the very best Southern fried chicken cookers on the planet—still is, too, and more besides. She has a catering service in Nashville these days. She was totally devoted to Gordon, no matter what he did or didn't do, and through it all she kept the family together.

Gordon was every bit as talented with a fiddle as Virginia was with a frying pan. He started working my shows soon after he left Ferlin Husky's band, doing a solo spot and opening the show. On stage he was all personality, a fabulous entertainer, and he was hot—he played the fire out of that fiddle. He got them warmed up, all right.

Johnny Western was fun, too. He brought cowboy glamour to the show, and it wasn't fake. He was a real authority on the Old West, both in reality and as it's been reflected in music, TV, and the movies. Moreover, he was the fastest gun alive at the time. I never saw anyone clear leather quicker than Johnny Western, and while I never approached his speed, he got me drawing pretty fast by the time he was through with me. He was also a fine guitar player, one of the very few who could play Luther Perkins–style guitar *almost* as well as Luther. (He was the first man I called when Luther died, but he had other commitments.) Between him and Gordon Terry and sometimes the Collins Kids, Larry and Lorrie, I had a powerful show going by the time I stepped on stage myself.

It was a new manager, Saul Holiff, who pushed me to take my show, and my career, to another level. I was perfectly happy where I was, doing what I loved to do and getting paid for it, but after I got to know Saul—we met when he booked a date for me in London, Ontario, where he lived—I started liking his ideas. Instead of just ballrooms and dance halls around the United States and Canada, he said, I could be aiming at Europe, the Orient, and big places in big U.S. cities, Carnegie Hall perhaps, the Hollywood Bowl. And that could be just the beginning. I took him on, and what he said, he did. Saul was my manager for the next decade, into the early 1970s, when he decided he'd had enough of show business and retired to live a happy life. He made many of the most significant moves of my career, and I owe him a lot. I don't think I wore him out—nobody did; he just had no need to keep working, so he didn't. But I certainly wasn't the easiest of clients. Saul stayed pretty well insulated from the fallout, though. When I did something that left a mess—things broken, people abused, money

squandered, laws broken, jail cells visited—his technique was simply to disappear, either back home to Ontario or out of touch, unavailable even by telephone. Marshall Grant was the one who had to deal with it.

It was Saul who put me together with June, professionally speaking, booking her to appear on my show at the Big D Jamboree in Dallas, Texas, on December 5, 1961, a date I knew was going to be the start of something big. Perhaps he knew too.

I first laid eyes on June Carter when I was eighteen, on a Dyess High School senior class trip to the Grand Ole Opry. I'd liked what I heard of her on the radio, and I *really* liked what I saw of her from the balcony at the Ryman Auditorium. She was singing with the Carter Family that night, but also doing her solo comedy act, using Ernest Tubb as her straight man. She was great. She was gorgeous. She was a star. I was smitten, seriously so. The next time I saw her was six years later, again at the Opry but this time backstage, because by then I was a performer too. I walked over to her and came right out with it: "You and I are going to get married someday."

She was either still married to Carl Smith or about to be married to Rip Nix, I forget which, so she wasn't available, and I knew that. I just wanted to let her know how much I thought of her, how great she was in my eyes.

She laughed. "Really?" she asked.

"Yeah."

"Well, good," she said. "I can't wait." And there went the seed, in the ground.

Another five years passed before December 5, 1961. Gordon Terry and Johnny Western were both on the bill, but the Big D Jamboree was a big deal, and Saul reckoned we could use another act. "I know you like June Carter, the girl on the Grand Ole Opry, so I booked her to appear tonight as well," he told me. Which was more than fine with me. She was better than ever on stage that night, which didn't surprise me at all and made my next question that much easier.

"How about joining our show, doing this some more?" I asked her.

She thought about it a little while, then said "Well, I don't know. I'll talk to Saul and see if I can work everything out with him. Then, if we can come to a meeting of the minds, you're on. I'd love to."

That made me happy indeed. She and Saul worked out the finances, and on February 11, 1962, she joined our company on the road in Des Moines, Iowa, for a show at the KRNT Theater booked by Smokey Smith, a disc jockey and friend of mine. Patsy Cline was on that show, too, and Barbara Mandrell, then just twelve years old and on her first tour.

It started happening immediately. I was all set to go on stage that night, primed and ready as far as I was concerned, but not in June's eyes.

"Here, give me that shirt!" she told me.

"What shirt?" I asked.

"That one you got on," she replied. "You're not going on stage with your shirt all wrinkled like that!"

I wasn't exactly accustomed to people ordering me around like that, so for a moment I bristled. Then I jerked the shirt off and threw it to her. She ironed it, and I went on stage in a nicely pressed shirt. Thus began her lifelong dedication to cleaning me up, and my lifelong acceptance of that mission.

I was enthralled. Here was this vivacious, exuberant, funny, happy girl, as talented and spirited and strong-willed as they come, bringing out the best in me. It felt wonderful. We all liked it, in fact; she was a tonic for our whole crew. Life on the road improved immensely.

After Des Moines we went to Oklahoma City for a show with Carl Perkins, Sonny James, and pretty little Miss Norma Jean, and already I had June riding in my car with me. I liked Luther, Marshall, and Fluke, but not the way I liked June Carter. I made the implications of that point clear to the boys, including Johnny Western and Gordon Terry. I let them know from day one: "Don't mess around with June Carter. I'm covering her. I'm watching over her like a big old rooster, and don't

you forget it." They didn't. It was a hard thing for Gordon in particular to pull off, not messing with a pretty girl when she was right there in front of him, but it helped that June had a very good reputation among her peers in the music business. It was known that she didn't mess around, that if she played at all, she played for keeps.

At the end of that first tour I asked Saul to make sure we had her booked for all our upcoming tours. He did that, and from that point on, June was with me every time I went on the road, for the good times and the bad.

5 One of the worst times came early: my concert at Carnegie Hall in May of 1962, which apart from being an event in itself was the final stop on one ride and the beginning of another.

When I got to New York I was already burned out. I'd been in Newfoundland with Merle Travis and Gordon Terry on a moose hunt sponsored by a company introducing walkie-talkies to the civilian market. One of the things a walkie-talkie would be good for, they figured, was communication between hunters in the woods, and we were there to publicize that proposition. As it turned out, the radios didn't get much use. I shot a moose about three hundred yards from the cabin and called Merle on the walkie-talkie to tell him so, and it went something like this:

"Merle, I got a moose."

"That's nice. I might get one too if you'd stay off this thing."

That was about it for the walkie-talkies. You don't need them when you're holed up together in a cabin taking drugs and drinking, which is what we were really doing those three days. We all had our own preferences in that regard—Merle was on sleeping pills while I was on amphetamines—but it worked out, more or less. If Merle could keep his dosage right, he'd stay in what he considered his mellow mood, not nervous, for long periods of time. In that state he could be hilarious, a wonderful conversationalist and raconteur. He took so many pills that eventually they'd start working like they were supposed to and put him to sleep, but sometimes that took three or four days. For me, the trick was to match my biochemical schedule, running on the fast track, to his. Sometimes it worked and great stories were told, great thoughts exchanged; sometimes it didn't and there was a lot of dead air.

Merle was truly one of the most interesting men I've ever met, certainly one of the most talented in many areas. He was a brilliant singer, songwriter, and guitar innovator—he developed "Travis picking," a step further on from the style Mother Maybelle introduced. On the side, so to speak, he drew wonderful cartoons, told fabulous stories, possessed authoritative knowledge in many different areas, and was a skilled taxidermist, master watchmaker, and expert knife thrower (he's the one who taught me how to sink a bowie from twenty paces). That's an odd-sounding combination, I know, but Merle was indeed a man for all seasons, in many ways the ideal companion. After three days in that cabin, however, I was about ready to kill him, he probably felt the same way about me, and Gordon Terry felt likewise about both of us. It was a relief to get ourselves and our moose meat out of there and go our separate ways.

I took myself and mine to New York City and met up with the regular gang, but by that time I was shot: voice gone, nerves gone, judgment gone. I did an interview with Mike Wallace during which I almost tore his head off (Question: "Country music at Carnegie Hall. Why?" Answer, snarled: "Why *not?*"). We made an arrangement with the chef

at the Barbizon Plaza and served moose meat at our press party, which may have been a miscalculation (and may not; I don't recall). Then the concert itself came up on me. Merle Kilgore went on and did well, then Tompall and the Glaser Brothers, then June and the Carter Family. Finally it was time for the headliner, me.

I was deep in my Jimmie Rodgers obsession at the time, so I'd thought up something special. Mrs. Rodgers, before she died, had given me some of Jimmie's things. When I walked onto that stage that night, not only was I intending to sing only Jimmie Rodgers songs, I was also wearing his clothes and carrying his railroad lantern. I lit it backstage, had all the stage and house lights turned off, and made my entry in the dark with just the flame of the lantern on me. The plan was to set the lantern down on a chair at center stage, prop my knee up on the chair just the way Jimmie did, start in to "Waiting For a Train," and wait for the roar of recognition.

It didn't work out that way. If there were any people in the audience who knew about Jimmie Rodgers (and I'm sure there were at least a few), they were slow to make the visual connection. Nobody else had a clue. I thought they were going to be in awe—*This must be something special. What's he going to do?*—but they weren't. They were yelling for "Folsom Prison Blues" before I even got to the microphone. So I turned around, handed the lantern to somebody, and went into my regular opening number, whatever that was at the time. Which would have been fine, I guess, if I'd been able to sing. But I couldn't. I was mouthing the words, but nothing was coming out. All the people were hearing from me was my guitar.

At first they laughed. They thought I was kidding, that this was a joke. Then they went quiet, and I had to do something. I stopped the song.

"I have laryngitis tonight," I said. "I have no voice. I don't know if I can sing anything."

I couldn't, but I tried to. I kept asking for glasses of water to ease my dry throat, but it didn't help. I kept hoping the pills I'd taken would boost me up to where I didn't care anymore, but they didn't. It was just

a nightmare, and I remember all of it with perfect clarity. June came out dressed in a beautiful white robe with a heart sewn into it for when I did "Ballad of the Heart Weaver." I did "Mr. Garfield," which isn't very funny if you're not on the right wavelength, and nobody was. I whispered my way through "Give My Love to Rose." I went back again and again to Jimmie Rodgers songs, hoping to pull it together somehow, but I failed. It was awful, start to finish. The memory of it still gives me a headache.

After the show June came up to me backstage, obviously depressed, and said, "I thought you were very good, but your voice just wasn't there, and I really feel sorry for you about that."

I was in a very bad mood, angry with everybody and everything. "Well, I don't feel sorry for me," I snapped. She backed off.

The next encounter I remember was similar. A man I didn't know who'd been watching me from the corner of the dressing room came over and said, "It's called Dexedrine, isn't it?"

"What is?"

"What you're taking."

"Yeah. Why?"

"I just kinda recognized it. I'm of a kindred spirit. I've been into all that stuff myself. I'm in a program right now and I don't take anything, but I recognize Dexedrine. That stuff will kill you, y'know."

I had a whole arsenal of flippant little dismissals for occasions like this. "Yeah?" I said. "Well, so will a car wreck."

He wouldn't give up. "You know, man, you can learn to sing around laryngitis a little bit. I'm a writer and a singer, I've been in this business all my life, and I've learned some stuff like that. If we spent a little time together, maybe I could show you how to take care of yourself a little better."

I rejected that out of hand, but something about the man made an impression on me. After learning who he was—Ed McCurdy, the singer of Irish and Scottish folk songs, especially the bawdier ballads—I told him to come by the hotel in the morning.

I was off for a while after Carnegie Hall, so I started hanging out with Ed, and for a few days I didn't do any amphetamines. One afternoon, though, Ed came by with a friend of his, Peter LaFarge, a Hopi Indian and a songwriter, and invited me to go down to the Village with them to hear some folk music at the Bitter End.

"Okay," I said, "but I'm not going down there without taking some Dexedrine."

That was okay with Ed, it seemed. "Go ahead, take some," he said. It was more than okay with Peter, whose reaction was to take some, too.

I'll always remember a conversation we had at the Bitter End. "Cash, you're getting screwed up again," Ed told me. "You know that, don't you? You're losing it. You're going to blow it. You're just getting your voice back, and now you're going to lose it again."

I'd had two or three days of being relatively straight, so I was perfectly serious when I told him, "Hey, it's all right. I can handle this."

Ed and Peter just looked at each other and started laughing.

I bristled. "I don't know what's so funny, but I *don't* like to be laughed at!"

"Oh, Cash, you are a funny man," said Ed. "What you're saying is funny—so stupid, you have to laugh. You can't *handle* it. There's no way you can handle it. *It's* handling *you,* and eventually it'll kill you."

I discounted that—I'd heard it all before, time and time again—and the night went on. Peter got up and sang some of his Native American songs and Ed got up and sang an archaic Irish version of "Molly Malone." I took some more Dexedrine and gave Peter some more. I also handed him some Thorazine I'd gotten someplace, for use when he needed to come down and crash.

The next day I got a call from Ed. Peter had taken all the Thorazine I'd given him, he said, eight or ten pills, and now he couldn't be awakened. We were really worried, but while Peter slept for three or four days, he didn't die. He and I went on to work together; he inspired me to do my *Bitter Tears* album and wrote "The Ballad of Ira Hayes." The son of Oliver LaFarge, whose novel, *Laughing Boy,* won a Pulitzer

Prize, Peter was a genuine intellectual, but he was also very earthy, very proud of his Hopi heritage, and very aware of the wrongs done to his people and other Native Americans. The history he knew so well wasn't known at all by most white Americans in the early 1960s—though that would certainly change in the coming years—so to some extent, his was a voice crying in the wilderness. I felt lucky to be hearing it. Peter was great. He wasn't careful with the Thorazine, though.

After he and I had become friends, he stayed in Nashville a while and he and Pop Carter formed a bond. Pop even went down to the reservation in New Mexico with him. Then Peter went back to New York, and the next news was another phone call from Ed McCurdy. Peter hadn't woken up again, Ed told me, and this time he never would.

I wrecked every car I had in those days. I wrecked other people's, too. I wrecked June's brand new Cadillac. In fact, I managed to get fired from the Grand Ole Opry and total my future wife's car all in the same night.

Technically, I wasn't fired from the Opry because I wasn't in fact a member when they asked me not to come back again. The Opry at the time required that performers who'd been invited to become members commit themselves to appearing on the show twenty-six times a year, the equivalent of every other Saturday night. I'd never been willing to take that deal, which would have placed drastic limitations on my touring and therefore my income, and so my status with the Opry management was that of a frequent guest star. Technicalities aside, however, there was no mistaking the message that was imparted to me as I walked off stage on the night I smashed all the footlights with my microphone stand. "You don't have to come back anymore," the manager said. "We can't use you."

I was pretty angry about that. This was just the same stuff I'd been doing for a long time, I thought, so why were they getting so upset about it now?

June, as usual, tried to insert the voice of reason into the equation. "Go back to the motel and go to bed," she said. "You'll feel better tomorrow."

Fat chance. Instead, I asked to borrow her car.

She didn't think that was a good idea, especially since I'd been drinking a lot of beer as well as taking amphetamines. But I wasn't too concerned about what she thought, so I kept at her until she relented, and off I went in her nice new Caddy. I didn't know exactly where I was going, or even *vaguely* where I was going, but it didn't matter. I was just angry and driving and speeding. A blinding electrical storm was in progress, with torrential rain, and that fit my mood. I couldn't see the road ahead, but I wouldn't have been able to see it anyway, even on a clear, crisp night with unlimited visibility.

I hit the utility pole head on. My face smashed into the steering wheel, breaking my nose and bashing my front teeth up into my upper lip. Stunned as I was, I looked up and watched as the pole snapped and began falling toward me. It smashed into the roof above my head, and the wires it was carrying spread out on the wet pavement around the car and lit up the scenery with high-voltage electricity. It looked like Christmas or hell, take your pick, a warm fiery glow all around the car.

Being intelligent and sensible, I decided against stepping out. As long as the rubber of the tires was between me and all those volts, I reasoned, I might be okay. And besides, I had a lot to do in the car. There were beer bottles and pills aplenty to hide, somehow or other, before the police arrived. Which they did very soon. I was in the heart of Nashville, just a couple of blocks from Vanderbilt Hospital.

My main concern was that June would be mad at me, so while I told the police whose car I'd destroyed, I didn't tell them where they could find the owner to give her the news. I also had my own way with the doctor who set my nose. It was going to hurt, he said, avoiding euphemisms like "this may cause you some discomfort," so he was going to give me morphine.

"No," I growled. "Don't give me any morphine. Just set my nose!"

"You won't be able to stand it if I don't," he argued.

I wasn't having any of that. I'd show *him* how much I could stand. "Yeah? Well, go ahead. I want to experience it."

He went ahead. I could hear the little bones cracking in there, and yes, it really was excruciating. I thought it was a fine test of manhood. I could *really* take it.

June learned about her car soon enough, of course, and found me even though I'd gotten my friend David Ferguson to hide me away at his house, lying in the dark with my face wrapped in bandages. She didn't try to come see me because she knew I didn't want to see her. She waited until I'd emerged back into the world, and even then she didn't harass me about it.

"You know you totaled my car out?" was all she asked. "I guess I get a new Cadillac now." And she did. Insurance paid for it, not me.

I felt kind of bad about it all, especially since the police officer investigating the wreck had been Rip Nix, who at the time was June's husband. I didn't hear directly from him about it, but June mentioned that the incident didn't go over too well at home.

June said she knew me—knew the kernel of me, deep inside, beneath the drugs and deceit and despair and anger and selfishness, and knew my loneliness. She said she could help me. She said we were soul mates, she and I, and that she would fight for me with all her might, however she could. She did that by being my companion, friend, and lover, and by praying for me (June is a prayer warrior like none I've known), but also by waging total war on my drug habit. If she found my pills, she flushed them down the toilet. And find them she did; she searched for them, relentlessly. If I didn't like that and said so, I had a fight on my hands. If I disappeared on her, she'd get Marshall or Fluke or someone else in the crew to go find me in the wee hours of the morning and coax me back to bed. If I'd been up for days until I'd finally had the sense to take a handful of sleeping pills and crash—there was always an instinct

telling me when to do that, pointing to the line between "almost" and "fatal"—I'd wake up from a sleep like death to find that my drugs, *all* my drugs, no matter how ingeniously I'd hidden them, were gone.

She only gave up once, in the mid-'60s in the Four Seasons Hotel in Toronto. By that time I was totally reduced—I hate the term "wasted"— and it's incomprehensible to me how I kept walking around, how my brain continued to function. I was nothing but leather and bone; there was nothing in my blood but amphetamines; there was nothing in my heart but loneliness; there was nothing between me and my God but distance.

I don't know what exactly brought her to the point of leaving me. I'd been up for three or four days and I'd been giving her a really hard time, but that wasn't unusual. I guess there'd just been too much of it for her. She'd set out to save me and she thought she'd failed. We had adjoining rooms; she came into mine and said, "I'm going. I can't handle this anymore. I'm going to tell Saul that I can't work with you anymore. It's over."

I knew immediately that she wasn't kidding. I really didn't want her to go, so I went straight out of my room and into hers, gathered up her suitcase and all her clothes—everything, her shoes included (she was barefoot)—and took them back into my room. Then I pushed her out and locked my door. *That should do it,* I thought. All she had on was a towel.

I could hear her crying in her room for a long time, but eventually she came knocking on my door. She promised not to leave if I gave back her clothes, and I believed her, so I did. And through all the trials to come, before and after she became my wife, she never tried to leave again.

6

I just went on and on. I was taking amphetamines by the handful, literally, and barbiturates by the handful too, not to sleep but just to stop the shaking from the amphetamines. I was canceling shows and recording dates, and when I did manage to show up, I couldn't sing because my throat was too dried out from the pills. My weight was down to 155 pounds on a six-foot, one-and-a-half-inch frame. I was in and out of jails, hospitals, car wrecks. I was a walking vision of death, and that's exactly how I felt. I was scraping the filthy bottom of the barrel of life.

By early October 1967, I'd had enough. I hadn't slept or eaten in days, and there was nothing left of me. J.R. was just a distant memory. Whatever I'd become in his place, it felt barely human. I never wanted to see another dawn. I had wasted my life. I had drifted so far away

from God and every stabilizing force in my life that I felt there was no hope for me.

I knew what to do. I'd go into Nickajack Cave, on the Tennessee River just north of Chattanooga, and let God take me from this earth and put me wherever He puts people like me.

You can't go into Nickajack Cave anymore. The Army Corps of Engineers put a dam in, which closed off the entrance we used. It was an amazing place, an opening 150 feet wide and 50 feet high into a system of caves, some of them bigger than two or three football stadiums, that ran under the mountains all the way down into Alabama. I'd been there before with friends, Bob Johnston once, Hank Williams Jr. another time, exploring and looking for Civil War and Indian artifacts. Andrew Jackson and his army had slaughtered the Nickajack Indians there, men, women, and children, and soldiers from both sides of the War Between the States had taken shelter in the caves at various times during the conflict. The Indians left their bones in mounds. The soldiers left their names and affiliations and sometimes a message carved into the limestone of a chamber close to the entrance: *John Fox, C.S.A.; Reuben Matthews, Union; Jeff Davis, Burn in Hell.* The remains of the dead among them were joined by the bones of the many spelunkers and amateur adventurers who'd lost their lives in the caves over the years, usually by losing their way, and it was my hope and intention to join that company. If I crawled in far enough, I thought, I'd never be able to find my way back out, and nobody would be able to locate me until I was dead, if indeed they ever could. The dam would be going in soon.

I parked my Jeep and started crawling, and I crawled and crawled and crawled until, after two or three hours, the batteries in my flashlight wore out and I lay down to die in total darkness. The absolute lack of light was appropriate, for at that moment I was as far from God as I have ever been. My separation from Him, the deepest and most ravaging of the various kinds of loneliness I'd felt over the years, seemed finally complete.

It wasn't. I thought I'd left Him, but He hadn't left me. I felt something very powerful start to happen to me, a sensation of utter peace, clarity, and sobriety. I didn't believe it at first. I couldn't understand it. How, after being awake for so long and driving my body so hard and taking so many pills—dozens of them, scores, even hundreds—could I possibly feel *all right?* The feeling persisted, though, and then my mind started focusing on God. He didn't speak to me—He never has, and I'll be very surprised if He ever does—but I do believe that at times He has put feelings in my heart and perhaps even ideas in my head. There in Nickajack Cave I became conscious of a very clear, simple idea: I was not in charge of my destiny. I was not in charge of my own death. I was going to die at God's time, not mine. I hadn't prayed over my decision to seek death in the cave, but that hadn't stopped God from intervening.

I struggled, feeling defeated by the practicalities of the matter. There I was, after all, in total darkness, with no idea of which way was up, down, in, or out of that incredible complexity of passages and chambers so deep inside the earth that no scent or light or sensation from the outside could possibly reach me. How *could* I escape the death I'd willed?

No answer came, but an urging did: I had to move. So I did. I started crawling in whatever direction suggested itself, feeling ahead with my hands to guard against plunging over some precipice, just moving slowly and calmly, crablike. I have no idea how long it took, but at a certain point I felt a breath of wind on my back and knew that wherever the breeze was blowing from, that was the way out. I followed it until I began to see light, and finally I saw the opening of the cave.

When I walked out, June was there with a basket of food and drink, and my mother. I was confused. I thought she was in California. I was right; she had been. "I knew there was something wrong," she said. "I had to come and find you."

As we drove back toward Nashville I told my mother that God had saved me from killing myself. I told her I was ready to commit myself to Him, and do whatever it took to get off drugs. I wasn't lying.

During the following days I moved through withdrawal to recovery. I retreated to the house I'd just bought on Old Hickory Lake and at first lived in just one room, one of the big, circular rooms overlooking the lake. June and her mother and father formed a circle of faith around me, caring for me and insulating me from the outside world, particularly the people, some of them close friends, who'd been doing drugs with me. June contacted Dr. Nat Winston, the Commissioner of Mental Health of the State of Tennessee, on my behalf, and Nat came to the house every day, holding my feet to the fire and giving me vital support.

At first it was very hard for me. To illustrate, in *Man in Black* I described a phenomenon that began on my third night home, when I was finally able to get to sleep at about three in the morning, and continued for about ten days.

It was the same nightmare every night, and it affected my stomach—I suppose because the stomach was where the pills had landed, exploded, and done their work. I'd be lying in bed on my back or curled up on my side. The cramps would come and go, and I'd roll over, doze off, and go to sleep.

Then all of a sudden a glass ball would begin to expand in my stomach. My eyes were closed, but I could see it. It would grow to the size of a baseball, a volleyball, then a basketball. And about the time I felt that ball was twice the size of a basketball, it lifted me up off the bed.

I was in a strange state, half-asleep and half-awake. I couldn't open my eyes, and I couldn't close them. It lifted me off the bed to the ceiling, and when it would go through the roof, the glass ball would explode and tiny, infinitesimal slivers of glass would go out into my bloodstream from my stomach. I could feel the pieces of glass being pumped through my heart into the veins of my arms,

my legs, my feet, my neck, and my brain, and some of them would come out the pores of my skin. Then I'd float back down through the ceiling onto my bed and wake up. I'd turn over on my side for a while, unable to sleep. Then I'd lie on my back, doze off, get almost asleep—and the same nightmare would come again.

I never imagined a hole in the roof. I just went right through it without an opening. . . . I wanted to scream, but I couldn't.

I also noted that as well as the glass coming out of my skin and the corners of my eyes, I had the old problem of splinters, briars, and thorns in my flesh, and sometimes worms.

Eventually—slowly, with relapses and setbacks—I regained my strength and sanity and I rebuilt my connection to God. By November 11, 1967, I was able to face an audience again, performing straight for the first time in more than a decade at the high school in Hendersonville, my new hometown. I was terrified before I went on, but surprised, almost shocked, to discover that the stage without drugs was not the frightening place I'd imagined it to be. I was relaxed that night. I joked with the audience between numbers. I amazed myself.

What happened *then* was even more startling. Vivian divorced me. June and I got married (on March 1, 1968). I went to Folsom Prison in California and recorded my *Live at Folsom Prison* album, which got me a huge hit (for the second time) with "Folsom Prison Blues" and lit a big fire under my career. The following year *The Johnny Cash Show* started up, putting me on ABC network television for an hour a week, coast to coast. Then, on March 3, 1970, John Carter Cash was born, and my happiness grew and grew. Sobriety suited me.

God had done more than speak to me. He had revealed His will to me through other people, family and friends. The greatest joy of my life was that I no longer felt separated from Him. Now He is my Counselor, my Rock of Ages to stand upon.

7

My liberation from drug addiction wasn't permanent. Though I never regressed to spending years at a time on amphetamines, I've used mood-altering drugs for periods of varying length at various times since 1967: amphetamines, sleeping pills, and prescription painkillers.

One such spell, the most serious and protracted, began when I took painkillers after eye surgery in 1981, then kept taking them after I didn't need to. It escalated after I was almost killed by an ostrich.

Ostrich attacks are rare in Tennessee, it's true, but this one really happened, on the grounds of the exotic animal park I'd established behind the House of Cash offices near my house on Old Hickory Lake. It occurred during a particularly bitter winter, when below-zero temperatures had reduced our ostrich population by half; the hen of our pair wouldn't let herself be captured and taken inside the barn, so she

froze to death. That, I guess, is what made her mate cranky. Before then he'd been perfectly pleasant with me, as had all the other birds and animals, when I walked through the compound.

That day, though, he was not happy to see me. I was walking through the woods in the compound when suddenly he jumped out onto the trail in front of me and crouched there with his wings spread out, hissing nastily.

Nothing came of that encounter. I just stood there until he laid his wings back, quit hissing, and moved off. Then I walked on. As I walked I plotted. He'd be waiting for me when I came back by there, ready to give me the same treatment, and I couldn't have that. I was the boss. It was *my* land.

The ostrich didn't care. When I came back I was carrying a good stout six-foot stick, and I was prepared to use it. And sure enough, there he was on the trail in front of me, doing his thing. When he started moving toward me I went on the offensive, taking a good hard swipe at him.

I missed. He wasn't there. He was in the air, and a split second later he was on his way down again, with that big toe of his, larger than my size-thirteen shoe, extended toward my stomach. He made contact—I'm sure there was never any question he wouldn't—and frankly, I got off lightly. All he did was break my two lower ribs and rip my stomach open down to my belt. If the belt hadn't been good and strong, with a solid buckle, he'd have spilled my guts exactly the way he meant to. As it was, he knocked me over onto my back and I broke three more ribs on a rock—but I had sense enough to keep swinging the stick, so he didn't get to finish me. I scored a good hit on one of his legs, and he ran off.

They cleaned my wounds, stitched me up, and sent me home, but I was nowhere near as good as new. Those five broken ribs *hurt*. That's what painkillers are for, though, so I felt perfectly justified in taking lots of them. Justification ceased to be relevant after that; once the pain subsided completely I knew I was taking them because I liked the way

they made me feel. And while that troubled my conscience, it didn't trouble it enough to keep me from going down that old addictive road again. Soon I was going around to different doctors to keep those pills coming in the kind of quantities I needed, and when they started upsetting my digestive system, I started drinking wine to settle my stomach, which worked reasonably well. The wine also took the sharper, more uncomfortable edges off the amphetamines I'd begun adding to the mix because—well, because I was still looking for that euphoria.

So there I was, up and running, strung out, slowed down, sped up, turned around, hung on the hook, having a ball, living in hell. Before long I began to get the impression that I was in trouble—I had bleeding ulcers, for one thing—but I kept going anyway. The idea of taking things to their logical conclusion, just drugging and drinking until I slipped all the way out of this world, began to dance quietly around the back of my mind. That was weirdly comforting.

I went low. On tour in England in 1983 I got into the habit of going into John Carter's room to sleep in the early morning, thus avoiding June's dawn rising. John Carter was twelve. One morning he looked under the bed and said, "Daddy, where did all those wine bottles come from?"

I had to tell him I'd got them out of the mini-bar and drunk them during the night.

"I didn't know you drank like that," he said. I told him I'd been in a lot of pain, so I'd *had* to drink like that.

I met my spider in England. Nottingham, to be precise, in the Midlands, a region hitherto unrecognized as a habitat of aggressive arachnids. Where there's a will, though, there's a way.

Nottingham was the last stop on our tour, and we'd checked into a hotel with beautiful old wooden paneling. I was in the room with June when I got the idea that there was a Murphy bed set into one of the walls.

"Look, June, I can pull this bed down and you can make it up and sleep on it."

"John, that's not a bed," she said. "There's no Murphy bed there."

I disagreed with her quite strongly—I was *convinced* it was there—so I proceeded to tear at that wall until the paneling started splitting, driving old dirt and splinters into my right hand. The hand was a bloody wreck by the time I understood that I'd hallucinated the Murphy bed.

I hallucinated the spider, too—saw it in the middle of the night, biting my hand, causing me intense pain. I told June about it in the morning, by which time my hand was twice its normal size. She believed me at first, just as I believed myself. I don't know what others thought when we made the story public: *Cash Bitten by Poisonous English Spider!!!* Perhaps they considered the possibility that a miracle had occurred in Nottingham, or that the spider had arrived in my baggage (or someone else's) from some likelier part of the world, Mozambique or Mombassa, Belize or Brazil, or that somebody nearby was running a game park for exotic arachnids, reptiles, and worms. Perhaps they thought I was on drugs again.

When I got home my hand was just a giant ball of infection, so I had to check into Baptist Hospital and have surgery on it. I knew I'd be in there a while, so I went prepared. I hid a survival stash of Percodans, amphetamines, and Valium—a fifty-dose card of Valium I'd acquired in Switzerland—in a tobacco sack tied to the back of the TV set in my room.

They did the surgery on my hand, but then they discovered a worse problem in my midsection: all that internal bleeding. So back into surgery I went, this time for removal of my duodenum, parts of my stomach and spleen, and several feet of intestine. That presented a pretty severe problem as far as maintaining my habit went, but I handled it—I had the whole card of Valium right there with me in the intensive care unit. I had a great hiding place for it, too: under the bandages over the freshly sutured incision in my belly. I managed to pull the dressing up and get it snugged in there, safe and sound. I thought I'd been really clever.

A couple of days later, they couldn't wake me up. They'd get a rise out of me for a moment or two, but I'd drift straight off again no matter what they did. That went on for a while—I don't really know how long—until, in a flash of life-saving brilliance, I understood the problem and managed, despite my slurring and blurring, to tell the doctor that he should investigate my dressing. He didn't get it at first—it looked fine, he said, he didn't need to take it off—but I insisted. When he peeled away what was left of the card of Valium, he found that about half the pills had already dissolved straight into my wound.

I don't know if it was the Valium's fault, but that was a horrible wound; it took months to heal properly.

As it happened, the Valium was superfluous, because they treated my postsurgical pain with such strong doses of morphine that I was just about as high as I could be anyway, lost in intensely vivid hallucinations. I half wrecked the ICU, upsetting IV poles and doing all kinds of damage, because I just *had* to make somebody understand about the commandos: they'd gotten into the hospital and were setting their charges all around the room.

Finally, someone got the message and told the flight crew. The copilot came on the intercom to put me at ease.

"We're going to fly this wing of the hospital away from here," he said. "Get you away from these people bothering you."

"Good," I said. "Let's take off."

No sooner said than done. I looked out the window and sure enough, our wing of the hospital had detached itself and was rolling on its takeoff run. Soon we were up, beginning our first turn over Nashville, and I could see the Cumberland River, then the green Tennessee countryside.

The pilot came on the speaker. "It looks like everything's all right now."

I didn't think it was. As I told the flight attendant—this was a full-service hallucination—"The charges still lead up here. They can still blow us up."

"No," she said, "you're wrong. There are no charges aboard."

The woman was crazy, I realized, or dense, or blind, or a member of the conspiracy against me: the charges were right there in plain sight.

"Look, you can *see* them!" I urged. "They're going to blow us up while we're still in the air!"

Somehow I got word to the pilot, and he did a good job, turning back immediately and beginning his landing approach without further ado. The hospital buildings swung into sight, then slid up toward us as we made a faultless landing and eased back into our place.

It was perfect, but pointless. The commandos came right back, moving grimly through the ICU and laying their charges all over again.

"We're gonna get you, Cash," said one.

That was bad enough, but suddenly I was out of the ICU and in a ward, and a commando was standing in the doorway with his gun to John Carter's head (this was post-robbery).

"We're going to kill you and your whole family!" he barked. I realized with horror that there wasn't any "if" or "unless" about it; they were just going to *do* it.

I started screaming . . .

When I hallucinated that intensely, the medics would respond by giving me even higher doses of morphine. They didn't know who they were dealing with, or what: more dope just made me more crazy.

The people closest to me had had enough. Unbeknownst to me, they got together with a wonderful doctor from the Betty Ford Clinic, a great man who will remain anonymous, and in the parlance of the trade they "ran an intervention" on me.

I knew the doctor was coming. I was semi-alert by that time, about twenty days after the surgery, so I'd understood fine when June told me that the doctor was in town with Gene Autry. Gene was in town to buy a baseball player, and while he had to get back to California posthaste, the doctor would be paying me a visit the next day.

That he did, along with June, Rosanne, my mother, John Carter, Cindy, Tara, Rosie, half the people who worked for me, and all the members of my band—about twenty-five souls in all. Every one of them had written out something they wanted me to know about my behavior toward them. So lying right there, literally a captive audience (unless I wanted to rip out a couple of IVs and risk spilling my guts on the floor), I listened. I heard about betrayals and broken promises, lies and neglect, love used and abused and abandoned and refused, trust destroyed, care turned to pain and fear.

Everyone read, and all the letters had their effect on me. Again, though, it was John Carter who got through to me most clearly. His letter was about one night at the farm when I'd fallen, stumbled and staggered, and otherwise made a fool of myself in front of his friends, embarrassing him and them terribly. I had to hold him and hug him while he read it, to keep his tears back; he hadn't wanted to write that letter and he wanted even less to read it to me.

The letters weren't designed just to vent their writers' anger, shame, or disgust at my behavior. Their greater purpose was to show me the depth of the trouble I was in, to express love and concern for me, and to ask me to accept help to save myself. As the doctor put it after everyone had read to me, "We all want you to get some help. We want you to go to the Betty Ford Center."

Simple request, simple reply. "I'm ready to go," I croaked, barely able to get the words out. "I want to go. I want some help."

I wasn't conning anyone, even myself, at that moment. I knew how serious my situation was. I was wasted, weak, hallucinating on the morphine every day, very far out in the cold—just a degree or two away from the physical final end, to say nothing of madness, spiritual bankruptcy, and financial ruin. I also knew that I was so close to death that if I really wanted, I could give up and go there quite easily. All the way down at the doors of death, though, I'd discovered that I didn't really want to die; I just wanted the pain and trouble and heartbreak to end, and I was so tired that dying seemed like the only way to get that

done. I wanted to stop hating myself, too. Mine wasn't soft-core, pop-psychology self-hatred; it was a profound, violent, daily holocaust of revulsion and shame, and one way or another it *had* to stop. I couldn't stand it any longer. So when the intervention came, it was welcome. As my friends and family spoke, I was telling myself, *This is it. This is my salvation. God has sent these people to show me a way out. I'm going to get a chance to live.*

I'm still absolutely convinced that the intervention was the hand of God working in my life, telling me that I still had a long way to go, a lot left to do. The amazing encouragement I got, the testimony of all those people, made me believe in myself again. But first I had to humble myself before God.

I was going to the Betty Ford Center. The doctor told me that John and Michelle Rollins were going to be in Nashville the next day with John's plane and pilots and that they'd fly me straight to Palm Springs. First I'd be checked into the Eisenhower Medical Center; then I'd go to Betty Ford. The doctor and June would make the trip with me.

I didn't understand how it could be done. The wound in my stomach was still open, and the dressing had to be changed every hour. The doctor said it would be okay, though, so I took his word for it. He even told me I could have anything I wanted to eat—I hadn't had any decent food in weeks—and I took him up on it. I ate two sacks of peanuts and a Coke and was more surprised that that didn't kill me than I was about surviving everything else.

At the Eisenhower Medical Center they examined me and promptly declared that I couldn't be released to go anywhere in the foreseeable future, let alone the few days the doctor had in mind. He stood his ground.

"He's already spent three weeks in hospital," he said. "He needs to be in a treatment center now." It was his view that the sooner I got away from modern medicine's arsenal of mood-altering chemicals, the better.

That was also the opinion of my treatment counselor, who must also remain anonymous. "I want Cash at Betty Ford," he said. "We'll take care of him there. We'll take care of that wound."

I was still worried about that. I asked *how* they were going to take care of it. He just told me, "You're not to worry about that. It'll be taken care of." I accepted that, imagining nice nurses attending to me at regular intervals.

That's not exactly what my doctor and counselor had in mind. It turned out that *I* was the one in charge of caring for my wound. *I* had to swab it out—stick a Q-tip a couple of inches into my belly to clean it and drain it—and then change the dressing. I got used to it after a while, and gradually the wound began closing up. Over the next four or five weeks it went from four inches down to three, then two, and finally became a single round hole that looked like it would never close, but it did.

I was in the Betty Ford Center for three weeks before I started really coming to life, but when that happened I felt wonderful. It was almost literally like being reborn; I'd never felt so fresh. It was a great place. The food was good, the people were good, the lectures were fabulous. Betty Ford herself gave a daily talk that I attended, and my counselor backed it up. He was hard-nosed and very effective. He wouldn't give me an inch, and he got the job done with me. Neither I nor any of the other celebrities got any breaks in any way, especially not in the process of education and self-discovery, basically a concentrated twelve-step program that's the core of the treatment. I wasn't allowed to get away with anything but "rigorous honesty."

The people running the program knew their business and the disease they were treating. Many of them knew it personally. The doctor certainly did. He himself had been so far along in his disease, alcoholism, that one night at a dinner party at his home, he'd walked out onto the front porch with a steak knife, rammed it into his stomach, pulled it around about eight inches to cut himself wide open, and then walked back into the dining room, holding himself together and show-

ing his wife that he was really badly hurt. He did it just to get attention, he told me, kind of ignoring the possibility that he might be killing himself but not *entirely* ignoring it. I could relate. The doctor had been to some of the places I'd been calling home, so I couldn't shock him, or fool him, either.

Betty Ford and all the others I can't or shouldn't name set me on the path of sobriety, teaching me the workings of my disease and showing me the way out of it, and for that I'll always be thankful and grateful. I *am* grateful. Now I know where to go to get help.

I've gone and got it several times since that first awakening, at the Betty Ford Center and other treatment facilities, because my problem persists. It's an ongoing struggle. I do know, though, that if I commit myself to God every morning and stay honest with Him and myself, I make it through the day just beautifully.

PART 4

Bon Aqua

1

I'm pottering about the house, as the English would say. I've been on tour again—Prague, Dresden, Düsseldorf, Oslo, Bergen, Bourges, Paris, Munich, Graz, Vienna, London, Berlin, Hamburg—and now I'm back home. As I usually do when I get off the road, I've packed my little suitcase and come on out to the farm to be by myself. Peggy Knight, our housekeeper, drove me out and readied the farmhouse for my stay, but now she's back in Hendersonville at the house on Old Hickory Lake, and for the first time in thirty days I'm all by myself.

This is a great place for pottering. I can cook my own food, read my own books, tend my own garden, wander my own land. I can think, write, compose, study, rest, and reflect in peace.

I can talk to myself. "Okay," I can say, "where do you want to put this book of eighteenth-century hymns you found at Foyle's in London?

Is it going to go in with the poetry books, or with the antiques you never look at?"

"The poetry books, I think. Then I might pull it out and read it sometime."

"Are you sure about that? Remember what you paid for it. You really don't want to be handling it too much."

"Okay. I'll put it in the antiques."

"Good. That's settled. Are you hungry?"

"Well, I certainly *could* be."

"Peggy left you that apple pie she baked, you know. That would be just about perfect right now, wouldn't it?"

"Oh, yes, it sure would. Wait a minute, though. What did I have for breakfast? Eggs, country ham, home fries, fresh-made biscuits with butter and jam? What's a big old slice of that pie, eight hundred calories?"

"About that, yes. You don't care, though, do you?"

"No, you're right, I don't, so . . . No, no, no. I'm *going* to care next time I put on my stage pants."

"All right. Later, maybe. Okay?"

"Sure. Good idea."

And so on. The creative process to which my mind is sometimes open happens, usually, without dialogue. It's the more mundane stuff, where the ego meets the daily road, that makes up my internal chitchat.

I'll just go on pottering. The poetry shelves in my library have caught my eye. The kind of poetry I really love is the corny stuff: the epic poem about Columbus, I forget its title, that we read in high school—"Before him not the ghost of land / Before him only shoreless seas"— and in the last verse, after sailing on and on and on, there's "a light, a light, a lamp!" and he's found America. How that thrilled me. I love Emily Dickinson, too. Sometimes I go a little deeper, into Edna St. Vincent Millay, or Milton; as much as I can stand, that is, until my brain gets tired. What I *really* enjoy is the Bible. I love to set myself a

test, give myself something to study. I find a passage I don't quite understand and chase it down in the concordance and the chain references until I learn what it means, or at least what the best-versed scholars have been able to interpret it as meaning.

I don't listen to music much at the farm, unless I'm going into songwriting mode and looking for inspiration. Then I'll put on something by the writers I've admired and used for years (Rodney Crowell, John Prine, Guy Clark, and the late Steve Goodman are my Big Four), or any music in any field that has real artistry, or something that promises a connection to what's essential in my own music: old blues, old country, old gospel. Most recently I've been listening to Rodney's *Jewel of the South* CD, one of his very best, and the chants of the Benedictine monks.

I've also been playing with my Tibetan singing bowl, which has its own wonderful world of sound. It's made of seven different kinds of metals—gold, silver, brass, bronze, and metals from the meteorites that land intact on the mountain peaks of the Himalayas, where there's less atmosphere than anywhere else on earth to burn them up before impact. The bowl produces the most amazing variety of sustained, unearthly tones. It comes with an instrument, wrapped in chamois leather, resembling the kind of pestle you use to crush corn or rock salt in a mortar. You rub that around the rim—how fast and hard you rub determines the pitch and intensity of the tone the bowl produces—and then you put your face down into the bowl and listen. It feels like hearing a pipe organ in a cathedral. It's a wonderful tool for taking me to another, more peaceful place.

I have a little garden here, an eight-by-twelve patch of ground in the yard where I used to grow vegetables, okra and tomatoes and peppers, but I've given over to my grape arbor now. A piece of ground that small can produce a lot of food if you work it right, and I know for a fact that, in time, my vines will give me many more grapes than I can handle myself; they've already produced about half a bushel this year. I put them in three years ago, with cuttings I took from my vines at

home in Hendersonville, which in turn grew from cuttings I took from my parents' arbor in California in 1968 and carried back to Tennessee wrapped in wet newspaper inside a suitcase. They're black Concord vines, hardy, with delicious grapes. You take the cuttings when you start to have warm nights and hot days, around early or mid-May in Tennessee. You cut off five joints of second-year growth and plant them with two joints in the ground and three above, then give them enough potassium, phosphate, potash, manure, and water, and watch them grow. If you get some good hot days, the sun will just suck those leaves out. I can't tell you how much pleasure that gives me.

I've read a lot of books on the subject, and now I almost know what I'm doing. The arbor at the farm is surviving and thriving, and so is the big one at home, and the grapes from both really are delicious. I love taking care of my vines, then having them take care of me.

This farmhouse sits aside a hill a couple of hours from Nashville. There's nothing special about its location, nothing it's famous for, and nothing much to distinguish it from hundreds of other places in this part of Tennessee. It has just the usual routine beauty, green and gentle, no spectacles. The spring from which it takes its name, Bon Aqua, is half a mile down the road.

My farmhouse is an old, simple, two-story structure, built in 1847 of yellow poplar cut with a broadax by a retired soldier of the Mexican War, Captain Joseph Weems. At this moment I'm sitting on the front porch, exactly where he sat in 1862 on the day, just after the surrender of Nashville to the Yankees, when two Union cavalrymen came riding up into the yard. Capt. Weems had a cow out in his pasture, now the empty field running up to the crest of the hill behind the house, and the Yankees wanted it; they were requisitioning chickens, pigs, beef, and whatever else they could find. They didn't ask politely, the story goes—they must have been feeling their oats—and neither did they take kindly to the fact that Capt. Weems was wearing his full Mexican War uniform. He was a military-minded man.

He spoke sharply. "You're not taking my cow. I've got babies who have to have that milk."

"Well, we're taking it anyway," said one Yankee.

"Are you armed?" asked the other.

"You'd just about have to search me to find *that* out, now wouldn't you?" was the Captain's reply.

Dumb Yankees. "Well," said one, "if you've got a gun, we're going to take it from you, 'cause we're not going to let you people keep your guns, either."

He started toward the porch. Capt. Weems didn't hesitate: he just pulled out his pistol and killed both those horse soldiers right there. They fell dead in the front yard, about where my Range Rover is parked right now.

Their comrades never found out what happened to them. Capt. Weems and his family chased away their horses, burned their gear, and buried them in unmarked graves in the family cemetery up the hill. They're still there today, though nobody knows exactly where. Capt. Weems is there too, his gravesite plainly marked.

The Yankees sure tried to get to the truth, coming back through here day after day, but nobody breathed a word, and in the end they had to give up and go away. The whole affair remained a family secret for a long time; now it's a local legend. I first heard it when I started coming here in 1972, from an eighty-year-old called Red Frasier, who was part of the local color at the time. I was walking from my pickup into the feed store when he called out to me.

"Hey, boy!"

I was forty years old, but I knew he meant me. "Yes, sir," I said.

"You got any frogs in that pond up there?"

"You mean eating frogs?"

"Yeah, that's what I mean."

"Well, yes. I got frogs up there I bet weigh two pounds apiece."

I knew the minute I spoke that I'd stretched it too far, though he didn't say anything. He just grinned, and I walked into the store.

He got me on the way back out. "Hey, boy!"

"Yes, sir."

"You pretty well eat up with frogs, ain't you?"

After that I got to know him, and he told me all kinds of stuff.

Back in Capt. Weems's day the family got their water from the Bon Aqua spring. That's what I do still; it runs year-round, and I pipe the water into the house. It feeds my ponds, too, the one with the frogs that was already here when I first came and the other I had made and stocked with fish. I like to go sit by the side of the new pond, sometimes fishing but more often just daydreaming, and every year I plant another two or three trees around it: pine, weeping willow, pin oak, willow oak, magnolias, cedar; handsome trees, pretty trees.

I like to dig in the dirt. I like to work in the fields and the garden. I come up here and I wear a cap or an old straw hat, no shirt, no shoes in summer. I live the life of a country boy. I love to and I need to.

It was odd how I acquired this place. Sad, really. It came to me as a result of a crime by a man I trusted.

June and I had just come off tour, and we went down to Hixon, Tennessee, to make a big furniture buy—a lot of the antique pieces, in fact, that are here and at Hendersonville now. It really was a substantial purchase, even by June's standards, so when the man told me the figure, I called my accountant, whom I'll call Pete (a nice man, "Uncle Pete" to our children), and asked him if we had enough cash in the bank to cover the check.

"Ooooh, I don't think you've got that much," he said.

"Oh, yes, I do too," I replied. "I just turned in twice that much to you from the tour."

"Yeah, but there are a lot of bills to pay."

Well, there weren't *that* many bills to pay, and even if there were, he hadn't had time to pay them yet. When I told him that, though, he got nervous and started mumbling, not making much sense.

"Well, we'll just talk about it when I get back," I said. "Right now I'm going to go ahead and write this check."

That made him even more nervous. "Go ahead, then, but I don't think there's going to be enough to cover it," he stammered.

I did write the check, and when I got back to the office I discovered that, sure enough, the current bills hadn't been paid. Neither had the past-due bills. The bills, in fact, hadn't been paid in quite some time. The man had been stealing our money, taking it for himself and buying properties with it. His wife had been using it to buy jewelry.

That was a hard lesson—harder for him than for me, because all *I* had to do was never again choose an accountant by driving down the main street where I lived and looking for a sign saying "Accountant," which is how I found Uncle Pete. Then I'd just have to keep at least periodic tabs on where the money was going, whoever was actually putting it there. Pete, on the other hand, had to give the money back and face the threat of prosecution. As it turned out, we decided not to prosecute—he had a lot of tragedy in his family around that time, and besides, he really was a nice man, well loved in the community. What we did was search out the properties he'd bought with our money and make him sign them over to us. We were doing that when it occurred to us that we should investigate his farm, where Carlene and Rosie had spent many a happy weekend playing with his kids. And sure enough, there it was: he'd paid cash for it, our cash.

We sold all the other properties, but this one I just had to keep. For me in '72 it was love at first sight, just as it would be at Cinnamon Hill a couple of years later: a place that moved into my heart immediately, a place where I knew I could belong.

2

The 1970s for me were a time of abundance and growth, not just in terms of finances and property, but personally, spiritually, and in my work. My marriage with June grew and flourished; John Carter came into the world; Bible study became an important part of my life and produced the most ambitious project of my career to date, the movie *Gospel Road*; and following the commercial success that began with my *Johnny Cash at Folsom Prison* album in 1968, plus the increase in public visibility my weekly TV show generated, I was able to walk through all kinds of new doors and go to all manner of new places.

On the other hand, the '70s also saw the implosion of my recording career. I ended 1969 with nine albums on the *Billboard* charts and began 1970 with "Flesh and Blood" moving up the country singles chart to its eventual position at number one. I ended 1979 and the

whole decade with only one more country number one to my credit, "One Piece at a Time" (in 1976). My singles spent a total of thirty weeks on the *Billboard* pop chart in the '60s; in the '70s the number was just eleven, eight of which came right at the beginning of the decade, in 1970. That was a trend, too; in the '80s, as I've said, I became invisible on the charts. No weeks at all on the pop charts, zero number-one country singles (unless you count "The Highwayman" with Waylon, Willie Nelson, and Kris Kristofferson in 1985; I don't).

In fact, if you look at the arc of my whole career from the perspective most commonly used, that of purely commercial success, you have to conclude that my star came on strong in the mid-'50s, cooled in the early and mid-'60s, reignited with a vengeance in '68, burned brightly until '71, and then dimmed again, save for a brief flare-up in 1976 with "One Piece at a Time" and my current comparatively small-scale popularity as a recording artist (which doesn't translate into "action" anywhere except on the new, alternative-style Americana chart, plus, thankfully, at the cash register). Which is fine with me. I'm happy in my personal and spiritual life, and any commercial success at all is icing on the cake.

My own version of my music's success or failure is a little different from that prevalent in "the industry." For instance, one of the main reasons my record sales dropped off so dramatically in the early '70s is that making secular records simply wasn't my first priority; that's when I turned down recording "City of New Orleans" because I was too busy working on *Gospel Road*. Then, too, low record sales in the '70s and '80s didn't translate into low demand for me as a performer. I've never had any trouble working as many concerts as I want, and that goes for TV specials, too.

I also disagree with the opinion that I didn't make good records in the '60s. That's when I did some of the work I'm most proud of today, particularly the concept albums I made between 1960 and 1966: *Ride This Train; Blood, Sweat, and Tears; Bitter Tears;* and *Ballads of the True West*. They brought out voices that weren't commonly heard at the time—voices that were ignored or even suppressed in the entertain-

ment media, not to mention the political and educational establish-
ments—and they addressed subjects I really cared about. I was trying
to get at the reality behind some of our country's history.

I tried hard, too. For *Ballads of the True West,* I just about became a
nineteenth-century cowboy. I attached myself to people, like Tex Ritter,
who'd spent their lives researching Western history. I haunted book-
stores, libraries, and record stores, looking at period newspapers and
memoirs and listening to documentary recordings of old cowboys. I
befriended a man named Joe Small in Austin, Texas, who published a
magazine called *True West,* and spent endless hours talking with him
and going through the mass of Western memorabilia and thousands of
stories he had in his office, all of it the real thing. He gave me a copy of
John Wesley Hardin's autobiography, *My Life,* in the form of a loose-
leaf copy that was typed straight from the original handwritten
manuscript before the book was even published, and for years I felt like
I knew Hardin as well as I knew myself.

Sometimes I might have gone a little too far, not such an uncommon
trait in a person on amphetamines. I'd put on my cowboy clothes—real
ones, antiques—and go out to the desert or an abandoned ranch some-
where, trying to feel how they felt back then, be how they were. I wore
authentic Western clothes on the road and in concert, too. Sometimes I
even strapped on my gun before I walked in through the backstage
door. It would be loaded, naturally.

Sometimes my amphetamine communions with the cowboy ghosts
were productive and ideas came to me that became songs, on the spot
or later. Sometimes the chemistry wasn't right, as they say (though not
in the sense I mean it) and not much happened in the way of creative
progress. I still have a sheet from a yellow legal pad on which is writ-
ten my entire output from a whole day in the desert: "Under the man-
zanita tree / Sits a pencil, a piece of paper, and me." You can't imagine
how much thought went into those words.

Bitter Tears, which preceded *Ballads of the True West* and in
which I was inspired by the Native American songwriter Peter LaFarge,

was another intense research project. I dove into primary and secondary sources, immersing myself in the tragic stories of the Cherokee and the Apache, among others, until I was almost as raw as Peter. By the time I actually recorded the album I carried a heavy load of sadness and outrage; I felt every word of those songs, particularly "Apache Tears" and "The Ballad of Ira Hayes." I meant every word, too. I was long past the point of pulling my punches.

I expected there to be trouble with that album, and there was. I got a lot of flak from the Columbia Records bosses while I was recording it—though Frank Jones, my producer, had the good sense and courage to let me go ahead and do what I wanted—and when it was released, many radio stations wouldn't play it. My reaction was to write the disc jockeys a letter and pay to have it published as a full-page ad in *Billboard*. It talked about them wanting to "wallow in [their] meaninglessness" and noted their "lack of vision for our music." Predictably enough, it got me off the air in more places than it got me on. I guess it didn't help that the disc jockeys and everybody else in the business knew about my drug problem. It was probably quite easy to dismiss my challenge on those grounds alone, if indeed any grounds but craven worship of the almighty dollar were needed. They certainly aren't today. The very idea of unconventional or even original ideas ending up on "country" radio in the late 1990s is absurd.

I was deeply into folk music in the early 1960s, both the authentic songs from various periods and areas of American life and the new "folk revival" songs of the time, so I took note of Bob Dylan as soon as the *Bob Dylan* album came out in early '62 and listened almost constantly to *The Freewheelin' Bob Dylan* in '63. I had a portable record player I'd take along on the road, and I'd put on *Freewheelin'* backstage, then go out and do my show, then listen again as soon as I came off. After a while at that, I wrote Bob a letter telling him how much of a fan I was. He wrote back almost immediately, saying he'd been following my music since "I Walk the Line," and so we began a correspondence.

Mostly it was about music: what we ourselves were doing, what other people were doing, what I knew about so-and-so and he didn't and vice versa. He asked me about country people; I asked him about the circles he moved in. I still have all his letters, locked up in my vault.

It wasn't a long correspondence. We quit after we actually met each other, when I went to play the Newport Folk Festival in July of 1964. I don't have many memories of that event, but I do remember June and me and Bob and Joan Baez in my hotel room, so happy to meet each other that we were jumping on the bed like kids.

Later, of course, Bob and I sang together on his *Nashville Skyline* album and I had him as a guest on my TV show when that rolled around. In between we met a few times here and there, one of those occasions recorded by D. A. Pennebaker in his documentary film *Don't Look Back,* which chronicled Bob's European tour in 1965. June and I went up to Woodstock to visit him once, too. I remember some of that: Rambling Jack Elliot, that fine and loving gentleman, driving us up from New York; Albert Grossman, Bob's manager, putting us up at his house, where the food was great, the spirit free, and the hours flexible; Bob and I, and whoever else was around, indulging ourselves in lots of guitar picking and song trading. There's nothing on earth I like better than song trading with a friend or a circle of them, except perhaps doing it with my family. As Bruce Springsteen wrote, "Nothing feels better than blood on blood."

Thinking about *The Freewheelin' Bob Dylan,* I have to say that it's still one of my all-time favorite albums. If I had to answer that old but still interesting question, "What music would you want with you if you were stranded on a desert island?" (assuming your cell phone didn't make it through the surf but your solar-powered CD player did), I'd say that *Freewheelin'* would have to be on the list. So would Merle Travis's *Down Home,* which has "Sixteen Tons" and all those other great songs on it and was the first country concept album (*Ride This Train* was the second). Then I'd have to include Jimmie Davis's *Greatest Gospel Hits,* Emmylou Harris's *Roses in the Snow,* my

daughter Rosanne's *The Wheel,* an album of Rosetta Tharpe's gospel music, something by Beethoven, and *You Are There* by Edward R. Murrow.

I'd be entertained and inspired quite nicely, I think.

The 1960s were probably my most productive time, creatively speaking. I ventured out, testing different waters, and I really enjoyed that. And a lot of good songs came out of that period. Often I wasn't in my best voice, because the amphetamines dried my throat and reduced me, at times, to croaks and whispers, but that wasn't the story all the time, and my energy and output were high. I was in the prime of life, after all, my late twenties and early thirties, and it took a lot to knock me down either physically or creatively. Eventually the drugs did that, but in the first half of the decade I often had it together as far as my music was concerned. That's how it felt to me at the time, anyway, and that's how it sounds to me still.

Don Law, my producer at Columbia, was a great help to me, but as it happened neither he nor Frank Jones, who came in to replace him when he reached retirement age, had much to do with my biggest commercial successes of the '60s, "Ring of Fire" in 1963 and my two prison albums in '68 and '69. Jack Clement was the man who actually ran the session for "Ring of Fire," and both *Johnny Cash at Folsom Prison* and *Johnny Cash at San Quentin* were made after I'd switched to Bob Johnston as my producer.

"Ring of Fire," written by June with Merle Kilgore, raised a lot of eyebrows in Nashville because we used trumpets on it. Trumpets were *not* country instruments, or perhaps more to the point, nobody had thought of using them so boldly on a country record before. Technically speaking, I didn't think of doing so either. I heard Anita Carter singing the song, with trumpets framing her verses, in a dream. It still sounded good in my head when I was awake, so I called Jack, who'd moved to Beaumont, Texas, after leaving Sun, and asked him to come up to Nashville and help me get it done. I knew he was the only one who'd

see how it could work; there wasn't any point in even discussing it with anyone else. So he found the trumpet players, came on up, arranged the song, and ran the session, with Don Law and Frank Jones in the control room. He never got credit for it, just as he didn't get credit for a lot of the work he did with me after that, but he was always there when I needed him.

The prison albums were natural ideas. By 1968 I'd been doing prison concerts for more than a decade, ever since "Folsom Prison Blues" got the attention of the inmates at the Huntsville, Texas, prison in 1957. They'd been putting on a rodeo every year, and that year the prison officials decided to let them have an entertainer, too; they asked for me. I showed up gladly, with Marshall and Luther, and we set up right in the middle of the rodeo grounds. As soon as we kicked off, though, a huge thunderstorm let loose—I mean a *big* one, a real toad strangler—and that cramped our style considerably. Luther's amplifier shorted out and Marshall's bass came apart in the rain. I kept going, though, with just my guitar, and the prisoners loved that. Word got around on the prison grapevine that I was okay, and the next thing I knew, I got a letter from San Quentin, asking me to perform at their annual New Year's show on January 1, 1958. I went ahead and did that, and did it again for several years in a row, taking June with me the last couple of years. I didn't know until years later, when he told me so, that Merle Haggard had been in the front row for three of those concerts. He wasn't a trustee, so we never got to meet each other.

Those shows were always really hot—the inmates were excited and enthusiastic, and that got *me* going—so I thought that if I ever did a live concert album, a prison would be the ideal place for it, especially if I chose the kind of songs the prisoners could relate to. I didn't get anywhere when I approached Don Law with the idea, though; he just didn't like it. Then when Bob Johnston took over my production, I mentioned it to him, and he *loved* it. He said, "That's what we've got to do, first thing." I called a preacher friend of mine back in California, the Reverend Floyd Gressett, who went into Folsom to preach once a

month and knew the officials there, and we set it up. The rest of the story is right there on the album. I was about as relaxed as a bug in a Roach Motel, being still new to the business of getting up on stage in front of people without a bloodstream full of drugs, but once we were into it, that was one good show.

I've always thought it ironic that it was a prison concert, with me and the convicts getting along just as fellow rebels, outsiders, and miscreants should, that pumped up my marketability to the point where ABC thought I was respectable enough to have a weekly network TV show.

3

There's a storm coming at Bon Aqua, a big one that's blown all the way from the Pacific over the southern end of the Rockies and on through New Mexico, Texas, Oklahoma, and Arkansas to the Mississippi, then into Tennessee and straight across the 300 miles of slowly rising, rolling farmland to the little patch of 107 acres that Captain Weems, Uncle Pete, and I have all claimed, foolishly, as ours. The land doesn't belong to us; we belong to it.

I'm sitting in my library, looking out the westward-facing window at the strengthening rain and the blackening sky above the deep green fields of this beautiful place, and I feel good. This log house is a warm, strong, secure little cocoon. Short of a tornado, nothing can hurt me in here. When a storm rages, as this one is doing now, I get a kind of sensuous, intimate feeling, safe and snug, calm and content. It's a different sort of sensation from the anticipation of a storm. That's more excit-

ing: exhilarating because I know it'll be such a big and glorious show, moving such huge forces and touching the lives of so many men, plants, and creatures, and also thrilling on the small scale, in the tiny personal universe inside me. When I was a boy on the farm in Arkansas, not very far from here, an oncoming storm meant that soon I could run from the toil in the fields to the magic in the house—turn on the radio, listen to the music made far away, let it take me where it pleased. Now I'm often content, more than content, to listen to the storm itself.

I love weather. I'm a connoisseur of weather. Wherever my travels take me, the first thing I do is turn on the weather channel and see what's going on, what's coming. I like to know about regional weather patterns, how storms are created in different parts of the country and the world, what's happening at different altitudes, what kinds of clouds are forming or dissipating or blowing through, where the winds are coming from, where they've been. That's not a passion everybody shares, I know, but I don't believe there are any people on earth who, properly sheltered, don't feel the peace inside a summer rain and the cleansing it brings, the renewal of the earth in its aftermath.

For me such moments are open invitations to closeness with God. Nature at work isn't itself God, but it is evidence of Him, and by letting myself be drawn into its depths and intrigues, I can come near to Him: see the glory of His creation, feel the salve of His grace.

Any combination of religion and TV, or religion and secular celebrity, makes for dangerous ground, full of traps and pitfalls, marked out with lines that can be too fine to see, and that's especially true for the man standing in the glare of the spotlights. I should know; I've crossed a few lines myself and found trouble on the other side.

The most significant instance was when I made a public profession of faith on my network TV show. It wasn't something I was driven to do by an urge to convert anybody or spread the word of the Lord; I did it because people kept asking me where I stood, in interviews and letters to the network, and I thought I ought to make it clear that yes, I was a

Christian. I sang those gospel songs on the show not just because I liked them as music (which I surely did) and *definitely* not because I wanted to appear holier than thou, but because they were part of my musical heritage—our musical heritage—and they were part of *me*. Yes, in short, I meant the words I was singing. When I actually came out and said the words "I am a Christian" on TV, that was the context: introducing a gospel song.

ABC didn't like it. I had one of the producers come up to me and tell me that I really oughtn't be talking about God and Jesus on network television.

I didn't like *that*. "Well, then," I told him, "you're producing the wrong man here, because gospel music—and the word 'Gospel' means 'the good news about Jesus Christ'—is part of what I am and part of what I do. I don't cram anything down people's throats, but neither do I make any apologies for it, and in a song introduction, I have to tell it like it is. I'm not going to proselytize, but I not going to crawfish, and I'm not going to compromise. So don't you worry about me mentioning Jesus, or God, or Moses, or whoever I decide to mention in the spiritual realm. If you don't like it, you can always edit it."

They never did edit me that way, and I never made any big fuss with them about it after that; I just went on doing what I was doing.

In many ways my TV show was a lot of fun. Mostly I liked it because it gave me a chance to showcase the music and musicians who moved me, everyone from Ray Charles and Louis Armstrong to Joni Mitchell and Linda Ronstadt, as well as many Nashville artists who didn't usually get network TV exposure. I also really enjoyed putting the "Ride This Train" segment of the show together with people like Merle Travis and Larry Murray, taking those imaginary journeys through American history and geography. I was proud, too, that the whole production was done, at my insistence, in Nashville, which got a lot of good people involved in new kinds of work and, I hope, communicated to the rest of the country some of what made the place special. And of course it was nice that I only had to drive fifteen minutes to work.

It was also great getting to know the guest artists who came to Nashville to do the show and to add them to the musical melting pot we had going at the house. I'd started up an informal tradition of "guitar pulls" in the big round room overlooking the lake, evenings when my favorite songwriters were encouraged to show up (and bring *their* favorite songwriters) and we'd all sit around in a big circle and show each other what we had. Kris Kristofferson sang "Me and Bobby McGee" for the first time on one of those nights, and Joni Mitchell "Both Sides Now." Graham Nash sang "Marrakesh Express" and Shel Silverstein "A Boy Named Sue." Bob Dylan let us hear "Lay Lady Lay." Guy Clark came, and Tim Hardin, and Rodney Crowell and Billy Joe Shaver and Harlan Howard and everybody, just everybody.

We did all the TV shows from the old Ryman Auditorium in downtown Nashville, a converted church which had been the home of the Grand Ole Opry since 1943, and that was both good and bad. To my mind the good far outweighed the bad. The Ryman was *the* place, the true home of country music, slap bang in the middle of all the authentic stuff and the real country people, both musicians and fans, while on the other hand, the difficulties just weren't that significant. It appeared to me that ABC was perfectly capable of overcoming the problems of lighting, wiring, and so on with which the old building presented them, and I could bear the heat if they could. The Ryman wasn't air-conditioned; we hung a thermometer in the center of the auditorium one midsummer night and got a reading of 140 degrees. At times like that it sometimes seemed to me that the network people might have a point in wanting the show moved to New York or Los Angeles, but once I cooled down I held firm.

I was on tour in Australia when I got the news that ABC had decided against renewing my contract for a third year. I was relieved. It had been hard work, and it had taken a lot away from my other work and even more from my home life. My weekly schedule while we were taping the show went like this: Monday morning through Thursday afternoon, rehearsal and preparation; Thursday night, taping the show

itself; Friday morning to Sunday night, travel and concerts; Monday morning, back to work on the show. And the TV work was demanding, physically and creatively. I had to learn and perform new songs every week, both by myself and with the guest artist, and it was difficult getting to the heart of the songs in such a short time, then having to forget them and move on to new ones.

One thing's for sure: I could never have done the work if I'd been on drugs. Though a lot of people had trouble believing it, I was straight and sober for every one of those TV shows. I did them relying on God, not chemicals.

Now, I think, it's a little easier for Christians on TV. Religion isn't quite such a taboo with the networks and cable companies, and there are shows like *Dr. Quinn, Medicine Woman* and *Touched by an Angel.* Perhaps the executives in Manhattan and Hollywood are beginning to realize that the majority of people in the United States have some sort of religious conviction.

A word of further explanation about why I professed my faith in Jesus Christ on network television. I knew it would turn a lot of people off because it might sound like I was proselytizing, but I had to let the chips fall where they may. If you want to be a good Christian, and by that I mean if you want to be Christ-like, for that's what "Christian" means, you have to be willing to give up worldly things in order to stay true to your faith.

I felt I had no choice but to declare myself. I was getting thousands of letters, the great majority from fellow believers, asking, "People say you're a Christian. Are you?" or "You sing as if you believe in Jesus. Do you?" I felt I had to answer those people and everyone else who was wondering but hadn't written. I had to take a stand on my beliefs. I had always been a Christian—somewhere between an A and D Christian. I didn't believe I could compromise or evade when the question was put to me. I had to tell the truth.

When I spoke out, I simply made my statement. I never said, "You need what I've got because you're wrong and I'm right," and after I'd declared myself I didn't set out to prove myself; I didn't start acting any differently. I didn't have to, because I'd been acting according to my belief before I spoke up, getting my spiritual high by singing gospel songs and trying, despite my many faults and my continuing attraction to all seven deadly sins, to treat my fellow man as Christ would. There never was any dividing line between the Johnny Cash of yesterday, today, or tomorrow.

The worldly consequences of my declaration were severe, not just in lost record sales but also in some of the reactions from religious people, which ranged from attempts to use me for their own purposes to condemnations and exclusions from their particular folds. But I've never regretted speaking up, and I believe that when I get to the Pearly Gates, that's one of the trials God might have in mind if He were to say, "Come on in, J.R. You've been faithful in a few things."

To be practical about it, you have to admit that if you were in my shoes and believed what I believe, you'd have been a fool to choose a decade or two's worth of record sales over eternal salvation.

I'm reflecting tonight on an old gospel song, "Farther Along."

> Farther along we'll know all about it,
> Farther along we'll understand why.
> Cheer up my brother, live in the sunshine,
> We'll understand it all by and by.

With my TV show ending, I took stock of my situation and considered my options. On the strength of the body of work I already had, I thought, I could tour forever, and I just might do that.

4

A man who really helped me deal with my faith as a public person in the secular world was Billy Graham. He and I spent a lot of time talking the issues over, and we determined that I wasn't called to be an evangelist; that was work for people other than me. He advised me to keep singing "Folsom Prison Blues" and "A Boy Named Sue" and all those other outlaw songs if that's what people wanted to hear and then, when it came time to do a gospel song, give it everything I had. Put my heart and soul into *all* my music, in fact; never compromise; take no prisoners.

"Don't apologize for who you are and what you've done in the past," he told me. "Be who you are and do what you do."

I liked the sound of that and felt that Billy knew what he was talking about—he was familiar with the ways of the celebrity world in

movies, sports, politics, and entertainment—and so I trusted his advice. It fit with my own instinct.

I first met Billy through his initiative. He called me in 1970 shortly after John Carter was born, said he'd like to meet me, and asked if he could come visit me at home. I couldn't believe he'd want to, but I agreed readily, and he flew in from Asheville, North Carolina, and spent the night at our house in Hendersonville. We talked a lot during that visit, and I really liked him. By the time he left, we'd become friends. He didn't ask me to do anything for him, it was *I* who told *him* that if he ever wanted me to sing at one of his crusades, I'd be there. He took me up on that, and after June and I had worked a few of his crusades, we decided that we'd appear whenever he asked.

Billy and I have become very close over the years. He's been our guest at Cinnamon Hill several times, and we do the same things I do with any of my other guests: ride the golf cart down to the sea, go up into the hills and see the sights, rest and relax in the beautiful old house. That's given me many opportunities for long, private talks with him covering all kinds of ground. We've talked about the music business, with him wanting to know what some of my fellow entertainers are like, what problems they've had in their lives and so on; he was interested, but never judgmental. We've talked about the younger generation, too—he's always worried about the young people—and I've expressed my faith in them. We've talked about politics, and he's given me his impressions of the politicians and statesmen he's encountered in his ministry.

I've always been able to share my secrets and problems with Billy, and I've benefited greatly from his support and advice. Even during my worst times, when I've fallen back into using pills of one sort or another, he's maintained his friendship with me and given me his ear and his advice, always based solidly on the Bible. He's never pressed me when I've been in trouble; he's waited for me to reveal myself, and then he's helped me as much as he can.

Billy is a tall man, taller than the length of the antique beds with which June has furnished Cinnamon Hill, and so he has his own special place when he comes down to Jamaica. We even call it "the Billy Graham Room" with "the Billy Graham bed," a standard Jamaican-style four-poster with a pineapple motif carved into the headboard, but an extra foot's worth of side rails added in, and a custom mattress.

Which brings to mind a story about an element of Billy's human side, his shyness. He and Ruth, his wife, were staying with us in Port Richey for a few days. One afternoon we went out in the boat to one of the fishing houses built on stilts above the water about half a mile out into the Gulf from the river mouth; a friend of ours owned it and let us use it whenever we wanted. They're wonderful places, those stilt houses. They have a fishing deck on three of their four sides, basic sanitary facilities in an outhouse, and one big room inside. You can go out there with a friend or friends and, if you want, spend up to two or three nights entirely in another element, with just the sounds and sensations of the sea and the sky all around you.

The weather was gorgeous when we were getting ready to go out with Billy and Ruth, and it looked like being a beautiful night, so I suggested that instead of heading back in at nightfall, we stay in the fishing house and spend the night on the water. There were five beds in the house, more than enough. Billy agreed, so we got everything together and went on out.

Around sundown, about the time I started yawning, he spoke up. "Where are we all going to sleep?" he asked. By that time he'd found out that there was just one big room.

"Well, we'll each just pick a bed and sleep in it," I said, thinking nothing of it.

Billy didn't reply, but he looked a bit uncomfortable. To encourage him I said, "It'll be really wonderful, you know, going to sleep hearing the water lapping at the bottom of the house and everything. You'll be so glad you did it."

"Well, I'm looking forward to it," he said, and I took it that he was reassured.

Then, though, I started noticing that every time June, who had a slight cold, coughed, he looked at her sharply. And when she was still coughing a little after the sun went down and nothing remained but to prepare for bed, he spoke with authority.

"I'm worried about June," he said. "She can't stay out here tonight. It's a shame, but we'll have to take her in."

And so we did.

I met Richard Nixon around the same time I met Billy; I remember that John Carter was six-weeks old, asleep in our hotel room with Mrs. Kelly, our housekeeper, watching over him, while the president was giving a speech of introduction for my performance at the White House. He thought John Carter was asleep in the Lincoln Bedroom at the time—he'd told us we could put him down in there—and he made a joke about that: the way John Carter was going, he said, he'd probably be sleeping in the president's bed someday.

John Carter was a famous baby. His appearance had been anticipated for a long time as June became more and more obviously pregnant every week on our TV show, and when he finally appeared, his picture was on the front page of most of the major newspapers in the country. By the time we played the White House, Marshall Grant was joking that June and I should just lie low for a while and he'd take John Carter on the road. People would pay more to see him than they would to see me.

Another part of the president's introduction became notorious at the time. Someone on his staff had called the House of Cash, where my sister Reba handled my affairs, and told her that Mr. Nixon had asked that I sing three songs very popular at the time: "Welfare Cadillac," Merle Haggard's "Okie From Muskogee," and my own "A Boy Named Sue." Reba passed the request along to me, and I told her I'd be

happy to do "Sue" but I couldn't do either "Welfare Cadillac" or "Okie." The issue wasn't the songs' messages, which at the time were lightning rods for antihippie and antiblack sentiment, but the fact that I didn't know them and couldn't learn them or rehearse them with the band before we had to leave for Washington. The request had come in too late. If it hadn't, then the issue might have *become* the messages, but fortunately I didn't have to deal with that.

Somehow, though, the news leaked to the press that I'd refused the president's requests, and that was interpreted somewhere along the way to publication as an ideological skirmish. "CASH TELLS NIXON OFF!" was one headline, and the others pitched the same story.

Nixon understood perfectly why I'd really turned him down, but he played it up anyway. "One thing I've learned about Johnny Cash," he told the White House audience, "is that you *don't* tell him what to sing." It got a big laugh and made the press very happy.

After the performance he and Pat Nixon were the souls of hospitality. For almost two hours they gave us a tour around the whole White House, including their private living quarters—no other president has done that with me—and pointed out all the things they thought we'd find interesting. The president even had me lie down and stretch out on the Lincoln bed (and didn't charge me, either). He was really kind and charming with us, and he seemed to be honestly enjoying himself. It was getting late, though, close to midnight, and I worried that we were taking up too much of his time. I brought that up.

"Mr. President, you've been very gracious to entertain us like this, but I know you have more important things to do. Don't you think we'd better leave and let you get some rest?"

"Oh, no, don't worry about it," he replied jovially. "I'm going to Hawaii tomorrow to meet the *Apollo 11* astronauts after they splash down, so I'll sleep on Air Force One. I'll be fine. I'll get plenty of sleep." So we relaxed and had a good time. We didn't talk about politics at all.

He made a very good impression on me. I couldn't detect any artifice or calculation about his friendliness and interest in me, or his

enjoyment; it seemed to be the real thing. That, I thought, must be what made him the consummate politician: the ability to focus, naturally, on whoever he was with and make them believe that at that moment they were the most important person in the world to him. I certainly felt, with some wonder, that I was being given priority over the crew of *Apollo 11* just then hurtling back toward the earth's atmosphere as the whole world held its breath.

President Clinton has that same quality. He hasn't afforded me the same attention Mr. Nixon did; but in my brief encounters with him I've seen how he can focus right in on you—look you straight in the eye and seem to be concentrating totally on what you're saying, or indeed to be really doing that, not pretending. He too has given me a tour of the White House, but not quite so intimately as Nixon did; I was with June at a reception for the Kennedy Center Honors, and he took me and the other 1996 honorees off and showed us around. He was very gracious, and completely open to anything we wanted to talk about. Most of the talk was light, of course; it was that kind of event. The White House Christmas tree, I remember, was beautiful, covered with ornaments from all over the world, a real dazzler. It took about twenty minutes for the Clintons to make their way around it, telling us about all the decorations, who they came from, where, and what they symbolized. I should say that I *think* there was a tree under all that stuff, you couldn't really tell.

I personally didn't have much to say to Mr. Clinton. There was a point during the intermission in the Kennedy Center show when he came over to me and we made some sort of small talk for a little while until I found myself standing there with a Coke in my hand, nodding, not knowing quite what to say. As I happened to be looking down at my feet at the time, I looked at his, too, and said, "Mr. President, what size shoe do you wear?"

"Twelve D," he said. "What do you wear?"

"I've got you beat," says I. "Thirteen D."

So there.

Another thing I noticed about Mr. Clinton was that he and his wife seemed to be in love. The way they held hands, the way they looked at each other—it had the feeling of real lovers together.

June and I had attended a function in New York with Hillary Clinton a few weeks earlier. It was a very small gathering at which they asked me for a few songs and I obliged, singing "Tennessee Stud," and some funny songs and spiritual songs and telling stories about Arkansas. That felt good, but I think Hillary was a little uncomfortable when I sang "The Beast in Me," Nick Lowe's dark little acknowledgment of how far out people like he and I can get, but other than that it was a fine evening, and it reminded me that I've always liked her. I don't care what she did in Arkansas. I like her husband too, even if I've never voted for him. Come to think of it, I didn't vote for Nixon, either.

Nor Ronald Reagan. He of course is a genuinely nice man—everybody knows that—even if he was also an actor above everything else. We had lunch at his White House, and I remember him as very friendly and down to earth. That affair felt strange all the same, though. Loretta Lynn and her husband, Mooney Lynn, were there with us, and she and I found ourselves hanging together amid people who were almost all strangers. Jimmy Carter and his people were recently gone from office, and we didn't know any of the new crowd. Loretta came up to me at one point and said, "It just don't feel right, does it, Johnny?"

"What doesn't?" I replied.

"Reagan in the White House," she said.

I had to agree. "Yeah, it felt pretty good with Carter here, didn't it?"

"It sure did," she said, sadly.

Jimmy Carter is a cousin of June's and we've known him since I was playing a show in Lafayette, Georgia, and he was running for governor. We'd been seeing flyers with his name on them, and then we saw him going around pasting them up himself. He saw us, came over, and introduced himself; he made a good impression, so that night at the show I brought him on stage and had him take a bow. The people really liked him; the applause was strong. After that, he and his

brother, Billy, and my friend Tom T. Hall got to be pretty close friends. Whenever he came to Nashville he'd stay with Tom T. and Dixie, and June and I would go over there for dinner if we weren't on the road. So he was family by blood, and just about family by heart.

He was the busiest president I've known. Our first visit to his White House was a whirlwind. When June, John Carter, and I got there and were taken to him, he said, "I've got a pretty crowded schedule today. Would you three run around with me to my meetings?" We barely had time to agree before he was out the door of the Oval Office and down the hallway, walking so fast we almost couldn't keep up with him. He'd duck into one meeting room where forty or fifty people were waiting for him, do his bit there, then march off to another. Each time he'd introduce June as his cousin and me as her husband, make his speech, then march off to the next room and do it again. He didn't seem phased at all when we finally got back to the Oval Office, but we needed a nap.

Gerald Ford, who had the same gift of focus as Nixon and Clinton, was also a very nice man—everybody knows *that*—and being with George Bush was like spending time with an old friend from home, talking about hunting the Texas hill country. It's not surprising, really, that all the presidents I've known have had a lot of personal charm. If they hadn't, they'd never have gotten to be president.

5 Anyone who talks about the early 1970s has to talk about Vietnam, of course. I've got a reminder right here in front of me on the wall at Bon Aqua, a print of the drawing from which the statue for the Vietnam War Memorial in Washington was created. It came with a note from the artist, which is displayed beside it:

> Johnny, I specifically wanted you to have this print as an expression of my appreciation for the values and principles you have so eloquently represented through the years. Where you choose to hang this drawing you reserve a place for honor. From your heart you are saying "Welcome home."

Welcome home. So many of our boys never heard those words. I'll never forget standing with our friend Jan Howard at the funeral of her

son and the terrible feeling that came over me as they folded up the flag that had been draped over the coffin and handed it to her. I loved that boy; I'd seen him grow from a baby. It just tore me to pieces to see him and other boys all around us, just eighteen, going off to fight those other boys in Southeast Asia. I had no really firm convictions about the rightness or wrongness of the war; my mind just wouldn't approach it at that level when my heart hurt so badly.

June and I went there, in the spring of 1969, just after the Tet Offensive. We stayed in a trailer at the big base at Long Binh the whole time, singing for different units of troops every night and visiting men in the hospitals every day, especially the ones who'd just been medevac'd in from the field. We watched them carry the soldiers out of the helicopters, torn and bloody and filthy, often reeking of napalm, sometimes burned almost beyond recognition as human beings. I almost couldn't stand it.

Long Binh at that time was "hot," with patrols and sweeps going out and enemy rocket and mortar rounds coming in. One night in particular the incoming fire was so close that our trailer kept jumping off the ground as the rounds impacted; when dawn finally broke and we were still alive, we noticed in a dazed kind of way that our little home was a few feet away from where it had been when we went to bed.

We'd go into the hospital and talk to the boys who could hear us and talk back, and June would write down their names and addresses and the telephone numbers of their loved ones back home, with notations about their wounds. When we laid over in Okinawa on our way back to the States she called all those numbers. Sometimes she could say, "I saw your son, and he looks okay, and he's going to be all right." Other times, when she'd seen that there was no hope, she'd say, "Well, he's hurt pretty bad, but they think he might be okay. He said to say hello, and he misses you."

The most vivid memory I have is of a night I sang in a big dining room full of soldiers who were going out into the boonies the next morning. They were all drinking—they were all *drunk,* as I would have

been if I were in their shoes—and emotions were running pretty high. When I sang "The Ballad of Ira Hayes," one soldier down front started crying, and his buddies picked him up and put him on the stage with me. When he got beside me I could see that he was a Native American; we stood there together, with him crying all the time, and sang our way together through that song:

> Call *him drunken Ira Hayes*
> He *won't answer anymore,*
> Not *the whiskey-drinking Indian*
> Nor *the Marine who went to war.*
>
> BY PETER LaFARGE, © 1962, 1964,
> EDWARD B. MARKS MUSIC COMPANY

We know what happened to Ira Hayes, who was a real person as well as a name in Peter LaFarge's song: he drowned in two inches of water in a ditch on the reservation, another no-hope, forgotten Indian. Years before, he'd volunteered for the United States Marine Corps and, after fighting his way ashore on Iwo Jima in February 1945, survived to become one of the men who hoisted the flag on the peak of Mount Suribachi in that great symbolic moment of American victory, hope, and sacrifice.

We don't know what happened to the man who sang with me about Ira Hayes that night, or at least I don't. All I know is that he and his buddies went out in the Hueys at dawn. I have no idea how many came back alive.

The hardest thing for me in Vietnam wasn't seeing the wounded and dead. It was watching the big transport jets come in, bringing loads of fresh new boys for the war.

We were everywhere in the early '70s, all over the country and the world, and "we" were quite a crowd. As well as June, John Carter, and myself, we carried a full complement of Carters, the Tennessee Three,

Carl Perkins, the Statler Brothers, Lou Robin, Mrs. Kelly, and whoever else I thought we needed: makeup artists, hairdressers, security people, everybody. And for a time everybody flew first class. Our party alone would have the whole first-class section on some flights. I was sitting there in my nice big seat one time, and Muhammad Ali came by on his way toward the coach section.

"*Now* I see why I can't get a first-class ticket!" he said. "Johnny Cash has got 'em all."

I offered him my seat and meant it, but he declined.

"Nah, I won't take your seat," he said. "I won't take any of your people's seats. You got there before I did, so you go ahead and enjoy it." That is one sweet, kind man, and not just because he let me keep my seat; he's just one of nature's best. He wrote a poem for me, "Truth," which I still have in my vault. One day I'll set it to music and record it.

Those were such busy, demanding days. Often they were exhilarating, but sometimes it felt like I was just a passenger on the Johnny Cash train, powerless over my destination, speed, or schedule. Still, I *was* riding first-class, and that made up for a lot. Considering what other people have to do every day to make a living or just to survive, I don't like hearing performers whine about the pressures of too much success, and I get pretty uncomfortable when I do it myself. There was no incoming on the road; nobody had to worry about napalm or B-52 strikes; nobody was being hunted or starved or tortured.

I was going at it hard. I've got one of my old date books with me here, open to the first week of January 1974. This is what it tells me:

Right after Christmas I left my family in Jamaica and flew to California to shoot an episode of *Columbo* with Peter Falk. While I was there, Kris Kristofferson came to my hotel room and sang Steve Goodman's "City of New Orleans" for me, which I declined as a recording prospect, as I've mentioned, to my eternal regret. Rosanne, too, came to see me on that trip; I remember the three of us, Rosanne, Kris, and me, sitting around trading songs.

Peter Falk was good to me. I wasn't at all confident about handling a dramatic role, and every day he helped me in all kinds of little ways. I only got mad at him once. He was telling me how to deliver a line, and he said, "I'd do it just like this—or however you people say it down there."

I just gave him a look and said, "Well, we people would probably say it just about how you people say it up there." To let him know I wasn't still fresh off the farm; I'd been to town.

There was a part for the band in the *Columbo* script, doing "Sunday Morning Coming Down" on a lawn, and they were flying in to join us when I got the news that Clayton Perkins, Carl's youngest and only surviving brother, the wildest, funniest, and hardest-drinking of the original three, was dead. He'd shot himself—accidentally or intentionally, we'll never know, because he was always playing with guns and people were always telling him he'd kill himself that way. Carl, on the plane with the Tennessee Three, hadn't heard yet.

I never did anything with so much regret, but I had to do it. I called the airport and talked to Fluke as soon as he got off the plane, told him the news, and asked him to bring Carl to the phone. Carl needed to hear about it right then, on the phone, because I knew he'd want to return to Tennessee immediately.

"Carl . . ." I began as soon as he got on the phone.

"What's wrong?"

"There's something bad wrong, Carl."

"Who is it? My mother?"

"No."

"My daddy?"

"No, Carl."

"Oh, no. It's Clayton, isn't it? What happened, John?"

"Well, Carl, the report is that he killed himself. He's shot himself in his bed with his pistol."

For a while Carl was off the phone, crying out of control, but finally Fluke came back on and said he'd take care of putting him on a flight back home. He did that, then came on into Burbank, and he and

Bob and Marshall did the *Columbo* scene without Carl. I finished my own work, and then I went back to Jamaica for a few more days with my family.

About the only saving grace in that whole situation was that Carl wasn't drinking in '74. I can't imagine him dealing with the weight of that loss, drunk. Well, that's not true; I can imagine it all too well.

I'll turn some pages here, to March 31, 1974. That day I did a benefit for an autistic children's home in Sumner County, Tennessee. The home got no public funding because autism wasn't on anybody's list of favorite charities back then (and still isn't). April 2–7, I played the Houston Music Theater with the entire crew, Carl included. On the 10th and 11th I was at home, but working: recording in my studio at the House of Cash. It doesn't say here *what* I was recording, and I don't remember. On the afternoon of April 12 I made a free appearance near home in Hendersonville with a preacher, James Robison, as a special favor for my mother, who admired him greatly and wanted to help him get started in his career (he's big on TV today). That same evening I played a free show for the inmates of the Tennessee State Prison.

Three days the next week, April 15–17, I taped a Grand Ole Opry TV special. On the 19th and 20th I had paying dates in Chattanooga and Johnson City, both in Tennessee. April 22 and 23 I was back again at the House of Cash, coproducing an album on Hank "Sugarfoot" Garland with my in-house engineer, Charlie Bragg. Hank, one of the great old guitar players, had been out of the business for a while following a bad car wreck and was trying to get back into playing. They were good sessions; we got some great stuff on tape, but we could never get a record company interested.

Two days later I opened at the Las Vegas Hilton for a week, and after that I went on tour in Australia. And so went a typical month.

In those days I got as much criticism for playing Las Vegas, consorting with the whores and gamblers, as I did for doing prison concerts. My response was that the Pharisees said the same thing about Jesus:

"He dines with publicans and sinners." The apostle Paul said, "I will become all things to all men in order that I might win some for Christ now." I don't have Paul's calling—I'm not out there being all things to all men to win them for Christ—but sometimes I can be a signpost. Sometimes I can sow a seed. And post-hole diggers and seed sowers are mighty important in the building of the Kingdom.

Carl had become a Mason after he got sober, and for a while he was very eager for me to try that. "Come on, John. Come with me to the Hendersonville chapter," he urged. "Let me introduce you to the men there. Then they can have a meeting and invite you in, and it will change your life. It'll be a wonderful thing for you."

Eventually I agreed, and we went to meet the Masons. I worked my way around the room shaking hands, and I'll never forget the way those men looked at me; it was as if they were being asked to kiss a rattlesnake. Right then and there I got the feeling that I wasn't going to become a Mason.

Doubtless they had certain images in mind. It was only a couple of years since I'd gotten away from pills, and a little more than that since every newspaper in the country had carried a photo of me being led into jail in handcuffs after buying amphetamines from the wrong pusher. Evidently the progress I'd made since then didn't count for much; I left the place with a less than lukewarm "You'll be hearing from us" rolling around in my head, gathering little charged particles of embarrassment and anger, and sure enough, in a couple of weeks a letter arrived informing me that my application was rejected "on moral grounds." I raged at the walls and ceilings for a while, and then I called Carl and raged at him, telling him I never wanted to hear another word from him about the Masons as long as I lived. I haven't.

I don't know. Maybe I'd have made a good Mason.

I'm flipping pages to 1976, seeing a long European tour, a Lionel Train commercial, a Billy Graham crusade, a Youth for Christ benefit in

Sacramento, a Bob Luman session at the House of Cash, a commercial for Victoria Station, another free concert in Davenport, Iowa, for another preacher who talked me into it, and concerts, concerts, concerts: the Indiana State Fair, the Nebraska State Fair, the South Dakota State Fair; Toronto, St. Paul, Wolf Trap—altogether, fifty-two paying performances in the first half of the year. For the Bicentennial I went to the nation's capital, where I gave a concert at the Washington Monument and then rang the replica of the Liberty Bell which was Great Britain's bicentennial gift to the United States, swinging that clapper two hundred times in front of a huge, happy crowd in the light of the rockets' red, white, and blue glare. The bell had a very good tone.

Even on that night, passenger flights were taking off from the Washington airport, very close to downtown, then climbing steeply on full power as they usually do in that airspace. From the crowd's perspective it seemed as if the fireworks were chasing the planes up the sky like missiles. People loved it: they laughed and cheered whenever a rocket exploded into what looked like a direct hit. The war was over by then, of course.

6 You could say that the heart of this old house is in my personal private library, and you could say, too, that Pop Carter's books are the heart of that library. He began passing them along to me in the late '60s, one by one, like trail guides to the new paths I was taking, and I still use them on my voyages of discovery today. The deeper into them I go, the more I find to hold in my hand and ponder and the more to reach for on another day—an endlessly absorbing journey, rich beyond my most ambitious imagining.

They're in the spirituality section of my library, next to my history and Americana shelves: *The Life of Christ* by Fleetwood and the same title by Farrar; *The Life and Acts of Paul the Apostle* by Conebere and Howsom; Lang's whole set of Bible commentaries, about thirty volumes; various books on various aspects of the Holy Land—its history, its archaeology, its horticulture—and many others in a similar vein.

They're all showing their age, and they have that old-book smell, which you'd expect since the very newest of them date from before Pop Carter's death more than twenty years ago now, but they're not dusty. I read them. I never tire of learning about the lives and times of the early Christians, the customs and traditions of the Palestinian Jews, the politics of the Roman Empire, and the trials of Christ's church in its first century. I've often found strength in the faith and courage of some of those early church fathers who kept the Word alive for us and refused to reject the Gospel in the face of torture and execution.

Pop Carter was the one who really got me going on Bible study. I liked him a great deal, and learned a great deal from him in the days after I came out of Nickajack Cave. A self-taught theologian and dedicated scholar, he was also a warm and caring man with a lot of good common sense, and he made a great instructor and discussion partner, feeding and stimulating the hunger for spiritual truths that led me after a while into more formal Bible scholarship through correspondence courses. June and I both enrolled in a study program, and for three years we spent much of our time on airplanes, in hotels, and on the bus doing our lessons. We both graduated. I can't speak for June, but for me the experience was both exciting and humbling; I learned just enough to understand that I knew almost nothing.

The spiritual well is so deep and unfathomable, but some beautiful water flows out of it. That's partly what John Carter and I had in mind when we wrote "Waters from the Wells of Home." The song wasn't just literal (though it was that too).

As I stroll along the road to freedom
Like a gypsy in a gilded cage
My horizons have not always been bright,
But that's the way that dreams are made.
Days all seem to run together
Like a timeless honeycomb;

I find myself wishing I could drink again
Water from the wells of home.

I've seen all the shining cities
Lean against a yellow sky;
I've seen the down and out get better,
I've seen many a strong man die.
Oh, the troubled hearts and worried minds
And things that I've been shown
Keep me always returning
To the water from the wells of home.

Always pray to go back someday
To the water from the wells of home.

BY JOHN R. CASH AND JOHN CARTER CASH,
© 1987 SONGS OF CASH, INC., AND AURIGA RA MUSIC

I believe that God's will for me is that I be content, even happy, and I know from experience that I'm happiest when I'm closest to Him, so it's no mystery why Bible study pleases me so. It's one of the ways I get to the well.

I don't feel any shame about my past today, but I do have some regrets about the time I've wasted, and one of the ways I work on that is to have a Bible next to me when I turn my TV on. I'm a channel surfer, so I flip through whatever's on, looking for something that grabs me—usually on A&E, CNN, PBS, the Discovery Channel, or the History Channel. But I've trained myself to turn the TV off right away if I don't find anything and pick up my Bible, either the old King James or the New International Version. I find a passage in one version that intrigues me and pick up the other to see how it's worded there; then I chase it down in one or more of the commentaries until I find what it really means. Once I learned what the Bible is—the inspired Word of

God (most of it, anyway)—the writing became precious to me, and endlessly intriguing. Every scripture has a realistic interpretation, but finding its spiritual interpretation is truly exciting. Sometimes, I'll suddenly understand that something I've been hearing all my life has a deeper, more beautiful meaning than I'd ever realized. That's a thrill, and more: usually at such moments I've just learned something new about how we humans are, and how to live in this world.

Here at Bon Aqua or at home in Hendersonville, I start most of my mornings with coffee, then CNN, and then the Bible, and that sets me up for a good day. On the road the habit is harder to keep, but usually I have a King James by my side on the bus, and wherever I am I have my Franklin Electronic Bible in my briefcase. That's a wonderful tool—just punch in what you're looking for, hit "Enter," and there's the scripture you want. I'm the spokesman for that product, and anything good you hear me say about it you can believe. At home my most-used tool is the Thompson Chain Reference system.

These days the man I go to for advice and inspiration in Bible study is Jack Shaw, a friend who's a minister in Johnstown, Pennsylvania. Sometimes we talk for a long time. Sometimes I call him and just say, "Hey, Jack, what's the good word for today?" and he reads me a scripture he's been thinking about, then sends me off to chase it down in the commentaries.

He's by no means the only man of God who's helped me over the years: the Reverend John Colbaugh, now preaching in Louisiana, became a close friend and anchor in the storm during my first years in Hendersonville. The Reverend Harry Yates, my sister Joanne's husband, is a great man to talk to on matters of the spirit, and so is Joanne herself; she's earned a master's degree in theology in recent years. And of course the Reverend Jimmy Snow, to whose Nashville congregation June and I belonged for several years, was and is a great preacher and teacher. It seems to me that God has always sent such people into my life just when I needed them. If Sam Phillips at Sun Records and George

Bates at the Home Equipment Company back in my Memphis days were angels in disguise, my Reverend friends have been angels in the open, obvious even to me.

The movie *Gospel Road,* as I've said, was the most ambitious project I've ever attempted. Its seed was planted during a vacation June and I took in Israel in 1966, and it grew in the period after I came out of Nickajack Cave, when I was most intensely involved in Bible study. The works I was reading, especially the nineteenth-century commentaries from "The Age of Higher Enlightenment," as they called it—and novels too: *The Robe, Quo Vadis, The Silver Chalice, Pillar of Iron*— drew me so powerfully into the story of Christ's three-year ministry on earth that I began to feel almost compelled to retell the story in my own words. I began writing with no clear picture of where I was going or what, if anything, I would do with the result.

The idea of going to Israel and making a movie emerged one morning when June woke up and told me about a dream she'd had in which she saw me on a mountaintop in the Holy Land, talking about Jesus. That seemed like a sign—one of many—and so I set to work. I enlisted the help of Larry Murray, my friend and the cowriter with Merle Travis of my TV show's "Ride This Train" segments, and we started working up a screenplay from the outline I'd been writing. It was finished in the fall of 1971. In late November of that year we set off for Israel to make a 16- millimeter, semi-documentary movie of the life of Christ, shooting wherever possible in the places where the events depicted actually took place.

We were stepping out on blind faith, using our own money and resources, with no outside sponsorship or any arrangements for distribution of the film. We took almost forty people with us, just about everybody who worked for me in the music business, and while many of them volunteered their time, I paid everyone's travel and room and board. I was more than happy to do so; a lot of money was coming through the door in those days, and I literally couldn't think of any better way to spend it.

We shot in Israel for thirty days with two cameras running almost all the time—a nightmare at editing time—and for me those days were intense and exciting. Much of what happened was self-evidently true, but it seemed strange; mysterious, often almost magical.

There was nothing big, just a succession of little things, almost every day. When we were filming on Mount Arabel, overlooking Galilee, June came up to me as I worked and said, "This is the mountain I dreamed about; this is where I saw you talking about Jesus." When we got to the Church of the Beatitudes, which we'd been told was closed, the custodian was there with the key; he'd just had a feeling, he said, that somebody was going to need to film in the church, so he'd come and waited for us. And while it didn't rain for twenty-nine of our thirty days in the Holy Land, it did rain a little, just enough, on the only day when we needed it to, just as we were shooting the scene in which Jesus calms the storm on the Sea of Galilee. Every way we turned, doors opened—some that had been closed, some we didn't even know were there.

We had some wonderful helpers. Joe Jahshan, from Jerusalem, one of our driver/guides, was plugged in with all kinds of offices of the Israeli government, and even though his car had license plates identifying him as an Arab, he could go anywhere and get anything done. He is a great man; John Carter grew so fond of him on later visits to Israel that he and Mary named their firstborn son, Joseph, after him. Our other driver, Shraga—Ben Joseph—was Jewish and had fought in the army. He was good at getting us into restricted areas like the Golan Heights, where the fiercest battles of the Six-Day War had been fought.

We found actors as easily as everything else. In need of twelve disciples, we placed an ad in the *Jerusalem Post* detailing our requirements, and on the appointed day about fifty young men gathered in the lobby of our hotel. They were a highly unusual collection of individuals—Swedes, Danes, Germans, Swiss, French, British, Americans, dropouts and draft resisters, seekers and adventurers and escapees from something or other, some of them half starved and sleeping in the streets,

none of them with money or means—and it wasn't hard at all to find the faces of our disciples in their ranks. One was obviously James, another John, that one Matthew, this one Mark. The young man who seemed like Peter turned out, most fortunately, to be a professional actor, Paul Smith, and did a fine job. We were well satisfied with the men we chose; they all did right by us in Jericho, in Nazareth, everywhere.

Both Larry Murray and our director, Bob Elstrom, did great work in Israel, and Bob and his editors performed virtual miracles in the editing room later, turning immense amounts of footage, much of it more or less improvised from day to day on location, into a coherent work. So despite the odds, it worked; it really did. The film is still out there doing its job today, circulated by the Billy Graham Evangelistic Association.

The other project to come out of my Bible study was my novel, *Man in White*. The last of my correspondence courses was on the life of St. Paul the Apostle, who fascinated me greatly, and eventually the thought occurred to me that I could do with his story what I'd done with that of Jesus in *Gospel Road:* tell it my way for my own benefit and that of anyone else who might be interested. Writing a novel was something I'd never done, so that's the form I chose.

It took me a long time, years and years during which my energies focused for a spell, then went somewhere else—music, drug abuse—but I kept at it, and eventually I finished it and got it published in 1986, which made me the first published novelist in the family (though neither the last nor, I expect from what I read of Rosanne's work, the most celebrated). The title *Man in White* comes from Paul's vision on the road to Damascus, the event that turned his life toward Christ. As with *Gospel Road,* the process of creating it and making it public was deeply rewarding and fulfilling for me. It was like giving back a little of what the story of Paul had given me.

Paul fascinated me so because, as well as experiencing such a dramatic conversion, he endured such trials of faith—he was shipwrecked,

beaten with rods, thrown in boiling oil, snake-bitten, stoned and left for dead—but he was still able to say, "In any situation I find myself in, I am content because of Jesus Christ." I wanted some of that.

Also interesting, for me at least, were the parallels between Paul and myself. He went out to conquer the world in the name of Jesus Christ; we in the music business, or at least those of us with my kind of drive, want our music heard all over the world. He was a man who always had a mission, who would never stop, who was always going here, going there, starting this, planning that; a life of ease and retirement wasn't on his agenda, just as it isn't on mine. I'm much more interested in keeping on down the roads I know and whatever new ones might reveal themselves to me, trying to tap that strength Paul found: the power of God that's inside me, that's there for me if only I seek it.

7

Theologically, June and I are on even ground, but she's a prayer warrior and I'm not. She's so good at it, in fact, that sometimes I catch myself thinking that, well, maybe I don't *have* to pray, because she's praying *for* me. Which of course is not a healthy idea and demonstrates one of the reasons she needs to pray so hard for me.

Always, though, the first thing I say when I get up in the morning, whether or not June's with me, before my feet hit the floor, is "Good morning, Lord." Then, by the time I'm on my feet, I say, "Praise God." I know that's not much—it's not the prayer Jesus taught us—but it's my way of establishing immediate contact with my Creator. At some time during the day I usually manage to recite the Lord's Prayer, if only to myself, silently.

* * *

The publicity in the 1960s was that June saved my life, and I sometimes still hear it said that she's the reason I'm alive today. That may be true, but knowing what I do about addiction and survival, I'm fully aware that the only human being who can save you is yourself. What June did for me was post signs along the way, lift me up when I was weak, encourage me when I was discouraged, and love me when I felt alone and unlovable. She's the greatest woman I have ever known. Nobody else, except my mother, comes close.

I wish the whole world could know how great she is. She's smart and she's brilliant. She's got a great personality. She's easy to live with, because she makes it a point to be so. She's loving. She's sharing. The main thing, though, is that she loves me and I know it. I used to take advantage of that—because I knew she loved me, I could get away with more—but again, that's not a healthy idea, and it demonstrates one of the reasons why she needs to love me so much. I don't do it so much these days. Perhaps she prayed me out of it.

June is formidable; she's my solid rock. She's my spark plug. When there are people to talk to and my shyness is welling up inside me, she holds my hand, fronts for me, and makes it possible, though not easy, for me to act with enough grace to avoid hurting people's feelings. As I've said before, I'm just fine on stage in front of ten thousand people I don't know, but I'm all awkwardness backstage with ten. June always sees that I've got the right thing to eat, if I'll agree to eat it. She likes the same kind of movies I do, and the same kind of TV shows.

She's got charm, she's got brains, she's got style, she's got class. She's got silver, she's got gold, she's got jewelry, she's got furniture, she's got china . . . she's got a black belt in shopping.

She's the easiest woman in the world for me to live with, I guess because I know her so well and she knows *me* so well, and we get along handsomely. If it looks like there's going to be some tension between us, we talk it out and work it out, or I take a walk and she takes a drive until it's over. Grandfather Rivers taught me that—"Your Grandma

and I never fought, but I took a lot of walks," he said, and that's what I do. By the time I'm back from a walk I'll be looking at the problem differently, and so will June. Whatever I do, I try not to blow up the way I used to, just explode and say angry and hurtful things. Then the pain is there, the damage is done, and there's no taking it back, no matter how many amends I make. These days I don't even have to walk away very often. June and I are usually on a pretty even keel in our home life, our social life, and our work.

She's a vital performer, and it's vital for me to have her on my concerts. This thing between us has been happening since 1961, and I just don't want to travel if she can't come with me. She almost always does. She's my life's companion, and she's a sweet companion. She's very loving, especially with me, and very kind—there are people who can be loving, but not kind, but she's loving *and* kind. She does everything she can to help me along with my day. She's a good woman. She's got standards. She's got tradition. She's got dignity. She's got china . . .

When we come in from a tour, we both need time and space apart, so I'll pack up my little suitcase and head out here to the farm, and she'll pack her suitcase and head for New York City. It's necessary, I think, for marriage partners to have some free time apart from each other. I've found it to be true in my own marriage, and it's straight from Scripture; Paul exhorted us to spend time apart so that our coming together is stronger. June and I don't let it go many days, though. Usually we're ready to be back together after just two or three.

She likes to go to New York and shop. She loves wheeling and dealing and haggling with her favorite jewelers in the diamond district and coming home with all these bargains, all this money saved—she saves me so much money, sometimes, that I just don't know where to spend it.

I don't mind, really I don't. She's earned her black belt. It's her right and her prerogative. She puts as much time into the family business as I do, and I'm only too happy to share the whole thing with her.

She and I have become so very close, so intimate. I think it might be because of all her prayer. I never see her praying, though, or at least

not when it's obvious. Sometimes I'll catch sight of her on a plane, say, moving her lips with her eyes closed, and I think that's what she's probably doing.

So yes, we're so close. Whenever I face a professional decision I always put it to her and get her opinion, because I know she'll be both objective and honest with me, and she's always the first to know about everything in my life. She's never judgmental. She lets me keep my small measure of dignity and prestige in both our relationship with each other and our relationship with the world. She's become everything that a wife should be, in my mind. We sleep together, we play together, we travel together, we work together, and we've both found our particular place where we totally belong, in every avenue of endeavor.

I'm not bad at shopping myself—not in June's league, but not totally untalented either. I built up a pretty impressive gun collection in my younger days, mostly classic nineteenth-century American pieces, Colt single-action revolvers and the like, mostly gone now, and these days I love to look for books. When I go to New York, one of the main attractions is the variety of antique and specialty bookstores. Usually we stay in Midtown Manhattan, in one of the hotels around Central Park South, and that's a great location for a bibliophile. A walk along 57th Street and down Fifth Avenue can turn up all kinds of treasures. The last time out I bought a very good edition of Trail's *Works of Josephus*, to my mind a much better translation than Whiston's.

I was walking down 57th Street with June one Sunday morning when we happened on the First Baptist Church of New York, which we hadn't noticed before because its entrance doesn't look like a church's. We saw from a sign outside that services were just about to start, so we went in, and the strangest thing happened. The congregation was seated as we entered, but about halfway down the aisle a young boy was turned around watching the door. He saw us, immediately jumped up, and yelled, "JOHNNY CASH!! Johnny Cash has come to church with me!"

As it happened, the only free seats were right next to him and his parents, so we took them, and that's when we saw that the boy was mentally handicapped. He was so excited. "I told you!" he kept saying to his parents. "I told you he was coming!"

The preacher came over and explained to us that, yes, the boy had told his parents, and the whole congregation, repeatedly that I was going to walk into that church, sit down beside him, and worship with him. And that's what I did. Being next to him was such a pleasure. He was so happy.

When the service was over, we walked down to the corner with him and his parents, and they filled in the story. They were Jewish, they said, but their son had decided to become a Christian after listening to some of my gospel recordings. That's why they were in a Christian church on a Sunday morning. They were in that *particular* Christian church because that's where he knew I was going to walk in the door.

When I was twelve, I was confused. My father didn't experience a conversion to Christianity until my brother Jack's death in 1944. The question is, what was he converted *from?* In his later years he became one of the sweetest, kindest souls I've ever known—particularly during the final few months, when he showed his love and concern for everybody who came to see him in the hospital—but I had memories of times when his ways could be harsh.

At the most basic level, the first time he ever told me he was proud of me was after I became a recording artist. He never once told me he loved me, and he never had a loving hand to lay on any of us children. He said once that he didn't have to tell people he loved them for them to know it, and perhaps that was true. Still, it would have meant an awful lot for me to have heard it, just once, before he died.

Some of my strongest early memories, and certainly my worst, are of the times when he'd come home drunk. I can remember waking up early one morning when I was eight to hear him yelling at Moma, rag-

ing and cursing. He went on and on, storming around, cutting her off when she tried to talk back to him until he said he'd had enough; he was going to beat her.

He started toward her to do just that, but Jack was up by then and he stopped him. Jack was only ten, but he stood up from his seat at the table and said, "You may hit Moma, but you're going to have to hit me first 'cause you're not gonna hit Moma. You may think you're gonna hit Moma, but you're not, Daddy. You're gonna have to hit me first."

Daddy stormed out the back door and into the fields. He never laid a hand on Jack, or me either.

I still remember that as the greatest nightmare of my young life, hearing my mother and dad fight. The subject of the argument that began the fight was Moma's desire to move back to the hill country where her people lived. Daddy wouldn't do it.

He also killed my dog. It was a stray that I'd picked up on the road into the Dyess town center when I was five. Daddy called him Jake Terry after the Farm Home Administration man in Dyess. Daddy didn't think too much of Mr. Terry, and he killed his canine namesake after I'd had it about a year because he said it was eating scraps that could go to fatten up the hogs. He didn't admit it at first. I came home from school one day and called Jake Terry, but he didn't come, so Jack and I set out looking for him. We asked Daddy as we passed whether he'd seen him. He said no. Eventually we found him at the far end of the cotton rows across a shallow ditch, dead, with a .22 bullet in his head. I guess I don't have to tell you how I felt. I was five, and he was my dog.

I was scared to say anything to Daddy, but Jack wasn't. He went straight to him and said, "We found Jake Terry down there across the ditch."

Daddy looked up and said, "Yeah, I killed him. I didn't want to have to tell you boys, but we just didn't need another dog around here." We already had a dog called Ray, named after Daddy.

I thought my world had ended that morning, that nothing was safe, that life wasn't safe. It was a frightening thing, and it took a long time for me to get over it. It was a cut that went deep and stayed there.

Daddy quit drinking after Jack's death, and in 1945 he took on duties as a deacon of the church. When he was called on to preach in the pastor's absence, he said, "You've called on me to preach today and I can't turn you down, but I don't deserve to be here. I'm an evil man. I always have been. I don't deserve to stand in this pulpit."

I thought he did. His subject was a passage in Second Chronicles— "If My people, which are called by My name, shall humble themselves and pray and seek My face and turn from their wicked ways, then I will hear from heaven and will forgive their sin and will heal their land"— and he was very effective. He didn't shout; he was calm, contained, reserved. I was impressed, and I think the congregation was, too. It was such a wonderful thing for me, seeing him in the pulpit.

He stayed completely dry for many years, but eventually he started drinking again. He couldn't do it in the regular course of business because my mother wouldn't allow alcohol in the house, but whenever opportunity knocked, he answered.

I don't have to bear my father's sins, and I don't bear any of his guilt. Sometimes I feel as if I'm not even related to him. Other times it's, "Now, *there's* a guy after my own heart." In degrees of male mania, I guess there's not much difference (though there is some) between killing dogs and smashing up hotel rooms. And I suppose I inherited my addictive nature from my father. It's his legacy, but it's my responsibility.

In some ways my father is an enigma to me. His presence in my memory is awesome, yet it's fleeting, something I can turn my back on and even, sometimes, laugh about. On stage the other night, for instance, I decided to do "These Hands" and said, "I'll dedicate this song to my mother and father, who worked so hard to put me through school and encouraged me to go out and sing."

Right then I felt my father's presence beside me protesting, "*I didn't encourage you!*" He was right, of course—his attitude had always been, "You won't amount to a hill of beans. Forget about that guitar"—and I almost laughed out loud right there in front of everybody.

I don't know. I don't think much about him anymore. I pass the cemetery almost every day when I'm home at Old Hickory Lake, but I don't visit his grave. I'm not haunted by him. On the other hand, he is the most interesting specter in my memories, looming around in there saying, "Figure *me* out, son."

I've certainly tried. Most of my life I did my best to remember the man who delivered the sermon, the man who held me on his knee, but in more recent years I've had trouble accepting his conversion and especially his atonement. I've thought, *Is my father redeemed or not? What happened to him to make him fit for the Kingdom of God or failed to happen, making him unfit? Was he justified? Was there justification that led him to sanctification?* For that's the whole point in justification and forgiveness. The line goes from redemption to justification and then to eventual sanctification through righteousness with God.

Was Daddy's conversion real, and if it was, why didn't I see that all the time, not just when he stood up and preached from Second Chronicles?

The question doesn't stop safely with him, either. Is that how it is with me? Was I evil, but then made a change, walked the line, and was a godly man, but then slipped and fell and became an evil man again? And how many times has God picked me up, forgiven me, set me back upon the path, and made me know that it was all right? Did all that happen to Daddy, too? And if so, where was the justification? Was he justified in his own mind? Was he *ever* justified in his own mind? I can never really know, but I don't think he was.

And how about me? Can the line possibly stretch all the way for me, from redemption to sanctification through righteousness with God?

No, responsibility for my deeds begins with me. I don't believe I can inherit heaven or hell from someone else.

8

It's a new day in Tennessee, and a pretty one. I walk out Captain Weems's front door, get in the Range Rover, and go for a drive.

This is good land. I bump up the back pasture, over the crest of the hill, into the woods, along the creek, and back up through the woods to the old family graveyard where Captain Weems and his people rest. It's good to stop here: another special place for peace and contemplation, restful and intriguing all at once. It has a different feeling entirely from another nearby place I like to visit, the remains of a tiny community that was abandoned in 1912 (I don't know why; somebody does, I'm sure, but not me).

There, the feeling is of human life interrupted rather than laid to rest. Any moment you expect to hear children's voices ringing through the trees, the sound of a dinner bell clanging or the thud of an ax chop-

ping firewood, even though everything you see makes it obvious that the people are absolutely gone. It's a strange sensation. Close to where the schoolhouse stood—razed to its foundation now—somebody in the first decade of the century laid out a ball field on more or less level, cleared ground using worn-out tires for the bases, and the tires are still there. The people left them where they lay, and as nature began reclaiming the land, plants grew up around and through them. Now, where second base used to be, there's a forty-foot elm with an intact pre–World War I automobile tire clinging tightly around the base of its trunk.

There's fine timber in these woods: yellow poplar, white oak, black oak, hickory, elm, cedar, ash. Down in the valley there must be two hundred yellow poplars more than a hundred feet high, arrow-straight; a few of them would build you a mansion. Several years ago I bought two parcels of land in here and I'm just sitting on it, watching the value grow with the trees until it's worth too much for me to justify keeping it. Not, again, that we own the land, but that's how we humans organize ourselves, so I do it too.

My Uncle Edgar, when I went to visit him in my brand-new Cadillac in the late '50s, stopped playing dominoes long enough to tell me, "Well, I don't know. You seem to be making a lot of money, but I hope you'll do one thing with it." Then he paused and waited me for me to speak my part, which I did.

"What's that?"

"Buy land."

I didn't pay any attention then, but I do now. Even if it's too late to do me any good, it'll serve my grandchildren well.

He gave me some more advice I didn't follow. "Another thing you ought to do is buy gold," he said. "Right now it's set at thirty-five dollars an ounce by the government, but they're going off the gold standard, and gold is going to go sky high. Anyone who's got a lot of gold is going to get very rich real suddenly, overnight."

He was right, too. I really should have paid attention.

* * *

I appreciate my Range Rover greatly. It's a special vehicle with a special story.

At a time when I needed a four-wheel-drive vehicle and had decided that I really wanted it to be a Range Rover, I was flipping through *The Robb Report* when I saw a photo of the one I had to have. It was an '89 model that had been used in the French production of the movie *The Jungle Book,* and it featured an appropriate paint job: a base of matte black, my favorite color, embellished all over with brightly colored, hand-painted jungle plants and animals, sort of Rousseau-esque but more primitive (for you art lovers). And it was a *bargain!* Only twenty-three thousand dollars would make it mine. That price, furthermore, just happened to coincide with the amount of money my brother Tommy, as executor of our mother's estate, had just told me to expect in the mail; all the legalities had been satisfied, and that was my share. Plus, the dealer was only a couple of hundred miles away in Memphis.

I called him, and of course he still had the vehicle. With all *that* going for me, how could he not?

"I want that Range Rover," I told him. "My mother bought it for me."

My mother died in March 1991, after a lifetime of encouraging me in my music, praying for my well-being, and helping me and all her children in every way she could. For about the last ten years of her life she worked at the House of Cash, running the gift shop. The shop, in fact, was her idea. When we first moved into the building and set up our offices and the recording studio, Moma came up with the notion that we should also open part of the building to the public and set up a museum and a place for fans to buy souvenirs, beginning with the cookbooks she'd written. I was a little hesitant, but she really wanted to do it, so we went ahead, and for many years Moma played host at the House of Cash. She did a lot of good there: greeted a lot of fans,

sold a lot of souvenirs, and satisfied a lot of people's curiosity and need for personal contact. At times it was difficult for me, having to meet anywhere from a dozen to a hundred people whenever I went to the office, but I swallowed my shyness and did it, and I survived and Moma enjoyed her job.

After she died I decided I didn't want to be in the souvenir business anymore and turned that part of my affairs over to Bill Miller of the Odyssey Group in California. Bill has been a good friend for years and a fan even longer; he was on the souvenir and collector scene when he was just a kid, "Little Billy Miller." He named a son after me, and I was honored.

Both the unfortunate story of how I acquired Bon Aqua and the happy fact that I'm sixty-five and solvent, with land, leads me to the subject of Marty Klein and Lou Robin.

I was introduced to them in 1968 by Barbara John, a very sharp and competent woman who was with me for about three years in all, handling the lighting on my shows. I started working with Marty and Lou shortly after that, and stuck. Marty was my agent until his death just a few years ago, and Lou is still my manager. Right from the start with me, those men did it right. They got my dates booked and covered and serviced, and for the first time in my career I started seeing the money that was due me immediately, without thirty-day gaps and all manner of deductions between the promoter handing over the cash and my check arriving in the mail. Lou gave me a check to take home with me on the night the tour ended, plus an exact accounting of every penny that had come in and gone out from start to finish. Needless to say, I liked that. I couldn't quite believe it at first, but it really was true.

Marty and Lou worked very closely and effectively, with Marty staying mostly at his home base in California and Lou traveling the road with me. It's coming up on thirty years now that everywhere I've worked, Lou has been close by, keeping it all running, putting out the fires, knocking down the problems, setting up the opportunities. At

times, neither he nor Marty had a very cooperative client in me, but they took my periodic abuse (usually in my times of active addiction) like true friends. Marty became a member of the family, and it was a very hard blow losing him to a heart attack. Lou is family, too, has been for many, many years. We're very close, and I trust him absolutely, with every reason to do so. He's traveled the world with me, been everywhere, seen everything, known every kind of scheme and scam and trick and trouble the music business has to offer, and he knew most of it, moreover, before he even met me. He was booking the Beatles when they first came around. Artists Consultants is the name of his organization; I'm not sure what kind of artist I've turned out to be, but he's a great consultant. He's kind, too, a genuine gentleman. These days he works closely with Roger Vorce at the Agency for the Performing Arts, Marty Klein's successor and another very good man indeed.

With these people advising me about business and handling the money I make, I've arrived in 1997 able to live very nicely and work as much as I want. I could even retire. In that case, though, I'd have to let many of the people who work for me go, and that's just not something I want to do. They're wonderful people, attracted to my employment and kept at my side by a kindly fate, some of them for decades, and I would miss them badly. Besides, I don't want to lounge around and get fat. The fun isn't over yet.

9

I came out to Bon Aqua today from Nashville, not the road. For a few days this week I was shooting a commercial for Nissan at their plant in Smyrna, Tennessee, and then this morning I went to the Cowboy Arms Hotel and Recording Spa, as Jack Clement has christened his studio/office/country soul salon on Belmont Boulevard, and recorded a spiritual with the Fairfield Four. That was fun. I love black gospel music, and those men are so good at it, and Jack's attic studio is a wonderful place to make music. That whole scene is where it's at.

Sometimes I go down to Belmont Boulevard to record. Other times I go just to sit across the desk from Jack and play his Gibson J200 while he plays his Dobro and we sing whatever we feel like—Hawaiian songs, "Steel Guitar Rag" (yes, it's got lyrics, even if most people don't know them), bluegrass songs, gospel songs, pop and country and blues songs

he and I have known all our lives and never get to sing anywhere else. We're from the same time and the same turf, Jack and I. We're on the same wavelength; we can just pull songs out of the air and click right into them together. Maybe we'll do the "Jack & John Show" sometime, he and I sitting on a pair of stools with just our acoustic guitars, swapping it back and forth. We did that on one of my Australian tours about ten years ago and had a really good time.

Jack's been a real inspiration to me, and also to a lot of other people. He's been a great innovator in the country music business and a great friend to other musicians, singers, and writers a little bit ahead of their time, outside the pack, and too good for their own good. He had a lot to do with the success of Sun Records, and even more with the quality of the music coming out of that studio. He introduced Charley Pride to Nashville and produced all his major hits. He wrote "Guess Things Happen That Way," "Ballad of a Teenage Queen," "It'll Be Me," "Fools Like Me," "Gone Girl," "Miller's Cave," and dozens of other great songs. He produced what many people think is Waylon's best album, *Dreaming My Dreams,* and was a major force in the Outlaw movement of the '70s. He's given shelter, encouragement, inspiration, often free recording time, and even financial support to many of the best songwriters ever to hit Nashville. He was experimenting with video long before anyone else in town. He's staged events and launched fads (polka fever, the Summer of Hula) that have delighted many and puzzled many more. He's gathered a corps of deeply talented music makers around him (keyboard man/arranger/producer Charles Cochran and engineer/producer David Ferguson are the ones I've known best and longest) and collaborated with them on all kinds of high-grade projects. He's welcomed talents from all over the world and all fields of music to the Nashville community and steered them where they'd do the most good (pointing Tom Petty and U2 toward me, for instance). All in all, he's done a fine job of being the chief wild card in Nashville's deck for the past thirty years. Surprises have always awaited at the Cowboy Arms.

Backstage in the 1960s

Our wedding day, 1968

With June and
young John Carter

John Carter today, with his wife, Mary,
June, and me, on the beach in Jamaica

My grandson, Joseph John
Cash, and me in the Dresden,
Germany, airport, April 1997

June and our daughter Rosie

Our daughter Carlene, with her fiancé, Howie Epstein

The Cash daughters. From left to right, Cindy, Rosanne, Tara, and Kathy.

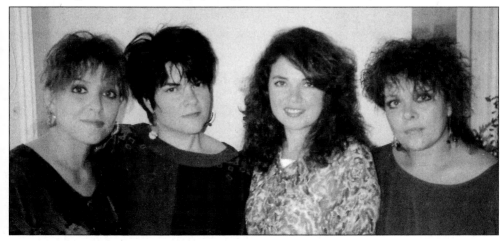

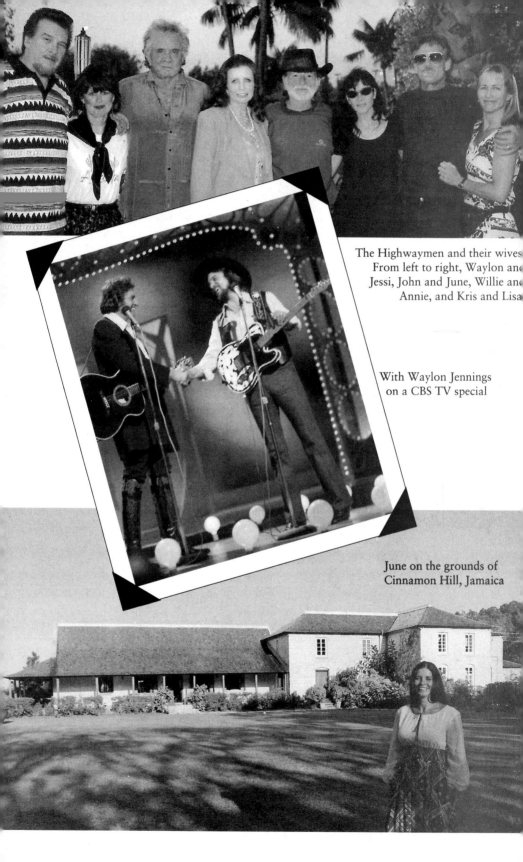

The Highwaymen and their wives.
From left to right, Waylon and
Jessi, John and June, Willie and
Annie, and Kris and Lisa

With Waylon Jennings
on a CBS TV special

June on the grounds of
Cinnamon Hill, Jamaica

June, me, and Reverend Gressett leaving Folsom Prison after a concert, 1968

Our farm at
Bon Aqua, Tennessee

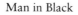
Man in Black

My manager, Lou Robin, and I preparing to descend a
thousand feet into a gold mine in South Australia, 1972

A 1996 Christmas TV special to remember.
From left to right, (*front row*) Michael W. Smith,
Billy Graham, Ruth Graham, (*back row*) Cee Cee
Winans, Franklin Graham, June, me, Amy Grant,
Cliff Barrows, and George Beverly Shea.

Visiting
Kirk Douglas at
his book signing
in Nashville,
1994

With my Range Rover, 1996

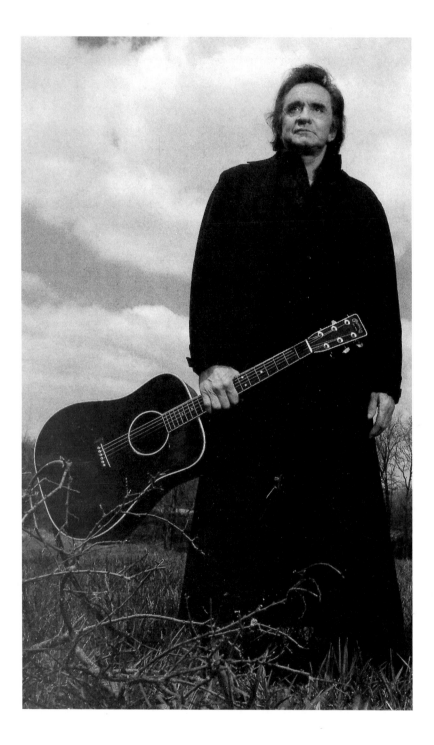

So, for me, has friendship. Jack has stood by me through everything, especially when life hasn't been too inspiring. Day or night, whatever my condition, I've always found a refuge in his presence.

Jack says he's a C-plus Christian, but if I were doing the grading I'd bump him up to a B minus. He makes an easy A in ballroom dancing—he used to be an Arthur Murray instructor—and his timing and physical coordination were good enough to win him a place in the United States Marine Corps ceremonial drill team. He's a patriot, though not a flag-waver; once a year he takes a trip to Washington, D.C., to visit the national shrines and spend a day in the Smithsonian, getting in touch with his American roots.

You don't get a yes-man when you work with Jack. If he thinks you haven't done your best, he'll tell you and make it clear he wants you to do better, and he certainly has his own ideas about how your records should sound. I'm bull-headed too, so he and I have locked horns many a time about almost anything a producer and artist can: song choices, instrumentation, the mix, the whole thing. We've always resolved our differences in the end, though, and it's never been boring. If there's been any consistent area of disagreement over the years, it's been the issue of minimal versus elaborate on my records. I like to keep it simple, just me and a basic band. Jack likes to play with it once I'm done, adding this, trying that, and working through as many changes as he wants until he's satisfied. He likes to live with a track in progress; when you stop by the Cowboy Arms you're quite likely to find him in his office, swaying in time or waltzing by himself in the middle of the floor, dreaming up new sounds as a song you cut a week or two ago thunders through his big JBL studio monitors at a couple of hundred decibels. People call him "Cowboy," though he can also be Pineapple Jack (in his Hawaiian mode) and Pop Country. Somebody should write a book about him. He should write a book about himself (or anything he wants, for that matter). He's a brilliant, talented, funny, ultramusical, very kind man.

* * *

I've had a lot of producers, which doesn't surprise me and shouldn't surprise anyone, given how many records I've made and how long I've been recording. It's possible, in fact, that I've even forgotten some producers with whom I made an album here or did a special project there. That's not a reflection on them by any means: it's just the sheer volume of recording sessions I've done combined with the inevitable attrition of the years on my memory. Anyone over fifty can relate, I'm sure.

The producers who stand out clearly and have been significant in my musical life are, in chronological order, Sam Phillips, Jack Clement, Don Law, Frank Jones, Bob Johnston, Larry Butler, Charlie Bragg, Earl Poole Ball, Brian Ahern, Billy Sherrill, Chips Moman, Bob Moore, and Rick Rubin. Among others responsible for various productions along the way are four of my now former sons-in-law: Jack Routh, Marty Stuart, Nick Lowe, and Rodney Crowell. And as I said, it isn't over yet.

Going back to the beginning, it was Sam Phillips, Jack Clement, the Don Law/Frank Jones combination, and Bob Johnston who took me up to 1974, when I underwent a kind of mental divorce from the CBS power structure on Music Row. At that point I pulled back to Hendersonville as far as recording was concerned, working in my own studio at the House of Cash, mostly with Charlie Bragg and Larry Butler, and recording whatever I wanted.

I made that change after going along, reluctantly, with the CBS bosses on *John R. Cash,* which was their idea of an album to restore my sales potential. They sent a producer down to Nashville with a bag full of songs they thought I should record, had me decide which ones I *would* record and what key I'd sing them in, and shipped the producer and the song choices back to New York. Then they recorded the instrumental tracks with their musicians and arrangements, sent the whole package back to Nashville, and had me record my vocals onto the tracks. I wasn't pleased with either the process or the results, so I decided I wouldn't do that kind of thing again—that is, I would *not* make any more music I didn't want to make. I'd never just cave the way I did on *John R. Cash.*

I went through the mid-'70s doing my own thing, staying away from the politics on Music Row, making my own albums my own way, and handing them over to CBS when they were done, and I'm still proud of some of that work. The soundtrack to *Gospel Road* was a monumental labor of engineering and production, and I think it stands the test of time; people still show up backstage at my concerts with copies for me to sign. I had three songs go into the top end of the country charts one after the other in 1976, and I still like them, too: "One Piece at a Time," "Any Old Wind That Blows," and "I Would Like to See You Again." I loved Guy Clark's "Texas, 1947" and "The Last Gunfighter Ballad," and *The Rambler,* in 1977, was another concept album from the heart; it's a shame CBS didn't see fit to tell many people about it. Generally speaking, I think we did okay out at the House of Cash.

Country music changed a lot in the 1970s, beginning with the Outlaw movement, a kind of revolution by Nashville's most creative people, and ending in the Urban Cowboy fad, a kind of feeding frenzy among their opposites. I wasn't profoundly affected by either extreme. I was never publicly identified with the Outlaw movement, though in both spirit and practice I was closely aligned, and, thankfully, I wasn't involved in the mechanical bull manure at the end of the decade. I just kept doing my own thing. The other stuff swirled around me without moving my music one way or the other.

I got into a good streak in 1979, when Brian Ahern came in from the West Coast to produce my twenty-fifth-anniversary album, *Silver.* He was married to Emmylou Harris at the time, and those two came down to Jamaica with us, which apart from anything else gave Brian and me time to get to know each other and start clicking creatively; by the time we got back to Nashville we were ready to record. He brought me a lot of good songs for that album—"The L&M Don't Stop Here Anymore" and "The Ballad of Barbara" stick in my mind—and the sessions were fun. I also enjoyed two other albums I made around then, *Rockabilly Blues* with Earl Poole Ball and Jack Clement, and my

double gospel album, *A Believer Sings the Truth*. The turn of the decade was a good time for my music.

The same wasn't true of my record sales, though, and my attitude suffered. Sometimes in the early '80s I really cared about recording, but sometimes I didn't. It was hard to get excited about an album project when I knew the people at my label had come to regard me as a long shot and, when the chips were down, weren't willing to put money and muscle into pushing my records. They, and all the other major record companies in Nashville, were betting on the younger generation and starting to play by the rules of "youth appeal." If you were a little too old and your anatomy not quite "hot," it didn't matter how good your songs or your records were or how many fans you'd had for how long: you weren't going to get played on the radio. So my record company was losing interest in me, and I in them.

Periodically, someone took the initiative and suggested something new or different to turn the situation around, but nothing ever worked. *The Baron*, my 1981 album with Billy Sherrill producing, was like that. Billy is legendary in the country music business for creating the slick "countrypolitan" sound of the late 1960s and early 1970s and producing strings of hits on George Jones, Tammy Wynette, Charlie Rich, Tanya Tucker, and others. But by the time I got to him and he got to me, we were both pretty cynical. I remember going into his office and seeing a big cardboard box full of tapes—songs submitted for my album by songwriters and publishers—and saying, "Well, what have we got?"

He didn't even look at me. "Absolutely nothing," he said, kicking the box over so the tapes, several hundred of them, spilled out onto the floor. "Isn't it about time for you to record 'My Elusive Dream'? Everyone else has."

And so it went. We tried, sort of, but we certainly didn't give it our best. *The Baron* flopped and the situation between me and CBS deteriorated. Maybe that's when the clock really started ticking. It was coming up on ten years since *John R. Cash*. My contract with CBS was set to expire in 1986.

Though I made some records between '81 and '86 that I still like—
The Survivors, recorded live in Germany with Carl Perkins and Jerry
Lee Lewis; my *Rainbow* album; *Highwayman* with Waylon, Kris
Kristofferson, and Willie Nelson; a collaboration with Waylon alone
called *Heroes*—I really wasn't motivated, and neither were the people
at CBS. I got so tired of hearing about demographics, the "new coun-
try fan," the "new market profile," and all the other trends supposedly
working against me, that I just gave up and decided to have fun with it.
The last record I gave CBS was called "Chicken in Black," and it was
intentionally atrocious. I was burlesquing myself and forcing CBS to go
along with it; I even made them pay for a video, shot in New York,
with me dressed like a chicken.

If I were running a record company and one of my artists did that,
I know exactly how I'd respond, so I wasn't surprised when Rick
Blackburn at CBS Nashville declined to renew my contract in 1986.
That caused a real uproar in some circles—people were going into
Rick's office, pounding on his desk and calling him names—but I
understood. I called him and told him, "Well, you did what you
thought you were supposed to do. I've always enjoyed working with
you, and I like you." Which was true.

Looking back on "Chicken in Black," it's no wonder to me that it took
a while to get another decent record deal. People were probably afraid
to bank on an artist who'd make a mockery of himself like that.

For a while I wasn't even interested in a new recording venture, but
that didn't last long, and soon I was shopping around. One possibility I
considered was Jimmy Bowen, who at the time was Mr. Big in Nashville,
producing best-selling albums night and day and running his own oper-
ation at MCA (or Warner Brothers, or Capitol, I forget which; for a
while there everybody on Music Row seemed to be playing Follow the
Bouncing Bowen). People kept telling me I should go see him.

I decided I'd approach him the way I did Sam Phillips: just go in
there by myself with my guitar, sing him some songs, and show him

what I had. Act like he'd never heard of me, in other words, and hang it all on the music. And that's what I did. I sat down in his office and sang songs to him for about half an hour. He sat back and listened intently until I put up my guitar.

"Well, that's all I've got that I can think of right now," I said. "What do you think?"

"Let me think about it," he replied. I said okay, put my guitar back in its case, left, and never heard a word from him after that. Not a phone call, not a note, not a peep. Bye-bye, Bowen.

I found a deal I liked at Mercury/Polygram with Steve Popovich, a good man, and with his blessing I teamed up with Jack Clement again. So I was very happy for a little while. We all were. Then the power at Mercury/Polygram in New York shifted and I became, again, an artist the company wasn't interested in promoting. Jack and I still cared and made some music to be proud of, but it was like singing in an empty hall. Radio stations didn't get my singles. There was no publicity. They only pressed five hundred copies of my last Mercury album, *The Meaning of Life*. I heard lots of interesting things about demographics.

Jack and Steve worked really hard for me, trying again and again to get New York to put up more money and muscle, but it was useless, and I probably didn't help much. By that point I'd given up. I'd already started thinking that I didn't want to deal with record companies any-more. Saying good-bye to that game and just working the road, play-ing with my friends and family for people who really wanted to hear us, seemed very much like the thing to do. I began looking forward to it.

Rick Rubin showed up in my life in 1993. He called Lou Robin and asked to talk to me; after hearing him out, Lou put it to me. Sure, I said, thinking I had nothing to lose but a few minutes of my time, and so we set it up. Rick came backstage at a show in Los Angeles, and I sat down and listened to what he had to say. He was interested in me as a possi-ble artist on his label, American Records, he told me, and he really wanted to hear the music I wanted to record.

I thought it all pretty unlikely. He was the ultimate hippie, bald on top but with hair down over his shoulders, a beard that looked as if it had never been trimmed (it hadn't), and clothes that would have done a wino proud. On top of that his label was all rap, metal, and hard rock: the Red Hot Chili Peppers, the Beastie Boys—young, urban music. Besides, I was through auditioning for producers, and I wasn't at all interested in being remodeled into some kind of rock act. Although the man knew my work and talked a good game and I thought I saw something in him—I told June after the meeting that he talked a little like Sam Phillips—I really didn't take it seriously. He'd lose interest after a while, I thought, or something else would distract him the way it does in this business.

I was wrong about that. He came right back at me on the same California tour and spelled it out for me: "I'm deadly serious about signing you to my label. I *really* want to produce you. I need you, and I think I know what to do with you, and we'll do it together." I started taking him seriously.

I asked him how he'd go about recording me. What would he do differently from what everyone else had tried?

"I won't do anything," he told me. "*You'll* do it. You'll come to my house and sit down in my living room and take a guitar and start singing. At some point, if you want me to, we'll turn on a recorder, and you will try everything that you ever wanted to record, plus your own songs, plus new songs I might suggest that you think you could do a good job on. You'll sing every song you love, and somewhere in there we'll find a trigger song that will tell us we're heading in the right direction. I'm not very familiar with a lot of the music you love, but I want to hear it all."

Now he really had my attention. His idea connected directly with a desire I'd had for years to make just such an album, a collection of my favorite songs recorded very intimately with just my voice and guitar, as if it were midnight and you and I were in a room together all by ourselves. I first started talking about it almost thirty years ago, in a con-

versation Marty Robbins and I were having about pet projects, and I'd
suggested it to CBS right after that. They thought it was a bad idea at
that time and had the same reaction when I suggested it again years
later. Mercury had the same reaction when I put it to *them*. Still I cher-
ished it. I even had a title, *Late and Alone*.

I saw problems, though. "I don't want to record on your label and
be marketed on the alternative music scene or to the rock 'n' roll
crowd," I told Rick. "I have no illusions about who I am, how old I am,
and what a stretch it might be to relate to these young people."

That didn't worry him. "I've watched you on stage," he said, "and
you haven't lost your fire and your passion. Let's bring that fire and
passion to our new work and see what happens. We'll just be totally
honest."

"That'll be the only way I'll do it," I said. "I won't record with a
lot of rock 'n' roll musicians just to try to relate, because the fans won't
take that. They'll throw the records right back at me, especially my
older fans."

He assured me that nothing of the kind was on his agenda, and I
believed him. I talked to Lou and June about it, and with them both in
agreement I decided to give Rick Rubin a try. My contract with Mercury
was running out, and the most this new initiative could cost me was a
wasted trip or two to California.

I went to Rick's house, and for three nights he and I sat in his liv-
ing room and I sang my songs into his microphone. When I was done
I was really excited. The idea of an album made that way had become
very appealing to me, and now I saw that it could work, it could
happen.

Rick was hedging his bets. "Well, just don't count on it all being
you and your guitar," he said. "We may want to put musicians on
some of these songs." I didn't know if that was a good idea, but I
trusted him, so I kept an open mind about it. I told Lou to go ahead
and negotiate a deal, and shortly thereafter I signed a contract with
American Records.

From there we proceeded exactly as we'd planned, with just him and me together. It was a great experience. I took my music all the way back to its roots, back to the heart, and recorded about a hundred songs. Then we listened to it all, marked out the songs that had the late-and-alone, intimate feeling we were looking for, and went to work getting them right. We experimented with added instrumentation, but in the end we decided that it worked better with me alone. We bore down on it that way and got our album: no reverb, no echo, no slapback, no overdubbing, no mixing, just me playing my guitar and singing. I didn't even use a pick; every guitar note on the album, which we called *American Recordings,* came from my thumb. So Rick really did succeed in what he set out to do: he got the honest, unadulterated essence of Johnny Cash, whatever that is.

The songs were about anything and everything, a couple of them outright humorous, another couple so dark that they shaded into the psychotic. Track one, "Delia's Gone," for instance, originated in a levee camp holler or a Delta blues song about the killing of a woman; I wrote new verses to it to make it a story song told by the killer. It was pretty strong. To write it, I sent myself to the same mental place where I found "Folsom Prison Blues" and, being older and wiser to human depravity, picked up on some darker secrets than I'd seen in 1956. It turned out to be a pretty popular song with young audiences, though it made a lot of people uncomfortable. I got no big kick out of singing it, but it was one of those things I felt right about doing at the time, and it definitely had a place on an album whose scope was all the music that had made me. Many of the biggest, most popular songs I grew up with, in country and folk and blues, were about crime and punishment, mayhem and madness, trouble and strife writ large and lurid.

The reaction to *American Recordings,* as I've already said, was very positive. I don't think I lost any of my old fans, and I might have gained a few new ones. I got good reviews and won a Grammy for "Best Contemporary Folk Song Album," and out on the road it started feel-

ing like 1955 again. I began playing young people's places like the Fillmore as well as the city auditoriums and arenas I'd been playing for the previous twenty years. I discovered all over again how it felt to play for a crowd of people with no chairs or tables, standing on their feet, jammed together, energizing each other. The new generation wanted to hear the songs I'd recorded at Sun in the '50s, and it was a real pleasure to oblige. I've always loved those songs, and it still thrills me to hear the beat kick in behind me and Bob Wootton's Fender start running its electric lines. When it came time for me to sing the *American Recordings* songs, I could bring it all down to just myself on a stool, with my black D28 Martin and two mikes, singing for the folks. I learned the trick of making myself feel like the audience was just that one other person late and alone in a room, and that too was a great pleasure. It was also more than rewarding to find that the young people were eager, perhaps even hungry, for the spiritual songs I've always loved. I'd always prayed that might happen.

I found acceptance and appreciation in different places. It felt great. At the Glastonbury Festival in England I sat on my stool and played my songs for an audience of a hundred thousand young people who really listened, and that night I realized I'd come full circle, back to the bare bones of my music, pre-stardom, pre-electric, pre-Memphis. I could have been back in Dyess, singing with just Moma to hear me on the front porch under the clear night sky of Arkansas in the 1940s with the panthers screaming in the bush, and it seemed, finally and almost miraculously, that the audience enjoyed that feeling almost as much as I did.

June also found a whole new world of appreciation among the young people. They loved the Carter Family classics, and they loved her. One night in England shortly after the release of *American Recordings,* as the new excitement was just beginning, she was coming off stage when a nineteen-year-old in tattered black, with tattoos and body piercings and spiky hair and the whole bit, tapped her gently on the arm and said, "Mrs. Cash, you really kick ass."

I like to remind her of that when she's feeling down or discouraged. "Mrs. Cash, don't worry about it," I'll say. "You kick ass."

I'm still going strong with Rick Rubin and American Records. I made a second album, *Unchained,* with a band (Tom Petty and the Heartbreakers, Marty Stuart, and others), and we're planning another, perhaps two. So my creative blood is up and I'm having a good time. These days, when songs start forcing their way up through me, I can allow myself a fair expectation that if I do my part with them, a significant number of people might hear them.

I have no idea what my long-term recording future will hold. Whatever it is, I'm looking forward to it. I'm certainly anticipating my next couple of projects with pleasure. At this point we have a large backlog of good songs, so the next album will probably be a selection of those and perhaps some others I haven't met or written yet, recorded with or without a band; we'll see. The other project really has my blood up. Rick and I are talking about mapping out a selection of spiritual songs—not old gospel music, but contemporary songs I've found and written that speak of the spirit—and then recording them in a cathedral. Rick has scouted out a location that might work. I can't wait.

10

Terrible news came today. The daughter of a friend of mine, aged just twenty-six, got drunk after being sober for three months in a recovery program and shot herself to death in front of her husband and children.

I don't know if you can imagine how I feel. Maybe you can if you yourself are an alcoholic or addict. It's not just—just!—that this poor girl did such an incredibly terrible thing to herself and her loved ones; it's that the disease got her—and everyone in her family. Her father, also an alcoholic, has been sober in recovery a long time, but it got him. Her children had never taken a drink or a drug, but it got them. It got me too, reminding me that I myself am surrounded by the ghosts of close friends killed by alcoholism and addiction, and I can't even begin to count the acquaintances, the friends of friends and the people I meet somewhere, then read about in the newspapers.

I've already called my children. They're all alive, they're all okay.

* * *

I've never considered taking my own life. I lay down to die in Nicka-jack Cave, it's true, but that wasn't suicide, and God didn't let me slip away from my hell on earth so easily.

I've been close to death, of course. It happened many times when I was high, probably more often than I even knew about. Crawling from the wreckage of this or that vehicle, I'd sometimes realize that death had passed by without taking me, but there must have been many other occasions when I felt its breeze but didn't recognize it or when just another few milligrams of some chemical would have pushed me squarely into its path.

Only once have I been right up to it and seen it. I was on a respira-tor in critical care with double pneumonia after my bypass surgery in 1988. There came a moment when, after fighting for breath for so long and not getting it anymore, I felt myself fading away. I could hear the doctors—"He's slipping, he's slipping! We've got to do something fast!"—but their voices receded and everything got quiet and dark and calm and peaceful. Then a light grew around me, and soon it enveloped me, and it was more than light: it was the *essence* of light, a safe, warm, joyous brilliance growing brighter and more beautiful every moment. I began to drift smoothly into its very center, where it was so much bet-ter than anything I'd ever experienced that I can't possibly describe it. I was unbelievably happy. I've never felt such utter joy.

Then it just vanished. It just went. My eyes flew open and I saw *doctors*. I couldn't believe it. Sorrow welled up in me. I started crying, and then I got so angry that I was sobbing and snarling at the same time. I found my wits and began trying to tell them to let me go, to send me back, but they had a tube down my throat, so I couldn't get it across to them. I gave up trying.

And then, after a few minutes, I was glad to be back. I was restored, as they say, to my senses.

I never forgot that light, and it changed me. When I was still in the hospital and one of my children came into my room, I'd feel a strange,

overpowering blend of joy and sorrow, and my tears would roll. After I got home, I'd bawl like a baby over a passage in a book or a scene in a movie. When friends came over, I'd watch them and a solitary little tear would sneak down my cheek. People got used to it. They'd see it and smile: there goes John, crying again.

It's not so extreme today, but I still cry at almost anything. It can be something as profound as the beauty of a grandchild in my arms or as trifling as the smile of a pretty girl winning a skating championship on TV. Life has become very moving.

Something thumps and stirs me from a reverie (a nightmare?) about a day on pills in the desert in 1963, and my eyes come open and focus. I'm back at home on Old Hickory Lake, and what's woken me is Joseph, my grandson. He's a couple of months into his second year now. He comes stomping into the room with his sturdy little legs spread wide apart for better balance, swaying a little with each step, still unsure on his feet and having to concentrate, controlling his momentum with a look of intense focus on his face as he lurches toward me. Then he arrives. He slaps his hands onto my knees for balance, breaks concentration, and turns his face up to mine with a big, delighted, wide-open smile.

What a tonic. How lucky I am. How grateful I am to be here now, not back there then. I'll take my cue from Joseph and concentrate on the really important stuff: my children and their children.

Rosanne Cash is my oldest. She's famous, and justly so. As a matter of fact, she's had as many number-one country hits as I have. She's a great singer and a great writer of songs, fiction, journalism, and poetry. Her first book of stories, *Bodies of Water,* got a wonderful review in the *New York Times,* and in *The Illustrated History of Country Music* it says that her music is "an *auteur* odyssey, a chronicle of songs taken directly from her own life and feelings with very few holds barred, for which there isn't a parallel in modern Nashville." All I'd add is that it's been a chronicle of very *good* songs, and she doesn't

live in Nashville anymore. She moved to New York a couple of years ago and is very happy there. That was the right move, I think; she belongs in a bigger, more cosmopolitan creative community.

Sometimes I call Rosanne "The Brain." She and I operate on much the same wavelength, so there's always been a special closeness between us. It's not a matter of deeper love (or hurt) than between me and the other girls; it's more like a greater degree of instinctive understanding. One of the nice ways she and I have shared each other in recent years is in book swapping. She's a great literature scout, going out there ahead of me and marking the trail.

Rosanne is married to John Leventhal, a fine musician and record producer; she and Rodney Crowell separated while she still lived in Tennessee. Caitlin, her eldest daughter, another writer, is sixteen, and Chelsea and Carrie are coming right along behind Caitlin. They're all still in school in New York. The other daughter of the Crowell-Cash household, Hannah Crowell, is already out in the world, living in San Francisco. Just as in my house, nobody in Rosanne's family talks about "stepdaughters" or "stepsisters."

Sparkle Carter, for instance, is my daughter, though not biologically. Publicly known as Carlene Carter, born Carlene Smith when June was married to Carl Smith, she's "Sparkle" to me because that's her character. You cannot keep Carlene down; no point in trying. She throws out sparks wherever she goes.

She too is famous and justly so: she's a very fine songwriter and singer and a *great* performer. I saw her once opening for Garth Brooks, and she just blew him away—so don't compete with Carlene unless you're Elvis, and I know you're not. She made some great country-rock records when she was on the Nashville scene in the '70s and then some very cool country–rock-pop–dance records while she was married to Nick Lowe and living in London. Now she makes wonderful Carlene Carter records that put it all together, usually with the help of Howie Epstein, her live-in beau. Howie plays bass in the Heartbreakers, Tom Petty's band, and is an ace producer.

Carlene's kids are Tiffany Lowe, who's causing a well-deserved stir in Los Angeles with her own music, and John Jackson Routh, the son of songwriter Jack Routh. John's a sharp boy and a hard worker, going to school at Vanderbilt University and holding down two jobs, one of them as football coach at Good Pasture Christian School in Nashville.

Like Rosanne, Carlene had a lot to prove when she first began making her way in the music business. People watched her closely and judged her very critically because of whose daughter she was, and in some ways I think she had a harder time making it because of her name. I'm proud of her for fighting her way through that.

Kathy, my second daughter and the last born in Memphis, holds the current family record among my children for marriage duration: she and Jimmy Tittle, a songwriter and once my bass player, are working on fifteen years now. Kathy never had any show business ambitions. All she ever wanted was to make a home and family, and she's succeeded; she and Jimmy live in a house they built on fourteen acres in middle Tennessee with two fine children, Dustin and Kacy Tittle. Kathy's first child and my first grandson, Thomas Coggins, is now a big, strapping specimen of a man who looks a lot like Tarzan (he works out) and is as decent and level-headed as you'd want a young man to be. He's a police officer in Old Hickory, Tennessee, but he also writes songs and plays guitar pretty nicely, so while he hasn't pointed himself in that direction professionally, I suspect he might someday. By the time this book comes out, he and his wife might well have given me my first great-grandchild.

I have twelve grandchildren, you know. Sometimes that just astonishes me.

Cindy, daughter number three, is the tomboy. She likes to shoot, and for a while she was into fast draw. I kept telling her she was going to shoot her toes off, but I was wrong. She doesn't do too much of that

now; she's more likely to be found on horseback or with a fishing rod, not a Peacemaker, in her hand.

She has a daughter from her first marriage, Jessica Brock, who's studying at Western Kentucky State University and is headed toward a career in family counseling. Cindy herself wears several hats. She's a master barber and a much sought after hair and makeup artist in the music video business; she recently authored and produced the excellent and successful *Cash Family Scrapbook,* although she doesn't have the kind of drive toward a musical career that Rosanne and I have—a compulsion, almost, down in our bones—she writes good songs and carries a tune with the best of them. Now and again she comes on the road and sings with us.

Cindy and I are very close. We love each other fiercely, and fight that way too. She fights just like her mother, though, so I win most of the time by being able to predict what she's going to do. She has fire. She used to be married to Marty Stuart, but that ended years ago and we all survived. Our sense of humor even came back. Marty called me the other day. "Uh, John," he said, chortling, "me and Cindy are having trouble."

If Rosanne is The Brain, then Rosie has to be The Voice. She's a regular part of our show, and she wows the crowd every time. Songs like "Amazing Grace" and "Angel from Montgomery," two of the numbers on which she solos regularly, were written for a voice like hers, big and bluesy, with immense power and depth. She has her own style and quality, but if I had to make comparisons for the sake of description, I'd look among names like Mahalia Jackson and Bessie Smith rather than any country singers I can think of.

I believe that if Rosie ever really wants to become a recording star, she will. She's been close several times, but something has always happened to keep her from the final step, and perhaps that hasn't always been someone else's fault; she may have been more afraid of success than failure. She knows that. I've told her. I've also told her that one

day she'll commit herself. When she does, watch out. Rosie has real soul.

She doesn't have any children of her own, but she loves them—and old people, and anyone who's in trouble and could use her help. She's one of the most actively compassionate people I know; a lot of her time and money are spent helping people, both in and around the family and elsewhere.

I feel a special spiritual connection with Rosie. Perhaps that's because I've seen her struggles with the family disease from closer range than has been the case with the other children.

And now, the babies. Tara, my youngest daughter, is in Portland, Oregon, with her husband, Fred Schwoebel, and their son Aran (named after the Aran Islands, where they went on their honeymoon). She, too, works in video, though mostly in commercials and on the production end of things. She's qualified for almost any job on the set, from wardrobe manager to assistant director, and she's got as much work as she wants.

Fred and Tara are low-consumption types, frugal and wise in how they live and how they spend their money. They're mountain climbers, hikers, and cross-country skiers. They're very good together.

Tara is soft-spoken and sweet by nature, not at all eager for conflict. For several years she went off and turned her back on the problems in the family, living her own life and doing her own thing until the rest of us began straightening out, and then she came around again. Once back, she stayed; she's steady and dependable, and her love is unconditional. I keep trying to tempt her back to Tennessee, but so far, no luck. She and Fred like their life in Oregon. Maybe one day they'll get tired of the rain.

That leaves my youngest child, John Carter, now twenty-seven. He was John Carter long before he was born or even conceived. I had brought four daughters to June, and she had brought two to me, so while we would have been very happy to have a girl together, we

prayed that our child, were we to be blessed with one, would be a boy. If he was, he'd bear both our names.

He's another big, strong boy, six foot four (though he doesn't work out), and another music maker. He had a metal period, which was sort of fun for me—we took each other to a Metallica show, which was spectacular, and he introduced me to Ozzy Osborne, who's a very nice person—but now he has an acoustic act, singing his own songs with just his guitar. He writes good songs, very different from mine; they have a depth of imagery I've never attempted. He doesn't sound anything like me, either, and he's a much better guitar player. He still can't outplay me at dominoes or Chinese checkers, though—but then, neither can most people.

John Carter was born when I was forty, my first son after four daughters and my first child with June, so for those reasons alone I was completely smitten with him right from the start. He got a much better deal from me than Rosanne, Kathy, Cindy, and Tara. I was there physically, and most of the time emotionally, while he grew up, and he and I were playmates in those magic years between toddlerhood and puberty when a boy and his father can really have fun. In some ways we grew up together. He might have taught me more than I taught him.

As I've said, John Carter travels with our road show, sometimes bringing Joseph along but more often leaving him at home with Mary, his wife. She's not a performer, but she used to be a model. Now she raises Joseph and goes to college. She's a godly woman, the daughter of neighbors who live a couple of houses down the street from our house in Port Richey. The first time I ever saw her was when she surprised me while I was in her backyard picking oranges—or more accurately, I surprised *her*. I felt bad about it, so I went over to the front door and introduced myself properly. John Carter got interested shortly thereafter.

John Carter is doing well in the field he's chosen, and so are all my children. They've stayed their courses and used their talents. Quite apart from the love I have for them, and the fear, I'm very proud of them. They're good people.

My Grandchildren

From grandson Thomas' wedding. First row *(from left to right)*: Vivian, grandson Thomas (Kathy's son) and his bride Chamisa. Second row: Granddaughters Carrie (Roseanne's daughter) and Kacy (Kathy's daughter). Third row: Grandson Aran (Tara's son), Tara, Roseanne, Kathy, Cindy, granddaughters Jessica (Cindy's daughter), Hannah and Caitlin (Roseanne's daughters). Fourth row: Fred, John, Jimmy and me. Top: Grandson Dustin (Kathy's son). Missing from photo is granddaughter Chelsea (Roseanne's daughter).

My granddaughter,
Tiffany, Carlene's daughter.

My grandson Joseph,
John Carter Cash's son.

My grandson, John, Carlene's son.

The Road Again

1

I'm relaxing on the porch of my room in a beautiful hotel in Ashland, Wisconsin, beside Lake Superior, gazing out into the soft, clear morning and seeing what I can see.

The lights are on in a house across the street. They didn't come on until about eight o'clock, by which time I'd been up almost three hours. The man of the house left for work about 8:45 in a little white car, one of those thirteen-thousand-dollar jobs. The house has two stories and a steeply sloping roof, like most structures where there's a lot of snowfall. A low chain-link fence surrounds the backyard and a barbecue grill is set up on the grass. A dog is roaming back and forth along the fence, trying to find a way out—no special breed, just a doggy-looking dog.

Over on the other side of the porch is the lake, which is peaceful today. The hotel manager has offered to take us out in his boat and find some fish—he knows where they hide—and I hope I'll be able to take

him up on that. I've got a large-scale map of the area (something I like to have wherever I go) and I've already spent some time poring over it, figuring out for myself where the fishing might be good. I've never been in Ashland, which is unusual. I like it when the road takes me places it hasn't taken me before. People are very friendly around here. Contrary to what you might expect, though, you don't see any more cheese in Wisconsin than anywhere else. I like Wisconsin cheese a lot better than the stinky stuff in Europe. Things that smell as if they've been dead too long don't turn me on.

I'm not sure whether or not there's a Wal-Mart here. June and I rate places that way—"This is a Wal-Mart town, I bet. It's easily big enough," or "Hang on, honey. Don't shop here. Tomorrow's a two-Wal-Marter"—but I can't read Ashland well enough to make a good guess. I know it's a nice place, though.

Maybe I'll go fishing tomorrow. Not today, anyway, because I have a show tonight, so as usual I have to guard my resources and energies: be careful I don't eat too much, make sure I get my afternoon nap, avoid turmoil and distraction, protect my time as fiercely as I have to. Then I'll be able to give the audience my best. When I first appear they might be thinking, *I didn't know he was getting that old,* or *Wow, he sure gained weight,* but by the second or third song they should be coming around a little. *Well, he doesn't move as much as he used to. He's slowed down a lot, but he still sings fairly well. For an old guy, anyway.*

Hopefully, that'll continue to be the final word on Johnny Cash right up to the moment when, halfway through "Ring of Fire" or "I Still Miss Someone" or "Sunday Morning Coming Down," I'll just keel over and die on the stage, under the lights, with my band and my family around me and Fluke still laying down the beat. That's every performer's dream, you know.

I hear people my age say, "I feel as good as I ever did." I don't believe them. *I* certainly don't have the energy I once had. I live with all kinds of aches and pains, and like anyone over fifty I find myself spending an increasing amount of time in doctors' offices for a patch job here

or a major overhaul there. The issue, though, is how you deal with that—how you stand up and bear the patching with grace. Not that I believe you have to "grow old gracefully." I go along with Edna St. Vincent Millay's idea that it's okay to go out screaming and scratching and fighting. When death starts beating the door down, you need to be reaching for your shotgun.

And when you know he might be in your part of town, which is true for anyone my age, you should be taking care of business. Quit gazing out the window at the lake and start telling your stories.

I have so many that I don't know where to start. Therefore I'll begin at the beginning, with the letter "A," and see where it leads me. I'm not sure I'll get to "Z"—I can't think of any good "Z" stories or people—but before this book is done, I'll just have to say how much I think of Trisha Yearwood, so I know I'll get to "Y."

Eddy Arnold was hotter than a pistol when I was growing up, and he had a big effect on my writing and singing. Every record he released went immediately to number one, and I knew them all, word for word. Still do. My favorite is "Cattle Call," with "Lamplighting in the Valley" close behind. You don't hear about him today the way you hear about Jim Reeves or Hank Williams or George Jones, but his records spent more time on the country charts than theirs—more than anyone's, in fact.

A lot of his songs stand up over time, too, which isn't always or even very often the case with old songs. When you approach them as material to record or perform today, you frequently find that they've lost the magic you heard in them when they were hits. Or as Chips Moman put it when he and I were fishing one day and talking about using an old country hit on an album we were making, "You know, that song is as good as it used to be."

John Anderson is about as country a singer as any I've known since Stonewall Jackson, and I mean that as a high compliment. I love the way he sings and I like the way he talks.

* * *

Bobby Bare is a free spirit and he always has been. I remember him in my California days, when he was out there, too, without a driver's license because he didn't want the responsibility of a car. He always had a girl to drive him around. The only thing I regret about Bobby is that he and I have talked fishing much more than we've done it. And even though it's been a long time now, I wish TNN hadn't canceled his TV show.

Bobby's buddy Shel Silverstein is an impressive man. There aren't too many people in the world equally talented as a cartoonist and a songwriter (though of course Merle Travis comes to mind. Even so, Merle's cartoons, unlike Shel's, weren't a prominent feature of the glory years of *Playboy* magazine). Shel's song "A Boy Named Sue" was a big hit for me and a great success the first time I performed it, at the prison concert that became the *Live at San Quentin* album. The lyrics were so new to me that I had to sing them off a sheet on a music stand, but they were exactly right for the moment. They lightened the mood in what was otherwise a very heavy show. In fact, the laughter just about tore the roof off.

Owen Bradley was the most important Nashville record producer of his time, the man behind the Nashville Sound of the '50s and '60s. I never worked with him, but I did record at his studio once, in my bad days. A case of amphetamine laryngitis had ruined my voice, so I took out my frustration on one of his fiberglass sound baffles. He was a perfect gentleman about the whole thing—never said a word, just sent along a bill for forty-three dollars a week or two later. Owen was and still is very well-liked, not just important.

Patsy Cline. When I first started working with June, Patsy was on one of the tours we did together, and of course I had to check her out. I went down the hall late one night after a show and knocked on her

door. The response came back immediately: "Get away from my door, Cash!"

"Well, Patsy, I just wanted to talk," I lied.

"The hell you did. Now, get away from here and go to bed!"

I did that, and I never hit on her again. To her credit, she was still nice to me. Patsy could cuss like a sailor, and I'd hate to have gotten in a fight with her, but she was kind to everybody who treated her right, she loved little children, and she had the heart of an angel to go with her voice. I never knew her very well, though. She was more June's buddy than mine.

Ray Charles was one of my guests on *The Johnny Cash Show,* and I enjoyed that. I love to watch him work. He's got such an incredible ear, and he's such a perfectionist without being obnoxious about it; nobody in *his* band can hit a bad note without his knowing exactly what happened. I was kind of pleased, at the time anyway, when he recorded "Busted" the way I had, rather than the way Harlan Howard wrote it. That was just arrogance, though. Harlan never said it, but I know he didn't like me messing with his song. And he had a right. Your songs are your babies.

Conway Twitty and I were alike in a lot of ways. We came from the same part of the country and shared the same kind of music, and beside that, I liked him. I thought it was a real tragedy that he died on his bus, of an aneurysm, while he was trying to get out of Branson. I don't know about Branson. I've played there, but I'd hate to get hooked into a routine there the way it happens to performers who have their own theaters. Two shows a day, every day, for months on end would kill me even quicker than lying around watching TV. Likely as not it would kill my creativity long before that, so dying just might be a relief.

Let me tell you more about some of my companions in my band and crew. I've already talked about Bob Wootton, the man with the electric

guitar who stands to my left, always in his snappy black Oklahoma cowboy hat, so I don't need to say anything more about him other than the fact that he's now my second most senior employee, with me since '68. That should tell you how highly I value him. I haven't said enough about Fluke, though—W. S. Holland, my drummer and the man above Bob as far as longevity goes. He's been with me thirty-eight years.

Fluke is that solid rock I can always lean on. No matter what's going wrong in the show or even in my life, he's there, ready to help, ready to listen. He's been a true friend, and he's the best drummer for my music that I can imagine. Fluke is a kind man. He's a peacemaker. He's who I turn to when there's trouble in the group; he'll calm things down with his gentle, laughing, but firm ways, and we'll get it sorted out. He's a grandfather now, like me, but just the other day he and I agreed that as long as we're able to, we'll be out here doing it, on the road.

There's no trouble today. On this tour, our outfit is running as smoothly as a new sewing machine.

On piano and keyboards, ladies and gentlemen, over there on my right (your left), it's Earl Poole Ball, with me twenty years now. Nobody plays like Earl. He's my Delta rhythm gospel boogie piano man, great on the rockabilly stuff and just beautiful with the hymns and spirituals. I love walking over there and standing beside the piano sometimes, singing right next to him while he plays—"Over the Next Hill," "These Hands," "Farther Along," some great country classic, or an old song of my own. It's a back-home, intimate thing, as it is when I sing with just my own guitar: the voice and the instrument blend into just one sound. Earl is the best-educated all-around musician in the group, and of course he's a good man. That should go without saying, but I'll say it anyway.

Dave Rorick, my bass player, is another well-rounded musician and nice man, even if he's a rookie by our standards. In years with the band, he's not even into double digits yet. He has *exactly* the right stand-up bass technique for me, and he fits just fine. The other guys

were very helpful to him when he first came along, showing him the ropes and telling him what to expect, and they had to be, because I'm not so good with that. I have a way of expecting people to catch on without my having to tell them. I also have a way of failing to show my appreciation when they do catch on. My instinct is just to *expect* people to be competent and hardworking, and only talk to them about the job they're doing for me when I think they need to do it differently, or better. I'm working on that. I should be freer with my compliments in life, not just in this book.

What goes for my band goes equally for my crew. They're solid. Jay Dauro, a twenty-year man, coordinates our travel and is the group manager, keeping the schedule straight, making sure everybody knows where they're supposed to be, and keeping us in touch with the home office via his laptop. Jay has a lot of vitality, even though he's not the kid he was when he joined us. You get an energy charge just being around him. When we're on stage, he's out in the audience at the lighting console; and he does a fine job there, too.

The man who sits next to him, handling the sound in the building, is Larry Johnson. The most relevant thing I can say about how he does *his* job is that since he's been with us, I've never heard a complaint from an audience that the sound wasn't right. I myself have messed up, getting too loud too close to the mike or too soft too far away from it, but Larry hasn't.

His partner in sound is Kent Elliot, who runs the board backstage, controlling the stage monitors so we in the band can hear each other and making sure the sound gets out to Larry and the audience. Again, no complaints there. Kent could do his job blindfolded.

Brian Farmer, my guitar tech, rounds it out. He's another high-energy worker and friend, good to be around and uncomplaining despite the long hours and hard labor. All four members of my crew are responsible for unloading our equipment from the truck, setting it up in the hall, tearing it all down again after the show, and loading it back into the truck for the next show. That's quite a job.

Brian is the best guitar tech I've ever known. He has the master's touch; he keeps my guitars up to par and perfectly in tune. There again, I might be off pitch, high or low, but my guitar isn't. I usually have at least two guitars on stage, a D76 Martin Bicentennial Model, of which only 1,976 were made, and the black custom model that Martin made for me in 1968. If one of those two develops a problem, I've got a D18 always in reserve. Martin, by the way, just came out with a run of two hundred special Johnny Cash models that I helped design. They're black and beautiful, with mother-of-pearl inlay work similar to that on the D45 Martin—and yes (again), that's a commercial. The profits will go to help support the Carter Family Fold in Virginia, which in turn will help keep mountain music thriving.

Behind my band and crew are the women who run the House of Cash: Kelly Hancock, Karen Adams, and Lisa Trice. Kelly is my niece, Reba's daughter. For almost her whole adult life, Reba was the one who coordinated everything in my business world and ran things at the House of Cash. In the last few years she's moved into retirement and now works only as an advisor, helping Kelly with the complexities of song publishing and a hundred other duties. Reba was absolutely indispensable to me for a long, long time.

As well as the House of Cash, there are the houses of the Cashes, where we live, and there again the people who keep things running have been with us for many years: our staff in Jamaica, already mentioned, and Peggy Knight, Shirley Huffine, Betty Hagwood, and Anna Bisceglia in Tennessee. Anna is the widow of Armando Bisceglia, my security chief for over twenty-five years, who died in 1996. Peggy, who often accompanies us on the road, has been with us all her working life. She might be the best Southern cook in the world. So might June. Maybe they'll both try harder to get to number one.

I feel comfortable, easy, safe, and lucky with these people.

A man who isn't with me after all these years is Marshall Grant, the original bass player in the Tennessee Two. These days he's managing

the Statler Brothers. He and I had a parting of the ways in 1980, and it wasn't a happy affair. We got to where we couldn't work together for one reason or another, it came to a head, and I fired him by letter. I've always regretted that. I don't know whether or not we could have gone on together after the problems we've had, but I do feel bad about that letter. I said things that should have been left unsaid, and I think I made a bad situation worse. Marshall and I had been so close for so long, and it was painful to have a rift between us like the one that followed. I've apologized to him since, and we've hugged each other and expressed our regrets and respect, but it's still one of the things in my life that I look back on with a shudder. I'm very glad he's doing so well now.

I was there when Dolly Parton first walked out on the Opry stage. She was thirteen, up from east Tennessee. I talked to her backstage about what she was going to sing, and she was about as nervous and excited as a person can be. Then, of course, she went out there and just destroyed them. They *loved* her. We all did. Man, she was good.

I haven't seen Dolly in almost five years. It's like that with a lot of performers I can claim as friends. We're all on the move so much that the only times we see each other, and then often fleetingly, are in airports or at awards shows. It's a shame, but there's nothing you can do about it.

You can't mention Dolly, if you're in country music, without also mentioning Porter Wagoner. He was one of the first artists I toured with; I remember him singing "Satisfied Mind" on that tour. I enjoy hearing him sing. I enjoy *him*. We all do; he's another very popular person in the business. Sometimes, when the light's right, his approach in one of his Nudie-type suits is like a fire coming. Like young Queen Victoria; like Black Elk in London.

Earl Scruggs was one of the stars who really helped me out and welcomed me when I first showed up at the Opry. Some people were sus-

picious of me, since I was one of those rockabillies from *Memphis* ("Hold your nose, Martha"), but not Earl and the boys in his band.

I ruffled some feathers on my first Opry appearance. I went on during the segment hosted by Carl Smith and had to do six encores of "Hey, Porter" before the audience would let me go, some other performers lost their slots that night and weren't too happy about it. I was upset, but Minnie Pearl came up to me backstage, pinched me on the cheek, and said, "You good-lookin' thing, don't you worry about that. You deserve everything you got tonight. You've got to come back." Then Ernest Tubb chimed in, "Yes, you do. We need people like you here." The same message came from Hank Snow, Hawkshaw Hawkins, and more than a few others. They rallied around and made sure I knew I was welcome.

For the past twenty-five years, Luther Fleaner has watched over my farm and taken good care of it and me, becoming in the process one of my closest friends. He's a country boy from Hickman County, Tennessee, a few years younger than me, old enough to have fought in the Korean War, the survivor of two bypass operations to my one, and the walking definition of good old-fashioned country kindness and hospitality. For almost thirty years Luther worked a forty-hour week at the Ford glass plant in Nashville, driving an hour to work and an hour back, as well as taking care of my place and his own. His sister, Wilma, helps him with the interior of my house. He just got married to a woman called Wanda, and that's just great. She's the same kind of person he is.

My other two best friends outside the music business are John Rollins, from whom I bought Cinnamon Hill, and John Traweek, the husband of Joyce Traweek, June's close friend since high school. The Traweeks stay with us every Christmas in Jamaica, so John and I have spent a lot of time together. He retired recently from his job at Willis Wayside, a home furniture business in Virginia Beach. He's a Johnny Cash fan, but

that doesn't matter; we don't have to talk about my life in music if I don't want to, which I usually don't when I've got life in Jamaica to fill up my senses. John and Joyce are strong Christians and great friends.

I've got a bunch of godsons I want to mention: all the Orbison boys, including Wesley; Shooter Jennings, Waylon and Jessi's son; and sons of John Rollins and Armando Bisceglia. There are also several boys named after me: sons of Henson Cargill, Bill Miller, Johnny Quinn, Kris and Lisa Kristofferson, and James Keach and Jane Seymour (all Johns or Johnnies) and Cash Gatlin, Larry Gatlin's boy. In every case I feel as honored as I should. I know that naming your child after a person is the highest compliment you can pay them.

You may have heard of the Highwaymen: me, Waylon Jennings, Kris Kristofferson, and Willie Nelson all together on a single ticket, four for the price of one. We got the idea when I was doing an ABC TV Christmas special in Montreux, Switzerland. The network told me to invite whoever I wanted to be on the show, so I asked Willie, Kris, and Waylon, and off we went to Montreux. We had so much fun, we decided to make a habit of it.

We shot the special in Montreux because it's beautiful there, and snowy, and they have a great music facility. That wasn't what Waylon said, though, when a reporter asked him, "Why Christmas in Montreux?" He gave her his famous "Who, me?" look and laid it on her: "Well, that's where Jesus was born, isn't it?"

Waylon really is the master of the one-liner. He got off a great one when he and I were recovering from bypass surgery together, which is a story in itself. It started when I went to visit him in the hospital. His doctor saw me and didn't like the way I looked, so he sent me off to another room for heart function tests, and the next thing I knew, he was asking, "Who do I call to cancel your vacation?" The following day I was in the operating room. The surgery was successful, though it's not something I'd call a pleasant way to pass the time. I felt at least

three-quarters dead in the few days after it, and Waylon said he felt the same. It definitely qualified as a close encounter with our mortality.

Waylon was in my room with me when a nurse's aide came in and started cleaning the place up. We stopped talking while she worked and watched her puffing and panting through her work, having a hard time of it because she was pretty seriously overweight. She finished up in just a couple of minutes and exited, sweating.

"Whew," said Waylon, weakly. "I'm sure glad she didn't sing."

The other Highwaymen don't go back with me as far as Waylon, but Kris comes pretty close. He and I have had a powerful connection ever since I noticed him sweeping out the CBS studio in Nashville in 1969 and saw the intensity in his eyes. I didn't know anything about his background—winning a Rhodes scholarship to Oxford, flying helicopters in the United States Army Rangers—and I couldn't see his future, but I surely knew that the fire burning in him was a hot one. When I paid attention to his songs, of course, his genius was obvious, and since it was first revealed to me I don't think I've performed a single concert without singing a Kristofferson song. "Sunday Morning Coming Down" is the one people identify with me most strongly, but if I had to pick the one I love best, I think it would be "Rainbow." In fact, that might be my favorite song by any writer of our time. Besides all that, Kris is kind and funny, and honorable; he stands up for his beliefs and he won't let you down. He, too, is one I love like a brother.

I don't know Willie very well. I never met him during his Nashville years, when he and Faron and the gang were trying to give Tootsie's Orchid Lounge a bad name, and after he left for Texas I didn't spend any significant time with him until we started working together in the Highwaymen (though "working" isn't quite the word). Even today I can't say I know him very well, either, because he's a hard man to know; he keeps his inner thoughts for himself and his songs. He just doesn't talk much at all, in fact. When he does, what he says is usually very perceptive and precise, and often very funny; he has a beautiful

sense of irony and a true appreciation for the absurd. I really like him. He and I have done some two-man shows together recently, just him on a stool with his guitar and me on a stool with mine, trading songs and jokes and stories. That's fun.

Speaking of fun, the greatest public honor I ever received, to my mind anyway, was being inducted into the Country Music Hall of Fame in 1980. I was the first living person to be so honored. I've been given all kinds of awards in my career, before and after 1980, including some big ones—Grammies, the Kennedy Center Honors, the Rock 'n' Roll Hall of Fame—but nothing beats the Country Music Hall of Fame, or ever will.

And then there's family. Joanne Yates is my sister. She's a singer and a very, very good one, although she's never tried to make a career of it. She also has a master's degree in Bible studies, and as I've already said, she's married to the Reverend Harry Yates. I love going to his church and hearing him preach; he opens up the Scriptures for me the way precious few can.

Louise, my oldest sister, is still married to Joe Garrett, her sweetheart who went off to war soon after Pearl Harbor and didn't come back until 1945, after more than three years in a Japanese prisoner-of-war camp. He didn't say much about life in the camp, but remembering what he did say still disgusts and angers me. He was very lucky to have even made it to the prison camp. He was on the cruiser *Houston* when it was bombed and sunk, but he managed to make it into the water and survive the first day's shark attacks. The following day, he and the rest of the men in the water were picked up by a Japanese navel vessel, but not with rescue in mind: all of them were stripped naked, whipped bloody, and then thrown back into the sea for the sharks. Only a handful from the hundreds who got off the *Houston* were still alive when a different Japanese ship picked them up and took them to a camp in Thailand.

The Japanese never informed the Red Cross or anyone else that Joe was still alive. Louise waited and waited, but three years went by without a word, and finally she married a man who looked just like Joe, Loys Fielder. She and Loys got along for a while, but then they started having trouble that ended with Louise filing for divorce.

Right about the time the divorce came through, a few weeks after V-J Day, Mr. and Mrs. Garrett got a call from somebody in the government telling them that their son had survived the camp and had been transferred to a hospital in Japan: nothing else, just that he was alive.

I was sitting on the steps of the church in Dyess one Sunday evening, waiting in the cool air before the service started, when a car pulled up and the skinniest man I ever saw climbed out. Joe is over six feet tall, but that day he didn't even weigh a hundred pounds. I had no idea who he was.

He walked up to me and said, "Hello, J.R. You don't know who I am, do you?"

I had to agree with him. "No, sir," I said.

"I'm Joe Garrett," he said. "Is Louise here?"

"No, sir, she's not," I replied, afraid to say any more. Even after he'd told me who he was, I couldn't see him in that walking skeleton. I knew it had to be true, though, because he sounded just like Joe. I got up and ran into the church, shouting "Joe Garrett's back! Joe Garrett's back!"

Joe and his family were among the best-liked people in Dyess, so that was wonderful news for everybody. They all crowded around him, hugged him, welcomed him home. Then we took him back with us to our house for dinner.

We got through the whole meal without mention of Louise. I'd already been sent to bed when I heard Joe and Daddy still together at the table. Joe was asking every question about everybody and everything he could think of, and Daddy was replying, until finally it couldn't be avoided anymore. Joe put the question, and Daddy told him.

"Well, Joe, she's been married, but she's divorced now. She's living over in Osceola."

Louise and Joe were wed shortly thereafter. Joe took on work as a carpenter and upholsterer, a jack of all trades and a master of many, and they raised a big family. Today they live in Gallatin, Tennessee. I like Joe, and I'm partial to a good love story.

I'm thinking back to Dyess and my little brother, Tommy. The first time I ever really took notice of his feelings was after Jack's funeral, when we were sitting together on the back porch at home. There was a big age difference between us; I was twelve and Tommy was only four at the time.

Tommy started crying. I hadn't cried that day. I put my arm around him and held him while he sobbed, realizing for the first time that we'd *both* lost Jack; it wasn't just me. What I'm trying to say is that for the first time I was really aware that Tommy was my brother exactly as Jack had been. He was more than just a little kid.

I haven't seen nearly as much of Tommy as I'd like, partly because he, too, lives the road life. As you might know, he rounds out the trio of Cashes to have gone to the top of the country charts (with "Six White Horses" in the mid-'60s), and he's always done very well as a club and concert performer, particularly in Europe. On stage, he's had to deal with being my brother just as much as Rosanne has had to handle being my daughter, and probably more. His response when someone asks him to sing one of my hits is, "No, Johnny and I don't sing each other's songs. We leave that up to each other. I can't sing them the way he can, so I shouldn't even try. Thank you very much for asking, anyway."

Tommy's not the only one I regret not seeing more. With one brother, three sisters, seven kids, and twelve grandchildren, I sometimes find myself fretting, wondering how I can ever spend enough time with any of them without retiring and making it a full-time job. That's silly, though. If I leave it alone, it seems to work out all by itself. We see each other when we should.

I went back to the old homesite in Dyess a few years ago. The house itself was very far gone, falling slowly into the Delta mud, and the land all around it, as far as I could see, was just huge flat fields, probably given over to rice or wheat in rotation, probably owned by some big agricultural corporation somewhere. I didn't remember the land being that flat. I remembered little hollows where the cotton wouldn't grow well if you got too much spring rain and little hills of sandy loam where Daddy planted watermelons. From our land back then you couldn't see the water tower two miles away in the center of town because of the lay of the land when you looked from some angles and the intervening trees when you looked from others. I stood at the old home place on that last visit and saw the tower as plain as day. The land had been flattened, and the trees were all gone.

So much life, so many people I love, sprang from that place.

2

We're not in Wisconsin anymore. Since Ashland I've been to New York, to New England, to South Carolina, to North Carolina, to Georgia and Alabama, over to Jamaica, and back to Tennessee. Now I'm in Öland, Sweden, where tonight we're playing an outdoor concert in the ruins of a twelfth-century castle. At this moment I'm in my hotel room, and I think it might be hard for me to get my afternoon nap. This is a resort town, and it's jumping. A gale of rock 'n' roll music from the beach is beating against my window.

Travel broadens my mind, you know, but not so much that I can't get my head out the door (with respects to Elvis Costello, who conceived that notion). In recent years June and I have made a point of arriving in places like this a little sooner than we absolutely have to and being tourists for a day or two, sometimes even more. If we're in Paris

or Cologne, someplace with a great cathedral, we'll be sure to go there and sit in admiration, absorbing the beauty of man's work in God's name and being quiet, being still. We always move on feeling strengthened, restored, and renewed. Notre Dame just stuns me, every time.

If we're in New York we'll go to the movies, maybe even two or three a day. I enjoy "good" movies, but I also want to see the big hits like everyone else. I'm the same way with books. I have my own special tastes and interests, and I get into themes—a string of biblical novels, a spell of Vietnam war chronicles—but I certainly don't want to let the cream of the *New York Times* best-seller list pass me by. I'm not one of those public personalities who "can't" go to the movies with everyone else. I walk the streets and shop in the stores and buy my movie tickets at the box office. People don't "leave me alone." They recognize me, and when I'm standing in line we talk, and if they want an autograph I give them one. Then we all say 'bye and go watch the movie. Of course, if I'd turned out to be Elvis or Marilyn Monroe, or Michael Jackson or Madonna, I might not want to do things that way. Comparatively speaking, being Johnny Cash isn't that tough a job.

As for other performers, Alan Jackson is one of the current country singers who, in my opinion, is a keeper. He has staying power. So, obviously enough, does George Strait. Marty Stuart, Collin Raye, and Travis Tritt are also in it for the long haul, I believe and Dwight Yoakam is doing a wonderful job. All these men, particularly Dwight and Marty, are keeping the traditions of country music alive while also pushing it into some very cool new places. They're not just trying to sound like George Jones and Lefty Frizzell, as too many other promising younger singers are doing. I wish these boys would try sounding like themselves and that their producers would let them.

You know, I was working in a studio in Nashville one time, standing behind the board in the control room listening to a playback, when a man from Randy Travis's record company came in.

"What's going on over there at Warner Brothers?" I asked him.

"Oh, well, you know how it is," he said. "We're just looking for the new Randy Travis."

"What's wrong with the one you've got?" was my response. I know exactly how it is, not just at Warner Brothers but everywhere else in town, too, and it really annoys me.

Someone who sounded absolutely, unmistakably, incomparably like himself was Roger Miller. And what a self that was: brilliantly creative, incredibly witty, and a kind and gentle human being. I was in Las Vegas once, suffering from that old amphetamine laryngitis, when he just showed up and told me he was going to do my show for me until I could handle it myself.

"You can't sing, and I can," he said. It was that simple. He saved all kinds of trouble and expense.

At the end of that engagement, June went home and Roger and I drove to L.A. together. Out in the middle of the desert he told me to pull over, then jumped out, and ran off behind a Joshua tree with a pad and pencil. When he came back he had a fully written song.

It was "Dang Me." He'd hidden behind that tree to write it because he knew it was just too hot a song to be created with me or anyone else anywhere near him. He had to bring it into the world all by himself, like an Apache woman giving birth. When he came back and sang it to me off the pad, I saw his point.

Bill Monroe is the only man I've ever known who invented a whole new style of music. They didn't call him "Daddy Bluegrass" for nothing, you know. I could sing his songs when I was a kid with a high tenor, before my voice broke. Later, when he came to the guitar pulls at my house, I'd back him on rhythm guitar and baritone harmony while he played mandolin and sang lead. "Will you second me on this one, John?" is how he'd always say it.

* * *

Johnny Paycheck and I had some serious good times together back when he was still calling himself Donny Young. So did Ray Price and I. We stayed up all night together in Miami once, while he had "My Shoes Keep Walking Back to You" on the charts. What a great song.

People gave Ray a lot of flak for recording "For the Good Times" with an orchestra, and I enjoyed how he handled that. When he got to the microphone at the CMA awards show after being handed the Entertainer of the Year award—the big one, for those of you unfamiliar with CMA ratings—he said, "Everybody's been wondering what I was up to with the orchestra I've been singing with." He paused a beat to punch up the drama, brandished the award above his head, and said, "Well, this is it." Then he just gave them a big, broad smile and walked off the stage.

I never did understand the resentment about country artists "going pop." Either you've got what it takes to appeal to a whole lot of people, or you don't.

Speaking of which, I once had a big night with Jim Reeves, too. I was down in San Antonio, visiting with my first parents-in-law, the Libertos, and he was playing a club. I went to catch his show and we ended up hanging out for hours and hours, way past dawn's early light. His "Gentleman Jim" image didn't stop him from consorting with the likes of me.

Linda Ronstadt. I had her on my TV show four times. Her first appearance was her TV debut, and the first song she sang was Bob Dylan's "I'll Be Your Baby Tonight." What a moment. I don't know how many people fell in love with her that night, but I'll bet they numbered in the thousands, at least.

Which brings me to some other wonderful women country singers. There's Connie Smith, the favorite of many Nashville people even though she hasn't had a record out in years. She married Marty Stuart just as few days ago—Jay Dauro got the news from Kelly Hancock via

e-mail and passed it on to the rest of us—and I must say, we were all very glad to hear that. Ever since Marty started going with her, there's been a bunch of us hovering around, telling him he'd better not hurt her. Connie is like our little sister: Waylon's, mine, everybody's.

Tanya Tucker, of course, isn't the little-sister type, but she too is a fair bit more than all right.

And that brings us to Trisha Yearwood. She moves me. She's a really fine interpretive singer, and she has great taste. I don't think anything as good as "The Song Remembers When" has been on the radio in a long, long time. I want to sing with her.

Her friends the Mavericks are a pretty hot band—very stylish, very interesting, very smart. Bobby Reynolds, the Maverick who married Trisha, is especially smart.

The light's beginning to fade in Öland. I'm thinking about all the many other places I've been and seen, the stops along my road. The pictures flit by in my head. A border checkpoint between Communist Poland and East Germany when June, Mother Maybelle, and I had to sing for the guards before they would let us pass. A castle in Scotland where we stood in the twilight and watched thousands of crows arrive and fly around the keep, as they've been doing at the dimming of the light every day for hundreds of years, who knows why. A morning in downtown Bangkok when I asked why there were no birds anywhere and was told that air pollution had killed them all. A concert for the remnants of the great Sioux Nation near the ground on the Rosebud River where they won their last victory, over George Armstrong Custer and his men. A morning in Greenwich Village with Rosanne, talking and singing with her at her childrens' school. A night in London watching Nick Lowe, Martin Belmont, and several other hardened, drunken rock 'n' roll Limeys playing George Jones's recording of "We Ought to Be Ashamed" and bursting into tears. Dyess, Arkansas, with Jack in the barn where we dried the peanuts from our fields, picking out the ones ready for roasting, then bagging them in brown paper sacks from

the co-op store to sell outside the movie theater, a nickel a small bag, a dime for a big one.

It's about time for me to go to work, or if you like, to go play. That's what we music gypsies call it, after all. I'll put on my black shirt, buckle up the black belt on my black pants, tie my black shoes, pick up my black guitar, and go put on a show for the people in this town.

A Recording Overview:

A JOHNNY CASH DISCOGRAPHY

Prepared by John L. Smith

Over the past forty-plus years, the career of Johnny Cash has literally reached international proportions. His recordings have been released in over twenty-six different countries and he has recorded material in both Spanish and German. Worldwide, the number of releases of Cash material is staggering: over 228 different record labels, close to 450 singles, 108 extended-play albums, over 1,500 long-play albums, and more than 300 compact discs. From the first Sun Record release in 1955 through his most recent, *Unchained*, Johnny Cash has kept his early audience while expanding his appeal to a younger generation of fans and fellow musicians. What follows may seem very sparse to long-time Cash followers, but it will provide a starting point for the new wave of international country fans.

For those wishing to delve deeper into the recording career of Johnny Cash, the following books are recommended: *The Johnny Cash Discography* (1984); *The Johnny Cash Discography, 1984–1993* (1994); and *The Johnny Cash Record Catalog* (1994), all from the Greenwood Publishing Group, Westport, Connecticut. A fourth volume, *Another Song to Sing: The Recorded Repertoire of Johnny Cash,* is now being readied for publication by Scarecrow Press.

The following, then, is a chronological listing of major releases, with annotation, from both the United States and foreign markets.

1955

Hey, Porter / Cry, Cry, Cry (SUN—221)

The first single released by Johnny Cash and the Tennessee Two, Marshall Grant and Luther Perkins. "Cry, Cry, Cry" spent one week on the *Billboard* charts at number 14.

Folsom Prison Blues / So Doggone Lonesome (SUN—232)

The initial release of "Folsom Prison Blues." It entered the *Billboard* charts on February 11, 1956, remained for twenty-three weeks, and peaked at number 5. On January 13, 1968, Cash recorded this same song again in a live performance at Folsom Prison, in California.

1956

I Walk the Line / Get Rhythm (SUN—241)

"I Walk the Line" would become Cash's theme song. It entered the *Billboard* charts on June 9, 1956, and remained there for forty-three weeks, reaching number 2.

1957

Hot and Blue Guitar (SLP—1220)

The first album released by Johnny Cash on the Sun label. In all, Sun Records released seven albums of Cash material extending well into his early Columbia years.

1958

What Do I Care / All Over Again (CBS/4—41251)

Cash's first single on his new label, Columbia Records. It became a double-sided hit appearing not only on the *Billboard* country charts but on the pop charts as well.

Songs That Made Him Famous (SLP—1235)

1959

The Fabulous Johnny Cash (CBS/CL—1253/CS—8122)

Although Cash signed with Columbia Records in August 1958, this, his first album release on the new label, appeared in January 1959.

Hymns by Johnny Cash (CBS/CL—1284/CS—8125)

Even though Cash had originally portrayed himself as a gospel singer to Sun Records, Sun released only a handful of religious songs. This was the first of many religious albums Cash released during his career.

Songs of Our Soil (CBS/CL—1339/CS—8148)

This album contains probably the first protest song Cash ever recorded, "Old Apache Squaw"; Columbia finally consented to its release on this album.

Greatest Johnny Cash (SLP—1240)

1960

The Rebel—Johnny Yuma (CBS/B—2155)

This extended-play release includes the theme song for the ABC TV series *The Rebel,* starring Nick Adams. Cash guest-starred at least once on the show.

Johnny Cash Sings Hank Williams (SLP—1245)

Ride This Train (CBS/CL—1464/CS—8255)

Cash's first concept album, a historical travelogue combining narrations and songs. Several more concept albums would follow.

Now There Was a Song (CBS/CL—1463/CS—8254)

This album is a departure from past Cash releases in that it is made up of old country standards. It is also unique in that it was recorded at only one session and no master required more than three takes to complete.

1961

Now Here's Johnny Cash (SLP—1255)

Lure of the Grand Canyon (CBS/CL—1622/CS—8422)
Cash narrates a trip to the bottom of the Grand Canyon on mules.

1962

Hymns from the Heart (CBS/CL—1722/CS—8522)

The Sound of Johnny Cash (CBS/CL—1802/CS—8602)

All Aboard the Blue Train (SLP/1270)

1963

Blood, Sweat and Tears (CBS/CL—1930/CS—8730)
This album includes a lengthy version of "The Legend of John Henry's Hammer" reworked by Cash and June Carter. The Carter Family—Mother Maybelle, Anita, Helen, and June—appear on this album. From this point on, this famous family would become an almost permanent part of the Johnny Cash road show and appear as vocalists on many future albums.

Ring of Fire / I'd Still Be There (CBS/4—42788)
"Ring of Fire" debuted on the *Billboard* charts June 8, 1963, and remained there twenty-six weeks, with seven weeks at number 1.

Ring of Fire (CBS/CL—2053/CS—8853)

The Christmas Spirit (CBS/CL—2117/CS—8917)

1964

Keep on the Sunnyside (CBS/CL—2152/CS—8952)
A Carter Family album release with Cash appearing as a "special guest" performing the parts A. P. Carter performed on the original version of the included songs.

Wide Open Road / Belshazzar (SUN—392)

After 1958, when Cash left the Sun Record label, Sam Phillips continued to release Cash material. This was the last Sun single to appear until 1969, when Shelby Singleton began reissuing the original Sun masters on his Sun International label.

Bad News / The Ballad of Ira Hayes (CBS/4—43058)

When "The Ballad of Ira Hayes" was released, radio stations around the country felt it was too controversial and, for the most part, refused to play it. It was only after Cash himself took out a full-page ad in *Billboard* magazine challenging disc jockeys to show some "guts" that it finally got airplay. It entered the *Billboard* charts on July 11, 1964, and remained for twenty weeks, topping at number 3.

I Walk the Line (CBS/CL—2190/CS—8990)

The Original Sun Sound of Johnny Cash (SLP—1275)

The last Sun album for Cash. Appearing in November, it contained some previously unissued material.

Bitter Tears (CBS/CL—2248/CS—9048)

This album includes "The Ballad of Ira Hayes" and could probably be considered Cash's first protest album. "As Long As the Grass Shall Grow" became somewhat of a national anthem for some Native American groups around the country.

1965

Orange Blossom Special (CBS/CL—2309/CS—9109)

Country performer Boots Randolph played saxophone on the title song on this album. "Orange Blossom Special" would become a regular feature of the Johnny Cash road show, supplemented with railroad footage and climaxing in an on-screen collision between two steam engines.

Ballads of the True West (CBS/C2L38/C2S838)

A double album showcasing Cash's talent at concept albums. The color and characters of the Old West are depicted in song and narrative. Cash also

provided exceptional liner notes. Maybelle Carter plays autoharp on much of the material.

1966

Mean as Hell (CBS/CL—2446/CS—9246)

Everybody Loves a Nut (CBS/CL—2492/CS—9292)

Happiness Is You (CBS/CL—2537/CS—9337)

1967

Jackson / Pack Up Your Troubles (with June Carter) (CBS/4—44011)

"Jackson" entered the *Billboard* charts on March 4, 1967, remained for seventeen weeks, and peaked at number 2. In spite of the numerous duets Cash and June Carter have done, "Jackson" remains the most popular and is always an audience favorite at any Johnny Cash concert.

Johnny Cash's Greatest Hits (CBS/CL—2678/CS—9478)

Carryin' On (CBS/CL—2728/CS—9528)

A full album of duets with June Carter, with the entire Carter Family (Maybelle, Anita, and Helen) providing background vocals.

1968

From Sea to Shining Sea (CBS/CL—2647/CS—9447)

Johnny Cash at Folsom Prison (CBS/CL—2839/CS—9637)

This album was recorded live at Folsom Prison on January 13, 1968, and started a second career for Cash. The live single release of "Folsom Prison Blues" entered the *Billboard* charts on June 1, 1968, and remained for eighteen weeks, with four weeks at number 1. The album itself spent eighty-nine weeks on the country charts, four of those weeks at number 1, and one hundred and twenty-two weeks on the pop charts, reaching number 13 there.

1969

The Holy Land (CBS/KCS—9726)

A combination of narratives, recorded on site in the Holy Land using a cassette recorder, and songs. It was during the making of this album that Luther Perkins, one of the original Tennessee Two, died in a house fire.

Johnny Cash at San Quentin (CBS/CS—9827)

Cash's second live prison album, recorded February 24, 1969. It includes the smash hit "A Boy Named Sue." The album entered the *Billboard* charts in July 1969, spending seventy weeks on the pop charts while peaking at number 1 for four weeks. During the same time period it spent fifty-five weeks on the country charts, maintaining number 1 for twenty weeks.

San Quentin / A Boy Named Sue (CBS/4—44944)

"A Boy Named Sue," written by Shel Silverstein, was recorded live at the San Quentin Prison performance in February 1969. It was a number-1 chart hit for five weeks on the country charts and reached number 2 for three weeks on the pop charts.

Original Golden Hits, Volume One (SUN—100)

In 1969 Sam Phillips sold his entire inventory of Sun masters to Shelby Singleton. Singleton, in turn, created a Sun International label and began reissuing the original Sun material. It had long been thought that Phillips had not actually released all the masters Cash cut during his Sun days and Singleton's reissues revealed that to be true. Not only did Singleton release unissued material but he also, either purposely or inadvertently, released a large number of alternate takes of previously released songs. These reissues, coming during Cash's current popularity with the Folsom and San Quentin albums, brought to a new generation of country music listeners the original Sun sound of Johnny Cash.

Original Golden Hits, Volume Two (SUN—101)

Story Songs of Trains and Rivers (SUN—104)

Get Rhythm (SUN—105)

Showtime (SUN—106)

1970

Thanks, in part, to the Sun International reissues, Cash ended 1969 with nine albums on the *Billboard* pop charts and started 1970 with no less than eight albums on the country charts.

Hello, I'm Johnny Cash (CBS/KCS—9943)

This album includes, in addition to fine music, the best set of liner notes ever appearing on any Cash album to date. They were written by the producer of the album, Bob Johnston.

The Singing Story Teller (SUN—115)

This Sun International album includes the previously unissued "I Couldn't Keep from Crying."

The Johnny Cash Show (CBS/KC—30100)

This "live" album is a combination of material from several of the Johnny Cash television shows that aired during 1969–70 on ABC TV.

The Rough Cut King of Country Music (SUN—122)

Included in this Sun International release are three songs previously unissued: "Cold, Cold Heart," "You're My Baby," and "Fools Hall of Fame."

I Walk the Line (CBS/S—30397)

The soundtrack album of the motion picture of the same name, starring Gregory Peck and Tuesday Weld.

Little Fauss and Big Halsy (CBS/S—30385)

Another soundtrack album release of a motion picture, this one starring Robert Redford.

1971

Man in Black (CBS/C—30550)

This album release entered the *Billboard* charts in June 1971, remained for twenty-nine weeks, and stayed at number 1 for two weeks.

1972

A Thing Called Love (CBS/KC—31332)

America (CBS/KC—31645)

Some of the material included in this album had originally been intended only for the crew of the *Apollo 14* space flight. For whatever reason, it was not used for that flight but instead was included in this release. This album, again, is a Cash concept album as only he can do it. Each song is preceded by a narrative adding background. This album includes the song "Big Foot," which was written by Cash as he drove through the Badlands of South Dakota immediately following a tour of the Wounded Knee Battlefield in December 1968.

1973

Any Old Wind That Blows (CBS/KC—32091)

Gospel Road (CBS/KG—32253)

A two-record set of the soundtrack to the motion picture Cash produced and narrated depicting the life of Jesus.

Johnny Cash and His Woman (CBS/KC—32443)

1974

Ragged Old Flag (CBS/KC—32917)

The title song for this album was recorded live at the House of Cash complex on January 28, 1974, at a luncheon for CBS Records. It was reissued as a single in 1989 as a result of the Supreme Court's flag-burning ruling.

The Junkie and Juicehead (Minus Me) (CBS/KC—33086)

This album includes Rosanne Cash, Carlene Carter, and a Cash duet with and Rosie Nix. Carlene and Rosie are June's daughters and Rosanne is John's daughter.

At Ostraker Prison (CBS—65308)

Yet another live prison album, recorded in Stockholm, Sweden, on October 3, 1972, and only released by CBS in Europe in December 1974. The concert was also filmed and shown in Europe by Granada Television.

1975

Children's Album (CBS/C—32898)

Unfortunately, Cash's only children's album to date.

Precious Moments (CBS/C—33087)

This album of religious music was dedicated to Cash's brother, Jack, who died at the age of fourteen.

John R. Cash (CBS/KC—33370)

Look at Them Beans (CBS/KC—33814)

1976

Strawberry Cake (CBS/KC—34088)

This live release is a compilation of two shows done at the Palladium Theater in London, in September 1975. During one of the performances the theater had to be evacuated because of a bomb threat.

One Piece at a Time (CBS/KC—34193)

The title song from this album, when released as a single, spent fifteen weeks on the charts, reaching number 1 for two weeks in a row.

1977

The Last Gunfighter Ballad (CBS/KC—34314)

The Rambler (CBS/KC—34833)

Another Cash concept album.

1978

The Unissued Johnny Cash (Bear Family/BFX—15015)

Second only in importance to the Shelby Singleton reissues of the original Sun material is the catalog of Bear Family Records of Germany. Beginning with this album, Bear Family began reissuing much early CBS material including many unissued masters. This album includes two songs in German that had been originally released as a single only in Europe.

I Would Like to See You Again (CBS/KC—35313)

On this album John Carter Cash appears for the first time, on "Who's Gene Autry."

Gone Girl (CBS/KC—35646)

Cash's producer at Sun Records in the late 1950s, Jack Clement, produced this album.

1979

Johnny and June (Bear Family/BFX—15030)

This European album includes several previously unissued masters, including the very first duet with June Carter, "How Did You Get Away from Me." Two more songs Cash recorded in German are included.

Silver Anniversary Album (CBS/JC—36086)

Tall Man (Bear Family/BFX—15033)

Another European album containing some unissued material.

A Believer Sings the Truth (Cachet/CL3—9001)

This double gospel album was Cash's most ambitious project aside from

the *Gospel Road* motion picture soundtrack. It took the better part of six months in 1979 to complete with some very extensive overdub sessions.

1980

Rockabilly Blues (CBS/JC—36779)

Earl P. Ball produced the album, with Nick Lowe and Jack Clement each producing one track.

1981

The Baron (CBS/FC—37179)

A music video was made from the title song of this album featuring Cash and a very young Marty Stuart.

1982

The Survivors (CBS/FC—37916)

A live performance of a Stuttgart, Germany, show from April 23, 1981. During the show Carl Perkins and Jerry Lee Lewis, former label mates with Cash at Sun Records, appeared unexpectedly and joined Cash on stage. It was produced by Johnny Cash, Lou Robin, and Rodney Crowell.

The Adventures of Johnny Cash (CBS/FC—38094)

Johnny Cash (Time-Life/TLCW—03)

A three-record set issued by the Time-Life Corporation and a very good overview of the recording career of Johnny Cash. It also contains a previously unissued master, "The Frozen Logger."

1983

Johnny 99 (CBS/FC—38696)

Koncert V Praze (In Prague—Live) (Supraphon/CBS/1113.3278)

A live concert performed in Prague, Czechoslovakia, on April 11, 1978. However, the album was not released until 1983 and then only in Europe.

1984

The Sun Years (Charly/Sunbox—103)

Besides the releases of early Cash material by Sun International and Bear Family Records, Charly Records of England provided some excellent repackaged Sun material. This five-record set includes original master releases, alternate versions, and some previously unreleased masters. The boxed set also included a booklet featuring many early photographs. Perhaps the highlight of the set are two previously unissued titles, "One More Ride" and "Leave That Junk Alone."

Bitter Tears (Bear Family/BFX—15127)

A revised edition of the earlier CBS album, but Bear Family added "Big Foot" and "Old Apache Squaw" and the album sleeve includes photographs of Cash's 1968 tour of the Wounded Knee Battlefield in South Dakota.

1985

Highwayman (CBS/FC—40056)

The first of three releases combining the talents of Cash, Waylon Jennings, Willie Nelson, and Kris Kristofferson. One unique feature of this album is the inclusion of the song "Big River." When Cash originally recorded it on November 12, 1957, at the Sun studio in Memphis, one verse had to be dropped because of the overall length of the song. However, for this album release the "missing" verse was reintroduced so that each of the four performers could do one verse. Both the single and the album reached number 1 on the *Billboard* country charts.

Rainbow (CBS/FC—39951)

1986

Heroes (with Waylon Jennings) (CBS/FC—40347)

Cash's last album with CBS Records, marking the end of an association that began almost thirty years before. This excellent album combines the talents of long-time friends Cash and Waylon Jennings.

Class of '55 (Mercury/Polygram/830—002—1)

This Mercury Records release features four former Sun performers, Cash, Carl Perkins, Jerry Lee Lewis, and Roy Orbison, recording again in Memphis. "Big Train from Memphis" includes a sweeping array of popular talent from John Fogerty to Rick Nelson.

Believe in Him (Word/WS—8333)

Marty Stuart produced this album of gospel music released on Word Records.

The Sun Country Years, 1950—1959 (Bear Family/BFX—15211)

An eleven-record boxed set from Bear Family Records devoted to early Sun recording artists and released only in Europe. Included are several alternate takes of Cash's previously released Sun material.

1987

Columbia Records, 1958—1986 (CBS/C2—40637)

A two-record set released by CBS Records soon after Cash left for Mercury Records. This is another overview of Cash's CBS career. This set also includes a previously unissued version of "You Dreamer You."

Johnny Cash Is Coming to Town (Mercury/Polygram/832—031—1)

This marks Cash's first release on Mercury Records and is highlighted, perhaps, by the inclusion of the Elvis Costello composition "The Big Light," "Sixteen Tons," and a duet with Waylon Jennings on "Let Him Roll."

1988

Classic Cash—Hall of Fame Series (Mercury/Polygram/834—526—1)

An interesting collection of material from Cash's past years rerecorded and issued on this Mercury Records album. This was originally intended as a European release only, but it was finally released in the United States to coincide with the Country Music Hall of Fame exhibit honoring Johnny Cash. Hence the title.

Water from the Wells of Home
(Mercury/Polygram/834—778—1)

The highlights of this Mercury Records release include a duet with Paul and Linda McCartney and two duets with John Carter Cash, Cash's son. This album also includes Roy Acuff, Emmylou Harris, Waylon Jennings, Jessi Colter, and Hank Williams Jr., among others.

1989

Boom Chicka Boom (Mercury/Polygram/842—155—1)

Produced by Bob Moore, this album was Mercury's attempt to recreate, with some success, the original Sun sound. When this was released in Europe it included an additional song, "Veteran's Day."

1990

Highwayman 2 (CBS/C—45240)

This is "volume two" by Cash, Waylon Jennings, Willie Nelson, and Kris Kristofferson.

The Spoken Word New Testament (TNO—7488ca)

A fourteen-cassette package of Cash reading the New King James version of the New Testament, released through Thomas Nelson.

The Man in Black, 1954—1958 (Bear Family/BCD—15517)

A five-CD boxed set by Bear Family Records, the first in an ongoing series, containing both Sun and CBS material and including virtually the complete sessions from 1954 through 1958. The fifth CD in this set is devoted to a single recording session from CBS featuring false starts and out-takes. A booklet is enclosed with this package featuring early photographs and a discography.

1991

The Mystery of Life (Mercury/Polygram/848—051—2)

Cash's last CD with Mercury Records.

The Man in Black, 1959–1962 (Bear Family/BCD—15562)

A continuation of the Bear Family Records series, this one from 1959 through 1962. Included in this five-CD boxed set are songs by Roy Cash and Ray Liberto, Cash's nephew and brother-in-law, respectively. Again, the fifth CD is a complete recording session from May 1960. A booklet is included.

Come Along and Ride This Train (Bear Family/BCD—15563)

A four-CD boxed set by Bear Family Records simply reissuing several of Cash's early CBS albums, including *Ride This Train, Ballads of the True West, Bitter Tears, From Sea to Shining Sea,* and *America.* An alternate version of "Come Along and Ride This Train" is used in addition to a previously unissued duet with Lorne Greene on "Shifting, Whispering Sands." A booklet accompanied this set.

1992

The Essential Johnny Cash (CBS/C3K—47991)

A three-CD boxed set featuring vintage material from 1955 to 1983, including both CBS and Sun masters. A booklet with a discography is included.

1994

American Recordings (American/45520—2)

In 1993 Johnny Cash signed with American Records. Now the recording career of a Country Music Hall of Famer was in the hands of Rick Rubin, one of the hottest rock producers in the industry. This unlikely union introduced Cash to a new and wider audience. This totally acoustic CD contained the controversial version of "Delia's Gone."

1995

The Road Goes on Forever (Liberty/C2—28091)

This is the third, and perhaps the last, of the Highwaymen projects, featuring Cash, Waylon Jennings, Willie Nelson, and Kris Kristofferson.

The Man in Black, 1963–1969 (Bear Family/BCD—15588)

A five-CD boxed set from Bear Family Records continuing its excellent series through 1969. Perhaps the highlight of this set is the inclusion of the July 1964 Newport Folk Festival performance.

Riding for the Brand (Soundelux/Mind's Eye Publishing)

The Highwaymen—Cash, Waylon Jennings, Willie Nelson, and Kris Kristofferson—lend their talents to this audiobook written by Louis L'Amour.

1996

The Sun Years (Charly/CD-Sunbox—5)

A three-CD boxed set from Charly Records containing the same material as its 1984 five-record set. This package includes an updated booklet.

Unchained (American/43097—2)

The latest release by Cash on American Records and a departure from the acoustic sound of his first Rick Rubin–produced CD. Musical accompaniment was provided by Tom Petty and the Heartbreakers, Mick Fleetwood, Lindsey Buckingham, and Flea.

One final word on the above listed releases. It is unfortunate that CBS Records could not have seen the value of reissues or had the imagination shown by foreign record companies such as Bear Family Records of Germany and Charly Records of England. The significance of the reissues of these two record companies cannot be overstated. To CBS's credit, however, it is beginning to reissue some of the early albums on CDs. It is hoped that this will continue and Cash himself can take an active part in the reissue process. Through the availability of previously unissued material and alternate takes of released titles, newcomers to the music of Johnny Cash, as well as existing fans, can build a strong base for a major part of the early recording career of a country music legend.

Photographic Credits

Grateful acknowledgment is given to the following individuals and organizations for the photographs that appear in this book.

Section 1

Carrie Rivers Cash: House in Dyess, AK. *Author's Collection:* Cash family. *Ray Cash:* Jack, Johnny and Reba. *Author's Collection:* Senior photo. *Carrie Rivers Cash:* Roy and Johnny, 1954. *Author's Collection:* Airman Cash, 1952. *Hope Powell:* Parents. *Author's Collection:* In the studio. *Courtesy of Grand Ole Opry:* June at the Grand Ole Opry, 1958. *Author's Collection:* Luther, Johnny and Marshall. *Courtesy of Grand Ole Opry:* Johnny with Ernest Tubb, 1956. *Author's Collection:* With Elvis. *Author's Collection:* Five Minutes to Live, 1961. *Author's Collection:* Johnny Cash and the Family Show. *Courtesy of Columbia Records:* At Gene Autry's movie ranch, 1959. *Author's Collection:* Johnny Reb. *John McKinney:* With Rick Nelson, 1969. *Author's Collection:* Carl Perkins, W. S. Holland and Johnny, 1970.

Section 2

Author's Collection: Johnny backstage. *Author's Collection:* John and June on stage. *Merle Kilgore:* Wedding photo, 1968. *Winifred Kelley:* June, Johhny and baby John Carter. *Peggy Knight:* Family on the beach. *Karen Robin:* Johnny with grandson, 1997. *Peggy Knight:* June and Rosie. *June Carter Cash:* Carlene with Howie Epstein. *Dennye Landry:* The Cash daughters. *KTI Jensen:* The Highwaymen and their wives. *Hope Powell:* Johnny with Waylon Jennings. *Johnny Cash:* June in Jamaica. *Copyright: The Nashville Tennessean:* Folsom Prison, 1968. *Johnny Cash:* Farm at Bon Aqua, TN. *Author's Collection:* Man in Black. *Reba Hancock:* Johnny with Lou Robin. *Russ Busby/BGEA:* Billy Graham Christmas Special group shot. *Alan Messer:* Johnny with Kirk Douglas. *Andy Earl:* With Range Rover, 1996. *Tamara Reynolds:* Johnny with guitar.